COLOR AND LIGHT

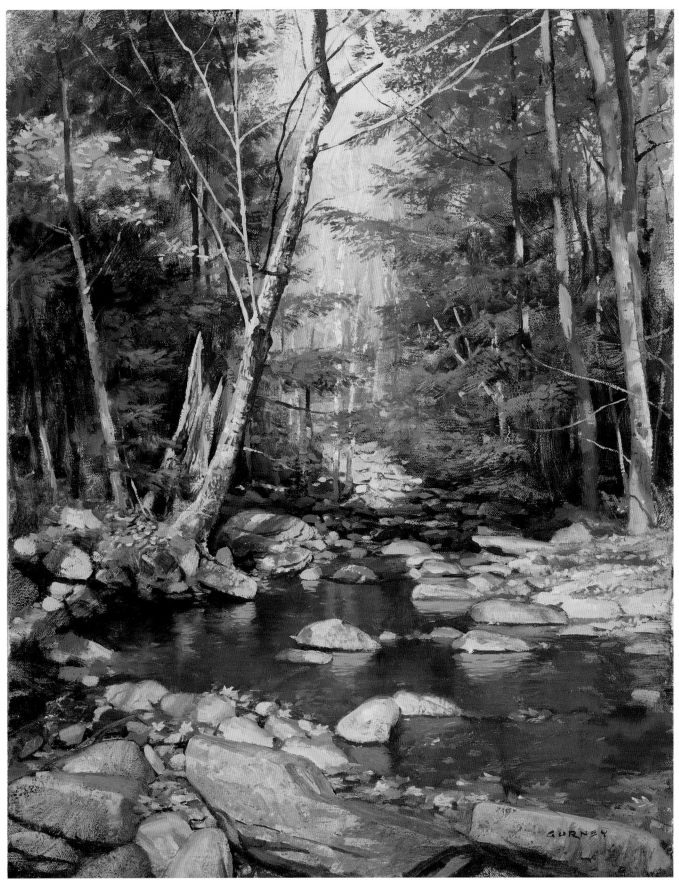

Above: Creek Above Kaaterskill Falls, 2004. Oil on canvas mounted to panel, 20 × 16 in.
Opposite: Into the Golden Realm, 2007. Oil on board, 12½ × 13½ in.

James Gurney

Color and Light

A Guide for the Realist Painter

Andrews McMeel
PUBLISHING®

Andrews McMeel Publishing
a division of Andrews McMeel Universal
1130 Walnut Street, Kansas City, Missouri 64106

www.andrewsmcmeel.com

23 24 25 26 27 SDB 25 24 23 22 21

ISBN: 978-0-7407-9771-2

Library of Congress Control Number: 2010924512

gurneyjourney.blogspot.com

ATTENTION: SCHOOLS AND BUSINESSES
Andrews McMeel books are available at quantity discounts with bulk purchase for educational, business, or sales promotional use. For information, please e-mail the Andrews McMeel Publishing Special Sales Department: sales@amuniversal.com.

CONTENTS

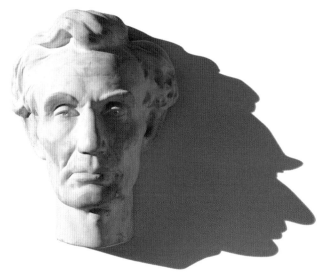

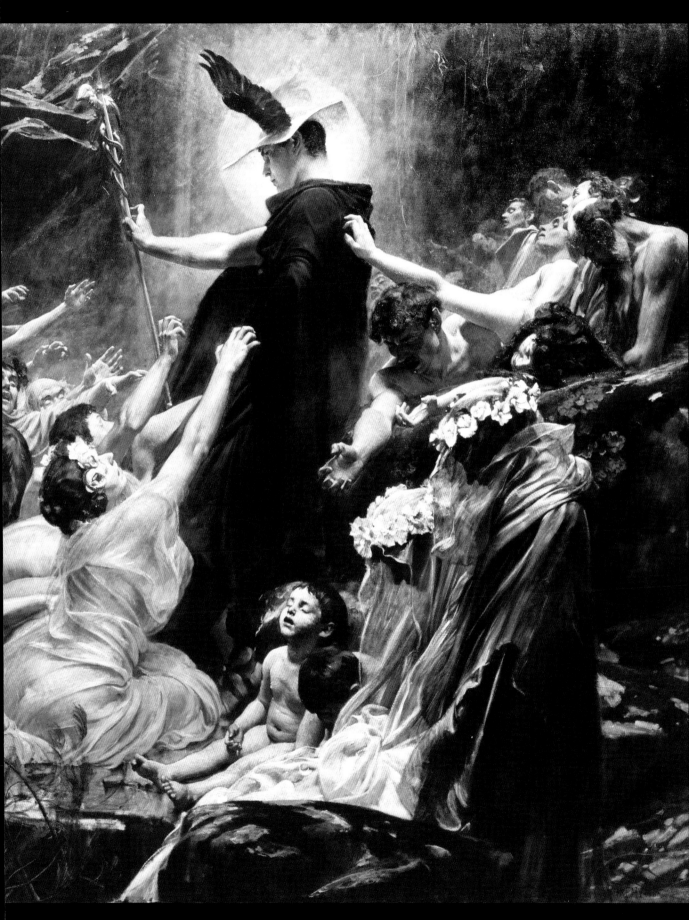

Adolf Hirémy-Hirschl, Hungarian, 1860–1933. *Souls on the Banks of the Acheron*, 1898. Oil on canvas, 85 × 134 in. Vienna, Österreishische Galerie Belvedere.

INTRODUCTION

This book examines the painter's two most fundamental tools: color and light. It is intended for artists of all media interested in a traditional realist approach, as well as for anyone who is curious about the workings of the visual world.

When I was in art school I took a color class that consisted of painting a lot of flat swatches, cutting them out with a sharp knife, and pasting them down into color wheels and gray scales. I spent months learning how to paint perfectly smooth swatches and trying to get the steps between them exactly even.

At the end of each day I would leave the classroom and look up at the colors of the sky, the trees, and the water around me. The sky was not composed of adjacent flat colors, but rather of an infinite variety of gradating hues. Why did dark colors turn blue as they went back toward the horizon—except in a few instances, such as in the painting opposite, when a setting sun casts the far vista in orange light? Why did the leaves have a sharp yellow-green color when the light shined through them, but a gray-green color on top?

In school I was learning how to see and mix color, but I had no idea how to apply this experience to real-world painting problems. Color theory seemed more like a branch of chemistry or mathematics, a separate science that had little to do with making a realistic painting. I felt like a piano student who had played a lot of scales, but had never gotten around to the melody.

If there were answers to my questions about how light interacts with color, atmosphere, water, and other materials, I would have to find them in fields like physics, optics, physiology, and materials science. I started digging back into art instruction books from more than seventy-five years ago, when it was taken for granted that artists were trying to

create an illusion of reality. Artists as far back as Leonardo da Vinci were struggling to explain the behavior of the visual world around them. Each old book had its vein of gold, but the information needed to be translated and updated for our times, and the old theories needed to be tested against recent scientific discoveries.

I investigated recent findings in the field of visual perception and found that many of my assumptions were mistaken, even about such basic things as the primary colors. I learned that the eye is not like a camera, but more like an extension of the brain itself. I learned that moonlight is not blue. It only appears blue because of a trick that our eyes are playing on us.

During the last few years, since the release of *Dinotopia: Journey to Chandara*, I have taught workshops at a lot of art schools and movie studios. I have also kept up a daily blog that explores the methods of the academic painters and the Golden Age illustrators and have adapted some of the blog content into my recent book, *Imaginative Realism: How to Paint What Doesn't Exist*. As I assembled that volume, I realized that the information on color and light was so extensive—and so popular with blog readers—that I decided it required a second volume.

This book begins with a survey of historic masters who used color and light in interesting ways. Although those paintings are a tough act to follow, for the rest of the book I'll use my own paintings—both observational and imaginative—as examples. Since I painted them, I can

tell you what I was thinking when I made them. Chapters 2 and 3 examine the various sources of light, and we look at how light creates the illusion of three-dimensional form. Chapters 4 and 5 cover the basic properties of color as well as an introduction to pigments and paints. Chapters 6 and 7 present the method I use called gamut mapping, which helps in choosing colors for a given picture.

The last chapters of the book deal with specific challenges that we face when we paint textures like hair and foliage, followed by the infinitely varied phenomena of atmospheric effects. The book ends with a glossary, a pigment index, and a bibliography.

This book doesn't contain recipes for mixing colors or step-by-step painting procedures. My goal is to bridge the gap between abstract theory and practical knowledge. I would like to cut through the confusing and contradictory dogma about color, to test it in the light of science and observation, and to place it in your hands so that you can use it for your own artistic purposes. Whether you work in paint or pixels, fact or fantasy, I want this book to bring color and light down to earth for you.

Above: Light on the Water, 2007. Oil on board, 12 × 18 in. Published in *Dinotopia: Journey to Chandara.*

Harry Anderson, American, 1906–1996. *The Widow*, 1948. Gouache on board, 15½ × 35 in. Private collection.

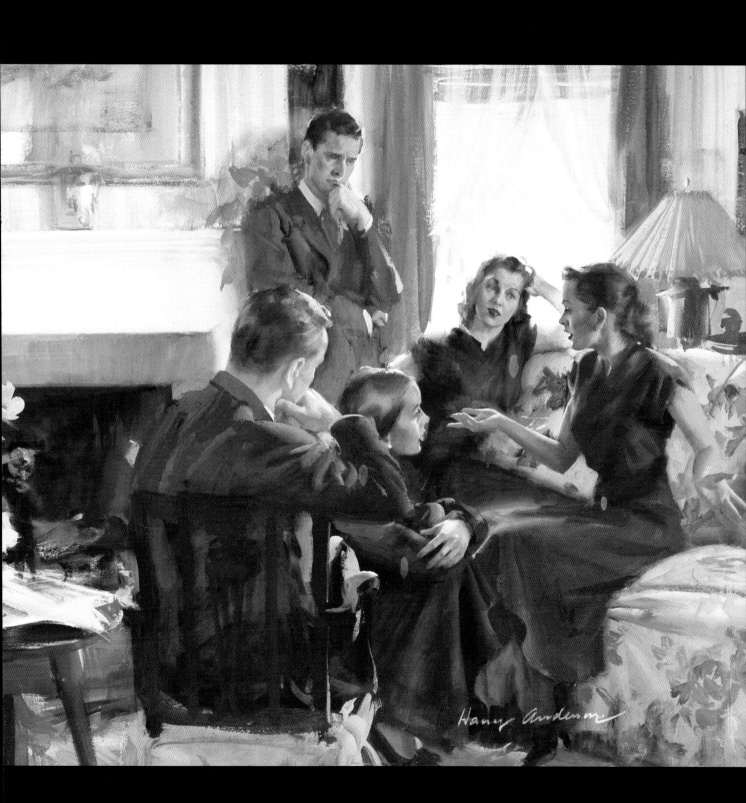

TRADITION

OLD MASTERS' COLOR

Light and color were precious to the old masters. Artists didn't have hundreds of available pigments, as we do today. Paint samples scraped from the edges of Vermeer's artwork show that he used no more than seventeen pigments.

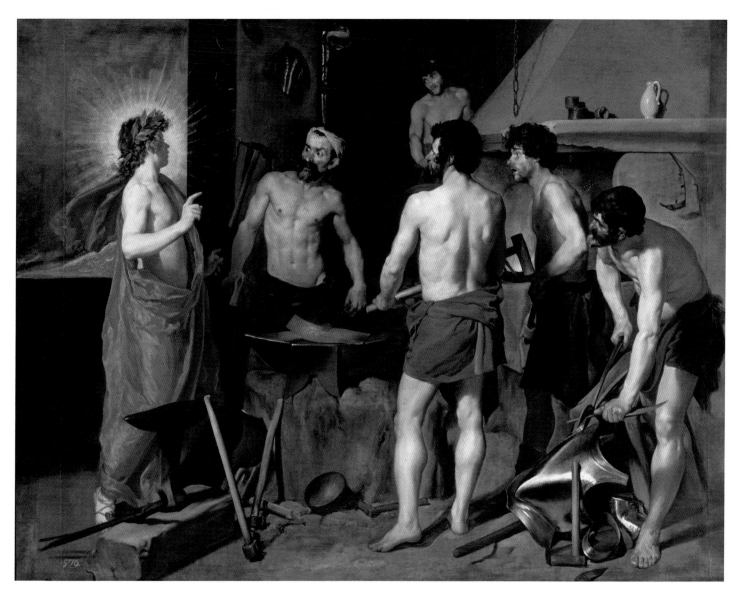

Diego Rodriguez Velázquez, Spanish, 1599–1660. *The Forge of Vulcan*, 1630. Oil on canvas, 87¾ × 114⅛ in. Museo del Prado, Madrid, Spain. Scala / Art Resource, NY.

In *The Forge of Vulcan*, Diego Velázquez surrounds the head of the god Apollo with a supernatural radiance, but uses light angled from the left to sculpt the mortal figures, even boldly casting a shadow of one figure onto another.

Vermeer's *Lacemaker* is a tiny window into an intimate world, made more real by the shallow-focus effects he observed in a camera obscura. The yellow, red, and blue colors shimmer against the variegated gray color of the background.

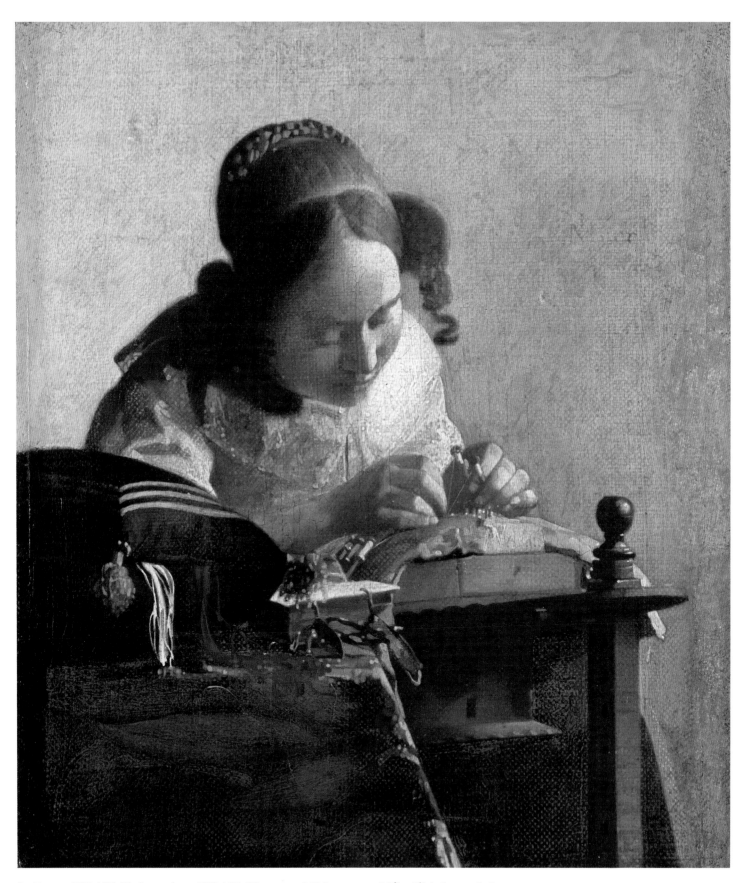

Jan Vermeer, 1632–1675. *The Lacemaker,* c. 1669–1670. Oil on canvas laid down on wood, 9 3/8 × 8 1/2 in. Louvre, Paris.
Réunion des Musées Nationaux, courtesy Art Resource.

THE ACADEMIC TRADITION

New ideas in chemistry and visual perception fueled a revolution in the use of light and color in French painting.

Nineteenth-century academic masters such as William-Adolphe Bouguereau (right) and Jean-Léon Gérôme (opposite) responded to three major innovations.

1. **Science of Perception.** Professor of chemistry Michel-Eugène Chevreul studied the perception of colors and demonstrated that colors can be understood only in relation to each other and that no color exists in isolation. Another influential scientist was Hermann von Helmholtz, who made the case that we don't perceive objects directly. Instead, our visual experience consists of color sensations on the retina. The result of these ideas was to dissociate color from surfaces and to emphasize the effects of illumination, surrounding color, and atmosphere on any perceived color.

2. **New Pigments.** The painter's palette expanded with new pigments, such as Prussian blue, cobalt blue, chrome yellows, and cadmiums. Both academic and impressionist painters sought out subjects to show off the new colors to their full advantage.

3. **Plein-Air Practice.** The collapsible paint tube was patented in 1841. It soon came into common use by artists painting outdoors. Although outdoor painting was pioneered as early as the 1780s, it was a familiar practice by midcentury. Jean-Léon Gérôme recommended to his students: "When you draw, form is the important thing. But in painting the first thing is to look for the general impression of color Always paint a direct sketch from nature every day."

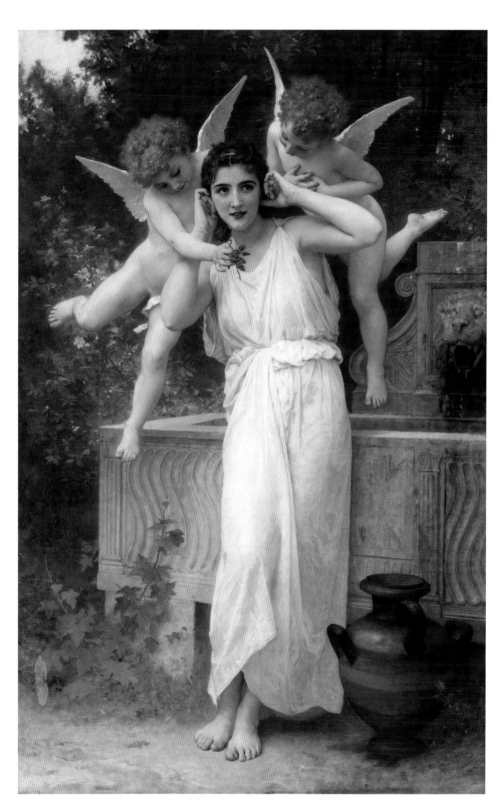

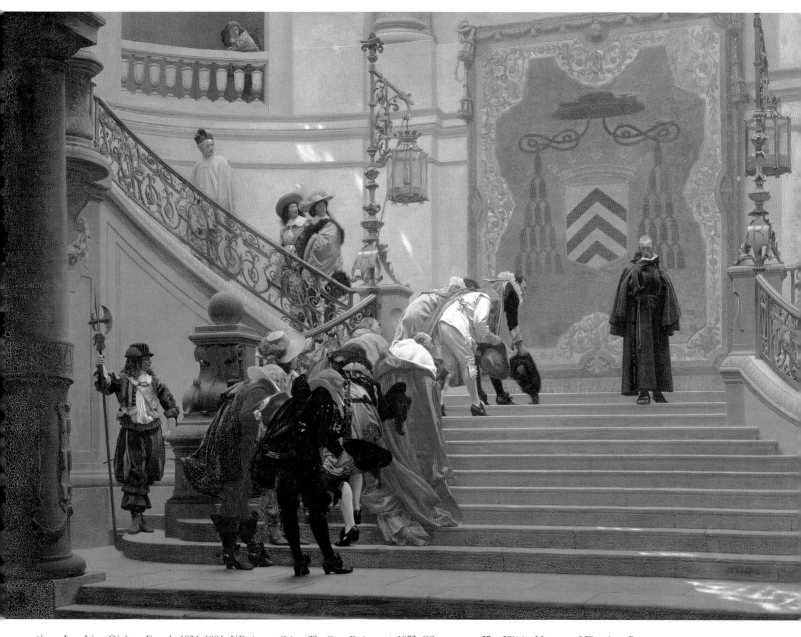

Above: Jean-Léon Gérôme, French, 1824–1904. *L'Eminence Grise (The Gray Eminence)*, 1873. Oil on canvas, 27 × 39¾ in. Museum of Fine Arts, Boston. Bequest of Susan Cornelia Warren.

Opposite: William-Adolphe Bouguereau, French, 1825–1905. *Jeunesse (Youth)*, 1893. Oil on canvas, 75¼ × 48 in. Private collection.

OPEN-AIR PAINTING IN BRITAIN

The changeable weather of Britain fostered a long tradition of observant colorists from Turner and Constable to later realists.

Opposite: John Everett Millais, British, 1829–1896. *The Blind Girl*, 1856. Oil on canvas, 32 × 24½ in. The Birmingham Museums and Art Gallery.

Below: Stanhope Alexander Forbes, R.A., British, 1857–1947. *A Fish Sale on a Cornish Beach*, 1885. Oil on canvas, 47¾ × 61 in. Plymouth City Museum and Art Gallery. Photo © Bridgeman Art Library.

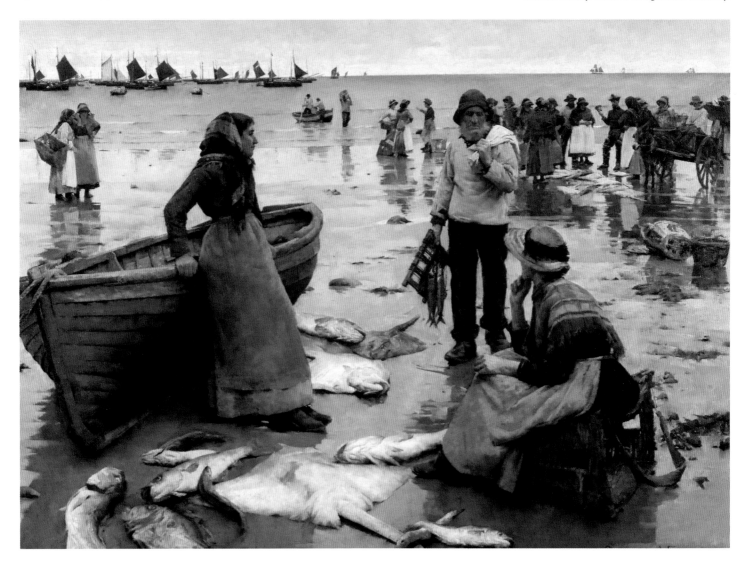

Stanhope Forbes helped establish a British art colony in the Cornish fishing village of Newlyn. He painted *Fish Sale* entirely outdoors. For nearly a year he overcame challenges of rain, wind, fainting models, and rotting fish. He was able to paint only when the tide was out and the sky was gray. Working out-of-doors was essential to capture the truthful effects of light and atmosphere and "that quality of freshness, most difficult of attainment by any other means, and which one is apt to lose when the work is brought into the studio for completion."

Sir John Everett Millais, one of the founders of the Pre-Raphaelite movement, painted the background of *Blind Girl* in Sussex in 1854, and then added the figures later. The pitiful condition of the beggar girl shows in her tattered and relatively dull-colored clothing, in contrast with the rich colors of the landscape behind her. She sees neither the double rainbow nor the butterfly on her shawl.

The Pre-Raphaelites experimented with new ways of painting, applying colors in transparent glazes over semidry white ground, and achieved a depth of color that struck some critics as garish, but others as faithful to nature.

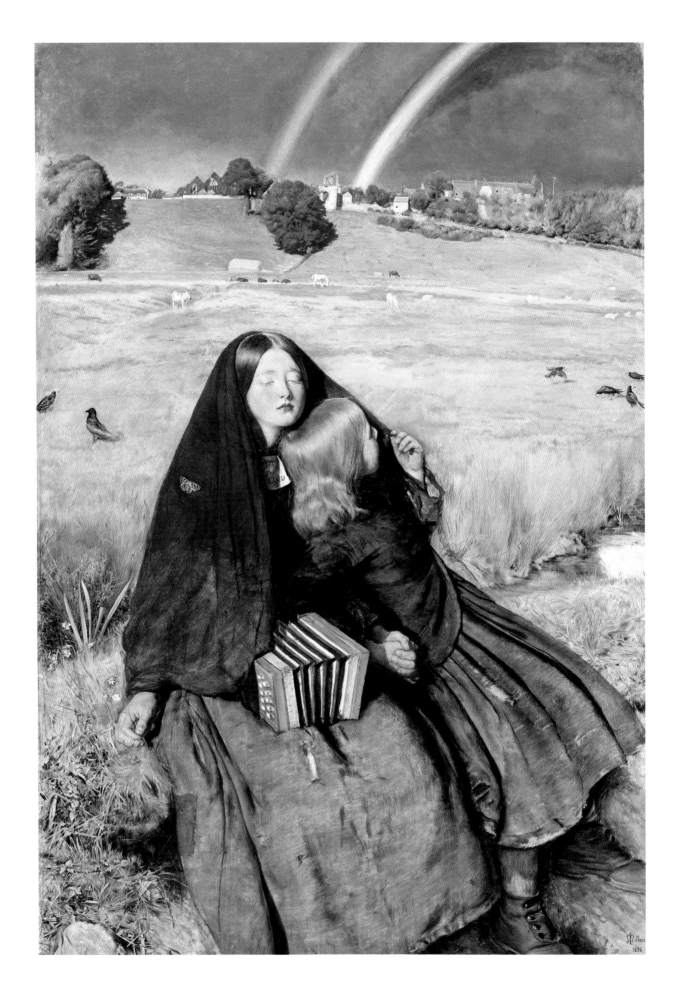

THE HUDSON RIVER SCHOOL

The otherworldly paintings of the Hudson River School painters owe a great deal to their use of light, which often seemed to emanate from within the picture itself. Careful studies made out-of-doors were synthesized into spectacular studio compositions.

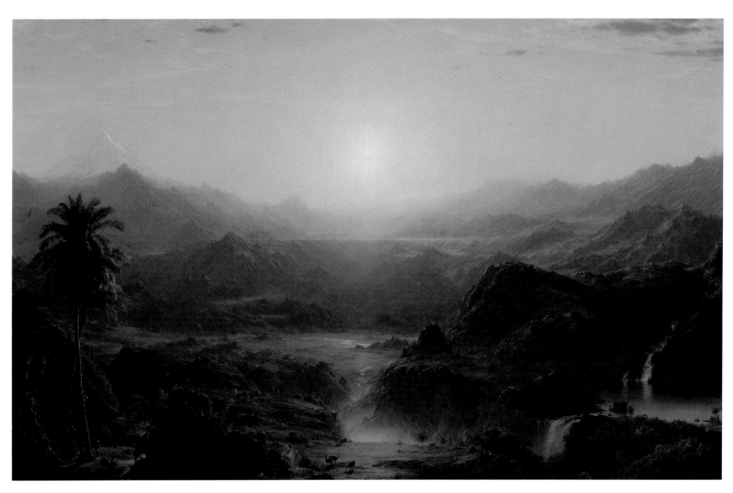

Landscape painting in mid-nineteenth-century America was fueled by both a tradition of close observation of nature and a fascination with nature's sublime moods, which were captured in epic vistas.

Frederic Church organized painting expeditions to Newfoundland, Jamaica, and Colombia, seeking dramatic natural effects. Improved pigments found their way into his images. His sunset epic *Twilight in the Wilderness* was partly inspired by a new formulation of madder lake.

Asher Brown Durand was the chief spokesman of the Hudson River School's preoccupation with painting outdoors. His famous essays, *Letters on Landscape Painting*, were published in 1855, the same year that he painted the study *Landscape with Birches*.

Above: Frederic Edwin Church, American, 1826–1900. *The Andes of Ecuador*, 1855. Oil on canvas, 48 × 75 in. Reynolda House Museum of American Art, Winston-Salem, North Carolina.

Opposite: Asher Brown Durand, American, 1796–1886. *Landscape with Birches*, 1855. Oil on canvas, 24¼ × 18⅛ in. Museum of Fine Arts, Boston. Bequest of Mary Fuller Wilson.

PLEIN-AIR MOVEMENTS

Painters outside of France combined their knowledge of
outdoor light with a powerful sense of composition.
Many nations, including America, Australia, Denmark, Italy,
Russia, Spain, and Sweden, each developed a distinctive
approach.

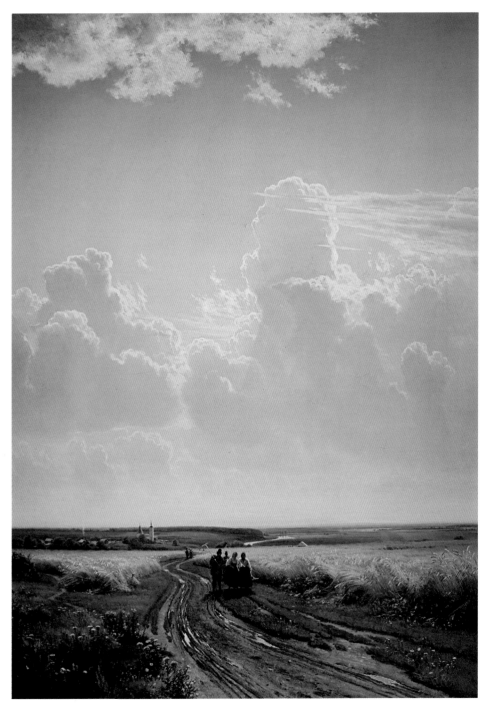

Russian landscape painter Ivan Shishkin
painted *Midday in the Outskirts of
Moscow* after doing countless plein-air
studies in the countryside. The painting
shows workers coming home from the
fields of rye. In the distance a country
church and a winding river are dwarfed
by the immensity of the towering clouds
above them. The spaciousness and
joyfulness of the composition had a
galvanizing effect on later generations
of Russian landscape painters, who
realized the potential for landscape to
be the vehicle for expressing the deepest
stirrings of the human soul.

Arthur Streeton's view of the Hawkes-
bury River in Australia, opposite, looks
across to the Blue Mountains in the dis-
tance. The title was drawn from poetry.
He said the painting "was completed
with a kind of artistic intoxication with
the thoughts of Shelley in my mind."
Indeed, he often brought volumes of
Wordsworth or Keats with him on
location.

Since he had no charcoal, Streeton
recalled that he designed the composi-
tion in red and cobalt blue. The noonday
light casts the tree shadows directly
downward, avoiding drama and playing
down sculptural relief. The square com-
position, a novelty in its day, emphasizes
the flat, decorative quality. The richest
blue is not in the sky or the far moun-
tains, but rather in the depths of the
foreground river, a color Streeton called
"the blue of a black opal."

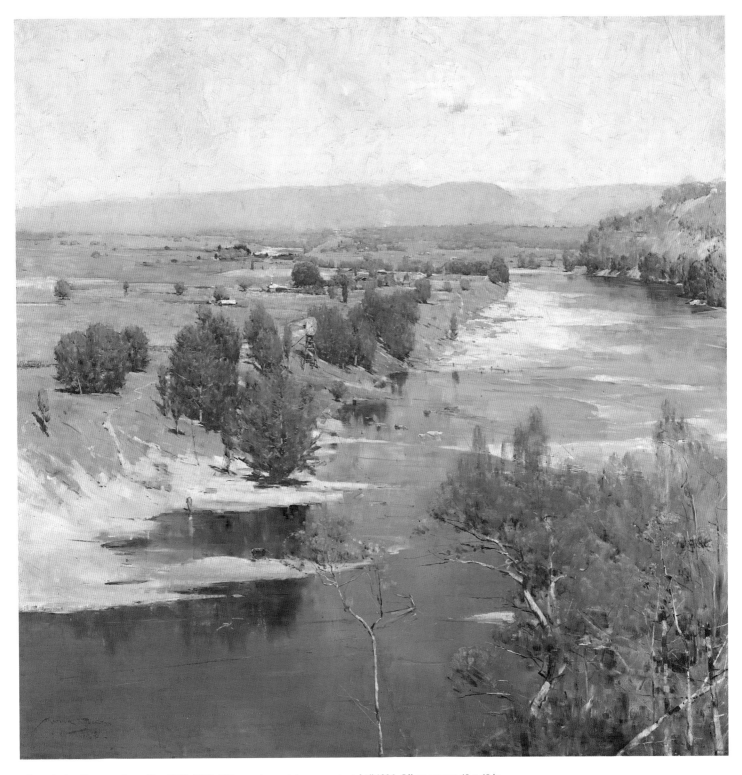

Above: Arthur Streeton, Australian, 1867–1943. *"The purple noon's transparent might,"* 1896. Oil on canvas, 48 × 48 in.
National Gallery of Victoria, Melbourne, purchased 1896.

Opposite: Ivan Shishkin, Russian, 1832–1898. *Midday in the Outskirts of Moscow*, 1869. Oil on canvas, 43¾ × 31½ in.
The Tretyakov Gallery, Moscow.

SYMBOLIST DREAMS

The symbolist painters used light and color to create images that stirred the imagination and evoked strange states of mind. They were interested in ideals of beauty often intermingled with an obsession with tragedy and despair.

Opposite: Alphonse Mucha, Czech, 1860–1939. *Apotheosis of the History of the Slavs*, 1926. Tempera on canvas, 187 × 156 in.

Below: Adolf Hirémy-Hirschl, Hungarian, 1860–1933. *Ahasuerus at the End of the World*, 1888. Oil on canvas, 54¾ × 90¼ in. Private collection. Christie's Images Limited.

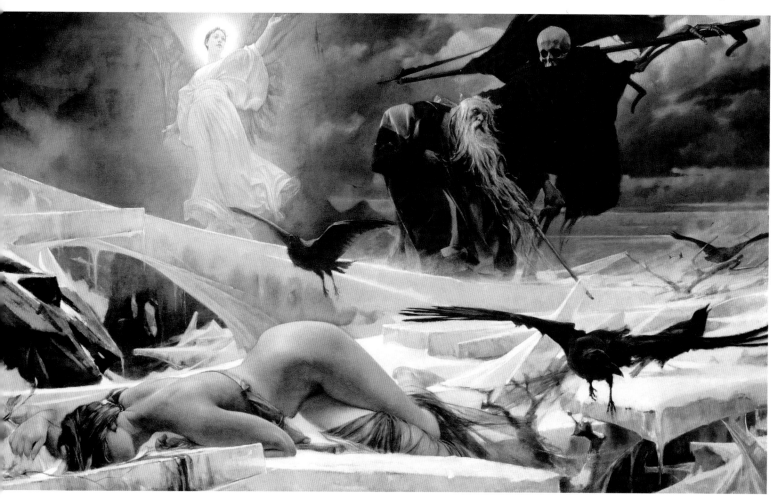

The poetic imagery of the Symbolists was a reaction to mundane realism. Their goal was to to evoke feelings of gloom, patriotism, and mystery. They showed that color doesn't have to be used in a literal or naturalistic way.

The painting above is by a Hungarian painter named Adolf Hirémy-Hirschl, who created dramatic scenes from ancient mythology. The bearded man is Ahasuerus, the legendary wanderer at the end of the world. He is the last man in the polar wilderness, caught between the angel of hope and the specter of death. Before him lies a fallen female figure, the personification of dead humanity, as crows circle ominously. Hirémy-Hirschl restricted his palette of colors to blue, gray, black, and white, with a faint hint of warmth in the human flesh, and a few touches of gold. The primary light appears to radiate from the distant angel, who hovers before a stormy sky.

Alphonse Mucha, opposite, dramatizes the patriotic spirit of the Slavic people. He achieves a dreamy, weightless feeling with carefully controlled tonal organization, framing the glowing center with darker and cooler areas. The color scheme is extremely disciplined. Bands of swirling hues suggest the movement of a flag. Mucha said, "The expression of beauty is by emotion. The person who can communicate his emotions to the soul of the other is the artist."

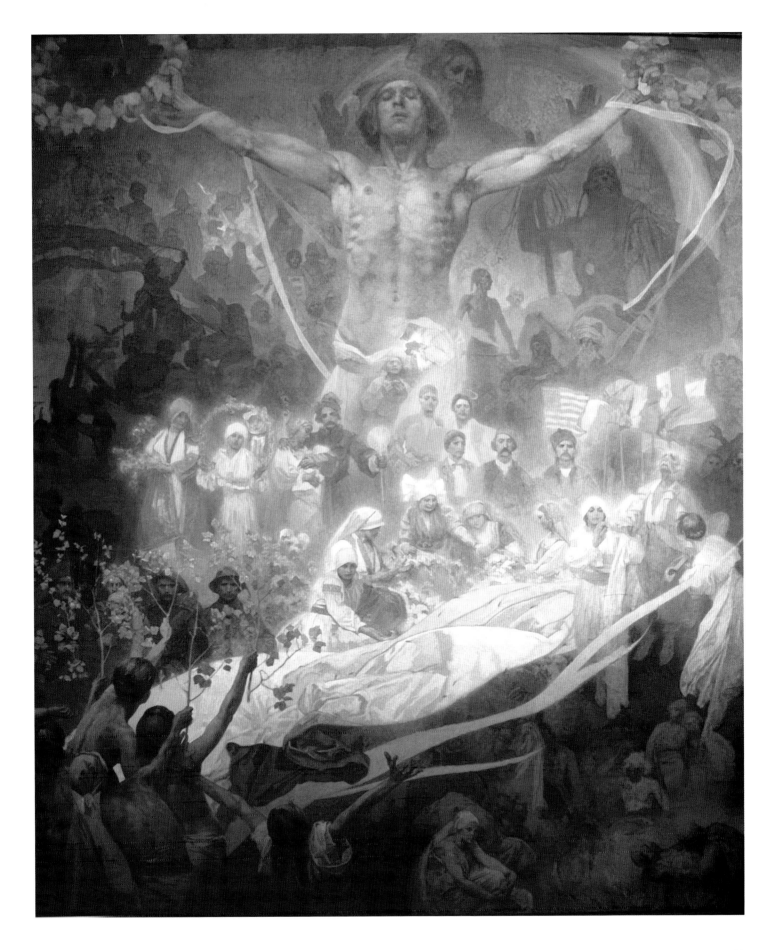

Magazine Illustration

In our own color-saturated times, it's hard for us to realize how much impact color reproductions in books and magazines had on readers' imaginations. The full spectrum of the art museum finally arrived on the coffee table.

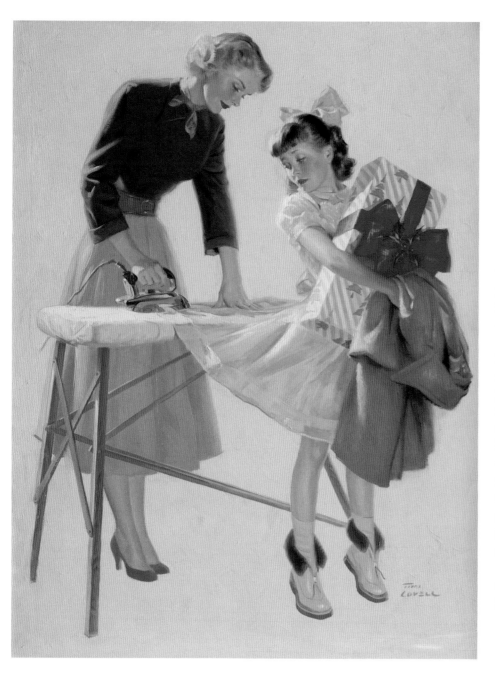

Color gradually trickled into the pages of popular magazines that had long been available only in black and white. Walter Everett painted the illustration opposite with a full-color palette, even though he knew it would be reproduced in tones of gray. Influenced by impressionism, he used broken color—the placement of adjacent strokes of contrasting hues, which mix vibrantly in the eye.

As the twentieth century progressed, many magazines added a single extra color to the black-ink run. Norman Rockwell's *Saturday Evening Post* covers were in tones of gray plus red for ten years. Other magazines printed story illustrations in black and green or black and orange.

Staying within the constraints of these limited palettes made those artists into resourceful colorists. Tom Lovell, who painted the magazine cover, left, started in the pulp magazines, where color was a luxury. With the full palette available here, he sets up a color scheme that contrasts greens with reds, while downplaying yellows, violets, and blues. The reds appear in their full intensity in the gift bow, and muted in the pinks of the girl's dress. The mother wears different greens in her shoes, skirt, and blouse.

Lovell's friend Harry Anderson takes a red-green palette through a similar set of paces on pages 10–11.

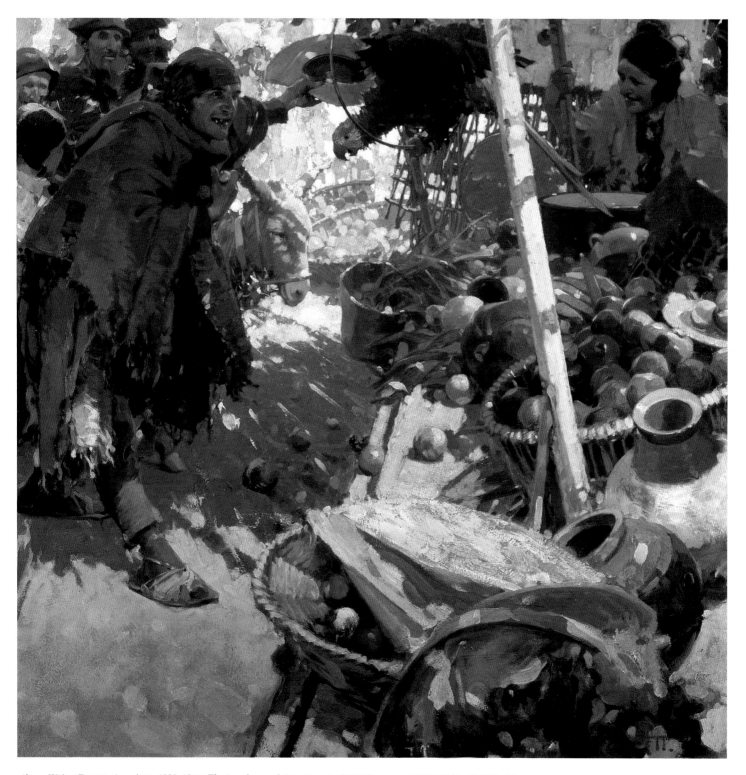

Above: Walter Everett, American, 1880–1946. *The Loneliness of Peter Parrot,* 1924. Oil on panel, 24 × 23½ in. Published in *Good Housekeeping,* January 1925, p. 39. Used with permission of the Kelly Collection of American Illustration.

Opposite: Tom Lovell, American, 1909 1997, *Just Right,* cover of *American* magazine, December 1951. Oil on panel, 23 × 18 in. Private collection.

SOURCES OF LIGHT

DIRECT SUNLIGHT

A clear, sunny day has three different systems of illumination: the sun itself, the blue sky, and the reflected light from illuminated objects. The second two sources of light derive entirely from the first, and should be subordinated to it.

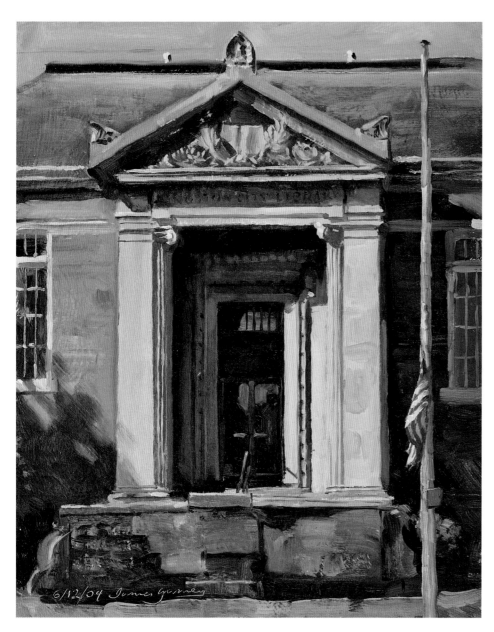

On a clear day, the luminous blue dome of the sky surrounds the sun. Compared to sunlight, skylight is a diffuse, soft light coming from many directions at once. At high altitudes, or if the air is especially clear, the sky is even more blue-violet than usual, and the shadows are darker and bluer relative to the sun. As more clouds appear in the sky, shadows become grayer. With more haze or smog, shadows appear relatively closer to the tonal value of the sunlight.

As we'll explore in more detail on page 66, the color of the ground and nearby objects reflects up into the shadow areas. In the painting at left, the warm light bounces into the sculpted ornament over the shadowy doorway, while the blue skylight is most noticeable in the shadow cast by the triangular pediment on the area above the doorway that says "KINGSTON LIBRARY."

In the figure at right, the blue sky color gives the top of the shoulder a greenish quality in the shadow. Where the sleeve drops from the shoulder, the yellow shirt picks up warm colors from the ground, and appears more orange.

Above: Kingston Library, 2004. Oil on panel, 10 × 8 in.

Opposite: Jeanette Sketching, 2003. Oil on panel, 10 × 8 in.

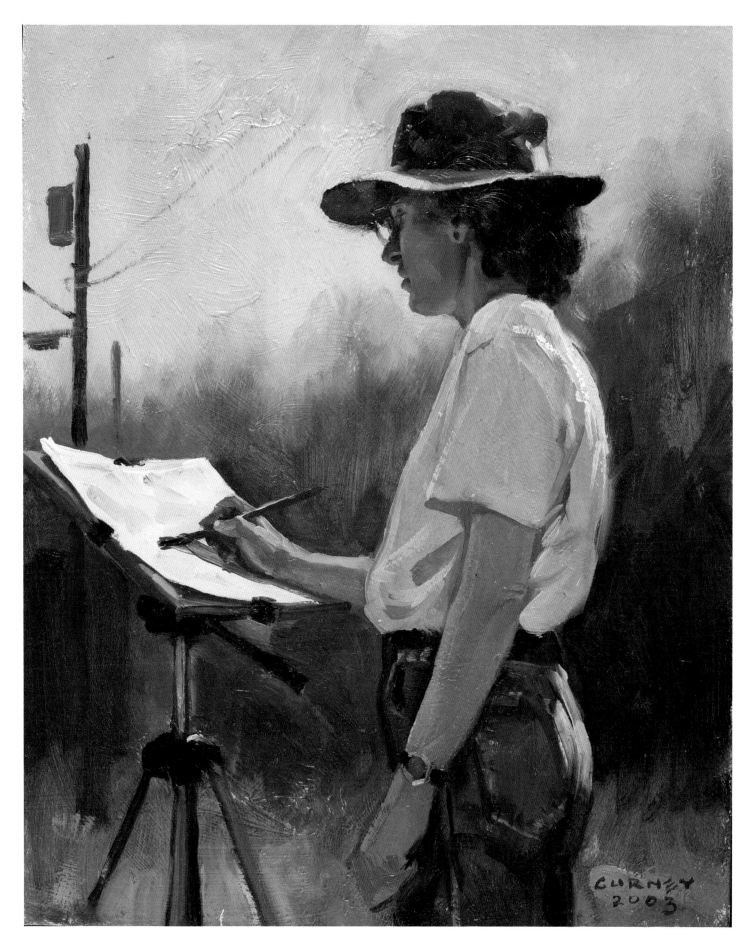

OVERCAST LIGHT

Most people like sunny, cloudless days, but artists and photographers often prefer the soft illumination of a cloud-covered sky. The layer of clouds diffuses the sunlight, eliminating the extreme contrasts of light and shadow.

Blockbuster, 2000. Oil on board, 10 × 18 in.

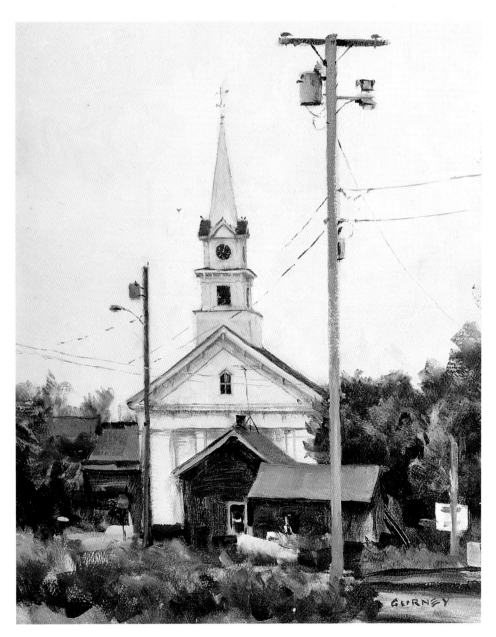

Maine Church, 1995. Oil on board, 10 × 8 in.

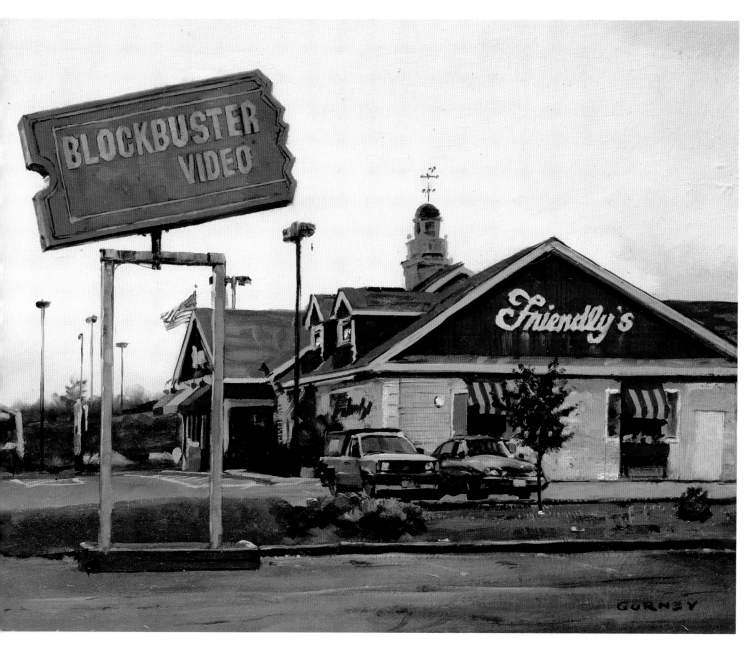

Overcast light is ideal for complicated outdoor scenes. One of its virtues is that it allows you to paint forms in their true colors without dramatic contrasts of light and shade. Without sharp shadows complicating the scene, a picture is simpler and the shapes are bigger.

Surprisingly, colors appear brighter and purer than they do in direct sunlight. It's easier to show the patterns of costumes or signs. The sky in the painting above appears light gray or white, often the lightest note in the composition.

The sketch in Maine, opposite, was painted on a rainy day. The white church steeple was a little darker than the sky.

Overcast light doesn't change much throughout the day. Its stability allows a plein-air painter to work for four or five hours without the light changing too much.

In art school you don't often get a chance to paint overcast light conditions because there's no way to simulate it perfectly indoors. A very large north-facing window comes close, but studio

north light is still directional compared to overcast light. Even a bank of fluorescent fixtures across the ceiling doesn't match it exactly because the light needs to be coming equally and evenly from above.

Photographers like to use overcast light because it's easier to expose a scene evenly. In 3–D computer-generated images, overcast light is one of the hardest light conditions to simulate because an accurate rendering involves such a vast number of mathematical calculations.

WINDOW LIGHT

Interior scenes in daylight are often lit by the soft light that enters the room through windows or open doors. This light has traditionally been popular with artists because of its constancy and its simplifying effect.

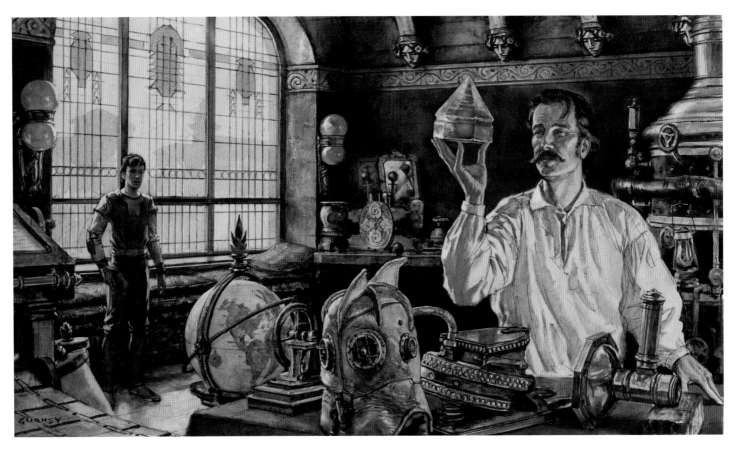

Assuming the sun is not shining directly through the window, the daylight that enters a room from outside is usually bluish. The cool color contrasts with the relatively orange color of artificial lights shining in the room.

On a sunny day there's often a second source caused by light that shines on the ground outside and bounces upward into the window. This light is best seen on a white ceiling. It's often comparatively green or orange in color, depending on the color of the ground surface. If you look closely at a room lit by a north-facing window, you'll notice the floor of

the room typically has a bluish cast from skylight and the ceiling has a green or orange cast from light reflected from the grass or the dirt outside.

In the Dinotopian workshop scene above, the large window provides a source of cool light coming from the left, while a warm lamp offscreen to the right provides a contrasting color of light.

The observational oil study of an Irish hearth, opposite, shows cool light from an open doorway and an adjacent window. You can tell the light comes from two side-by-side sources because of the twin vertical highlights on the teakettle,

water pot, and stovepipe. The light was brightest on the left of the scene, at the place where the owner once replaced a broken black tile with a white tile.

The light casts soft warm shadows to the right of the black stovepipe, the china dogs, and the plastic bucket of turf.

Above: Denison's Study, 1993. Oil on board, 11½ × 20 in. Published in *Dinotopia: The World Beneath.*

Opposite: Irish Stove, 2002. Oil on panel, 10 × 8 in.

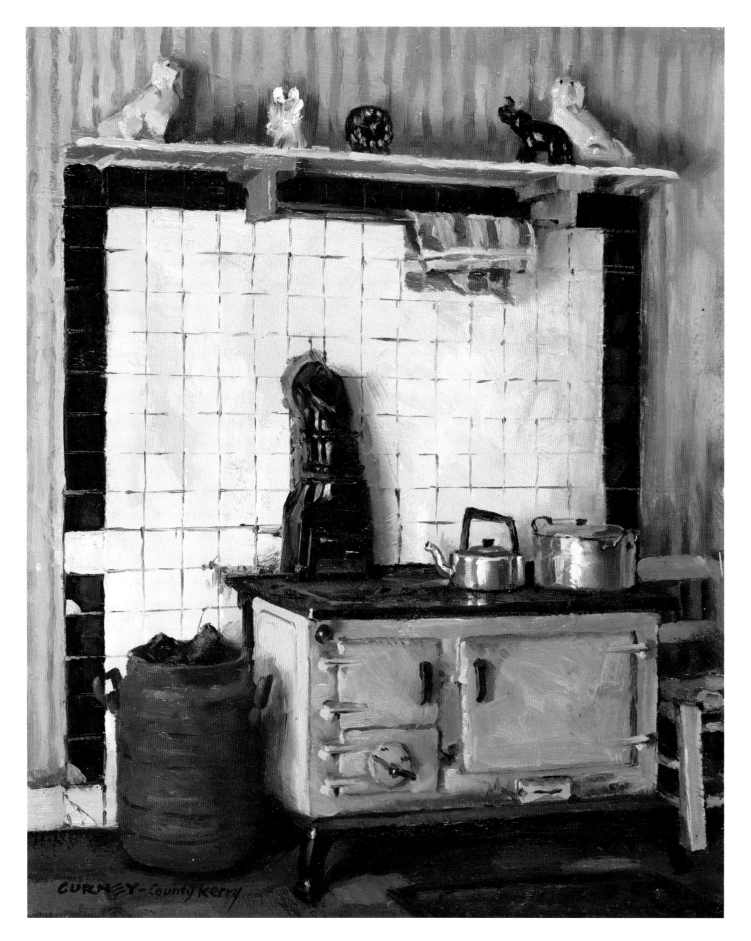

GURNEY - County Kerry

CANDLELIGHT AND FIRELIGHT

Candlelight, lantern light, and firelight are all yellow-orange in color. The light is fairly weak, dropping off rapidly as objects recede from the flame. After the sun sets and twilight deepens, the effects of flame-based light become more noticeable.

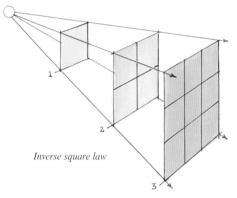

Inverse square law

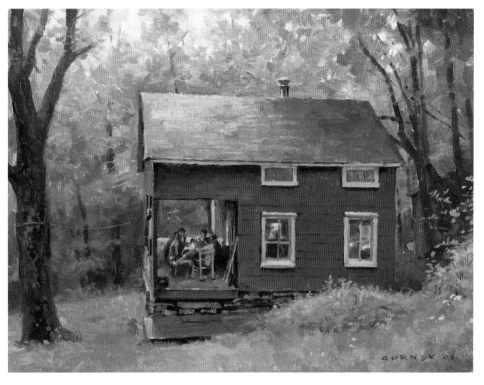

Cabin at Platte Clove, 2005. Oil on canvas mounted to panel, 9 × 12 in.

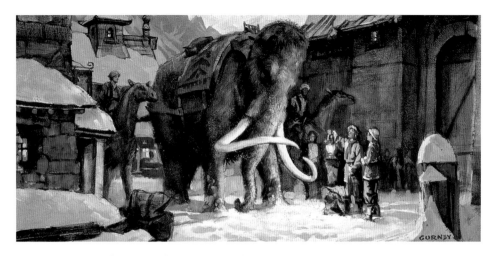

Mammoth in Snowy Village, 1991. Oil on board, 7 × 16 in.

In the days before electricity, lamps and lanterns were lit at dusk when there was still enough light to find the matches. In the painting *Garden of Hope*, opposite, the lantern shines in a garden just as the last sunlight fades on the far mountains.

The lamp is surrounded by a halo of warm orange color that makes it impossible to see details of the far forest canopy. Light streams down on the white dresses, the lilacs and roses, and the wall behind the figures.

In the cabin scene at left, painted from observation during an evening rainstorm, a kerosene lamp provides the light for a board game on the porch. In such firelit environments, smoke often scatters the light, leaving no deep darks in the vicinity of the light sources. Photographs of night scenes often miss these qualities, making the darks appear profoundly black. To the eye they often have a glowing appearance, with plenty of soft edges.

FALL-OFF

The brightness of any point-source illumination diminishes rapidly with distance. This weakening of light is called *fall-off*. It diminishes according to the *inverse square law*, which states that the effect of a light shining on a surface weakens at a rate comparable to the square of the distance between source and surface. As the diagram above demonstrates, at twice the distance, the light is only one fourth as bright because the same rays must cover four times the area. At three times the distance, it drops to one ninth as bright.

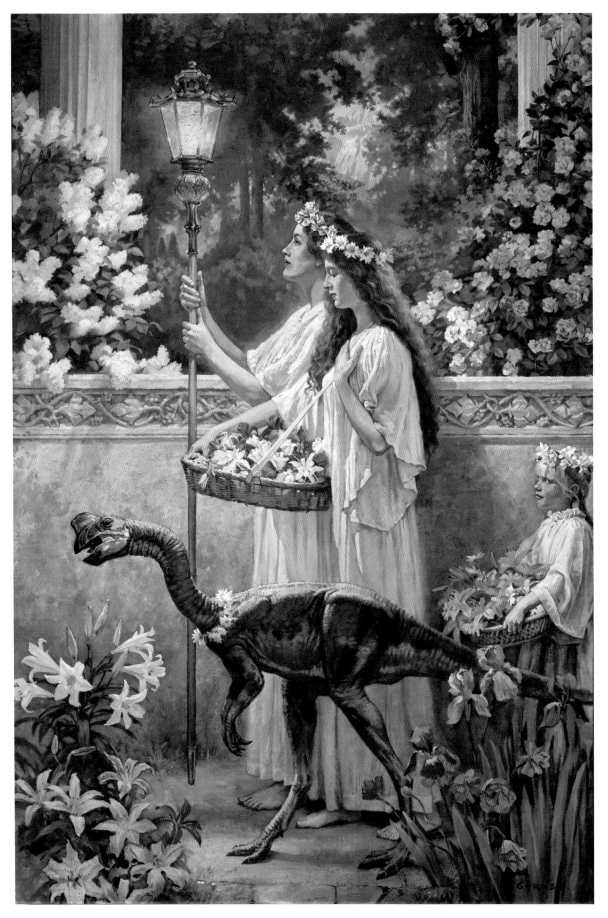

Garden of Hope, 1993. Oil on canvas mounted to panel, 36 × 24 in. Published in *Dinotopia: The World Beneath.*

INDOOR ELECTRIC LIGHT

The most common indoor lights are incandescent and fluorescent. To paint their effects, you have to keep in mind three qualities: relative brightness, hardness or softness, and color cast.

BRIGHTNESS

The brightness of bulbs is measured in lumens, but what matters to artists is relative brightness within a scene, especially when you have more than one source. The relative brightness depends on such things as the wattage, the type of lamp, how close the subject is to the light, and how bright the other lights are.

HARDNESS OR SOFTNESS

Hardness or softness refers to how large the patch of light seems to be from the point of view of the subject. A *hard light* comes from a sharp, small point. The sun—or a spotlight—is a relatively

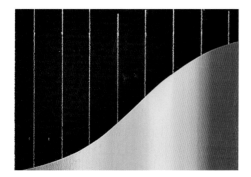

Figure 1. Spectral power distribution for incandescent light.

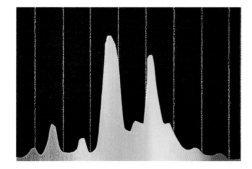

Figure 2. Spectral power distribution for fluorescent light.

hard source of light. Hard light is more directional and more dramatic. It casts crisper shadows and it brings out more surface texture and highlights.

A *soft light* emanates from a wider area, such as the large panel of fluorescent-like tubes over the workbench in the scene at right. In general, softer light is more flattering and reassuring. It's better for task lighting because it reduces the confusion of cast shadows. Tonal transitions from light to shade are more gradual in soft light compared to hard light. Lighting designers routinely turn a hard source into a soft source using large translucent "silks" or diffuser panels. It's also the reason people put lampshades over incandescent bulbs.

COLOR CAST

The *color cast* is the dominant wavelength of a light source, often measured in degrees Kelvin, a standard measure based on the main color of light that an object emits when it is heated to extreme temperatures. The color cast is sometimes hard to judge by just looking at a light. The graphs of *spectral power distribution* (left) show which wavelengths of the visible spectrum have the strongest output.

Regular incandescent lights are strongest in the orange and red wavelengths, and they tend to be weak in blue. That's why red colors in a picture look so good—and blue colors look so dead—under normal incandescent light.

Standard warm white and cool white fluorescents emphasize yellow-green.

They're made to give the most light in the range of wavelengths to which the human eye is most sensitive. In the painting above, the light has a yellow-green cast. The outdoor light looks violet by contrast.

Gideon's Room, 1998. Oil on board, 12 × 19 in. Published in *Dinotopia: First Flight*.

STREETLIGHTS AND NIGHT CONDITIONS

Before outdoor electric light was developed in the late nineteenth century, there were two colors of light at night: moonlight, which appears blue or gray, and orange flame-based light. As electric lighting developed, new colors entered the nightscape.

Old Hudson, 2004. Oil on canvas, 24 × 30 in.

The painting opposite sets up the blue-green moonlight in contrast to the warm light of the shops and streetlights. The goal is to show what the eye would see, rather than the camera's view, which would include a lot of black shadows. Light from both the moon and the gaslight shimmers off the wet cobblestone streets. The gaslight is a relatively weak light, much weaker than modern electric sources.

The modern nightscape includes incandescent, fluorescent, neon, mercury vapor, sodium, arc, metal halide, and LED lights. Each has a distinctive spectral power distribution. The variety of outdoor lighting colors is best seen when flying over a city at night.

The little oil sketch, right, painted from observation from a hotel balcony, records some parking lots in Anaheim, California, during the predawn hours. The orange sodium vapor light of the foreground makes a striking contrast to the blue-green mercury vapor lights in the farther parking lot.

Sodium vapor is rapidly replacing mercury vapor. A sodium lamp gives off a very narrow set of wavelengths, which gives it a sickly look. Mercury vapor has a wider spectral output, but the cool color drains the warmth out of flesh tones.

Here are some tips if you want to learn more about night illumination:

1. Take photos with a digital camera set on its night setting. New cameras are excellent at capturing low-level lighting effects.

2. Disable the white balance setting and photograph a color wheel under different streetlights. Then compare the digital photos side by side to see how the colors are skewed.

3. Try some urban night painting, using a portable LED light to illuminate your palette.

4. Start a scrap file of photos showing modern cityscapes at night.

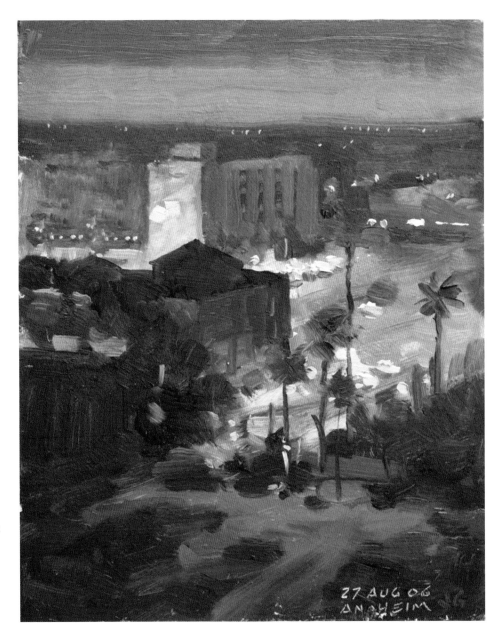

Anaheim Glow, 2006. Oil on panel, 10 × 8 in.

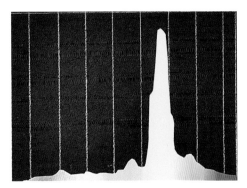

Figure 1. Spectral power distribution for sodium vapor streetlight.

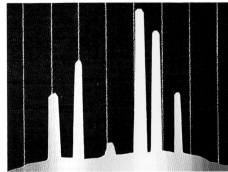

Figure 2. Spectral power distribution for mercury vapor streetlight.

LUMINESCENCE

When hot or flaming objects give off light it's called incandescence. But some things give off a glow at cool temperatures through a process called *luminescence*. This light can come from both living and nonliving things.

In the science fiction universe of *Dinotopia: The World Beneath*, 1995 (right and opposite), large caverns beneath the island are lit by glowing algae, crystals, and ferns. Although higher plants in the real world aren't known to give off their own light, many things are luminescent.

BIOLUMINESCENCE

Organisms that can produce light live mostly in the ocean. They include fish, squid, jellyfish, bacteria, and algae. In the deep sea beyond the reach of light, the light patches function to lure prey, confuse predators, or locate a mate. Some light-producers are activated by mechanical agitation, creating the milky light in the ocean alongside ships' wakes.

Land animals that emit light include fireflies, millipedes, and centipedes. Some kinds of mushrooms that grow on rotting wood emit a dim light called foxfire.

FLUORESCENCE

Fluorescence is light that is produced by an object that converts invisible electromagnetic energy, such as ultraviolet radiation, into a visible wavelength. Some minerals, such as amber and calcite, will give off colorful visible light when they're lit by ultraviolet light.

TIPS AND TECHNIQUES

1. Luminescent colors often gradate from one hue to another.

2. Blue-green colors are most common in the ocean because those wavelengths travel the farthest through water.

3. Paint the scene first in darker tones without the luminescence, then add the glowing effects last.

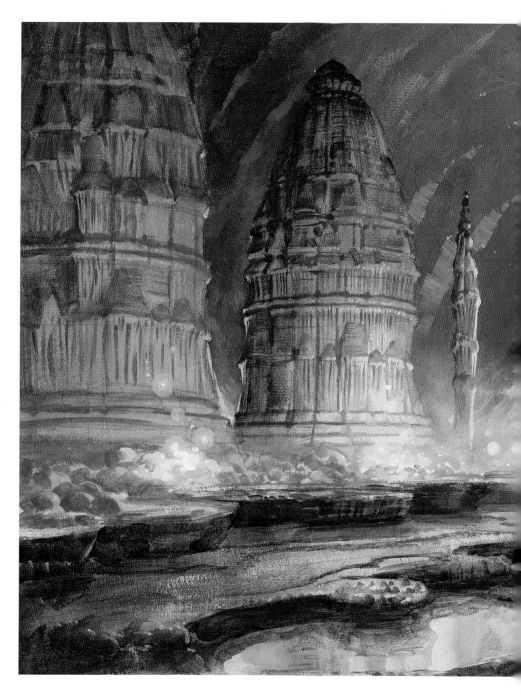

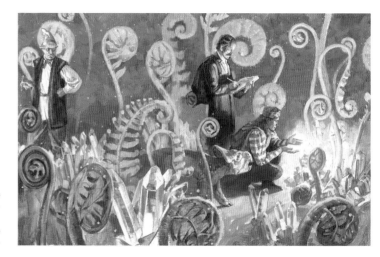

Right: Glowing Ferns, 1994. Oil on board, 11 × 17½ in.
Published in *Dinotopia: The World Beneath.*

Below: Golden Caverns, 1994. Oil on board, 14 × 29 in.
Published in *Dinotopia: The World Beneath.*

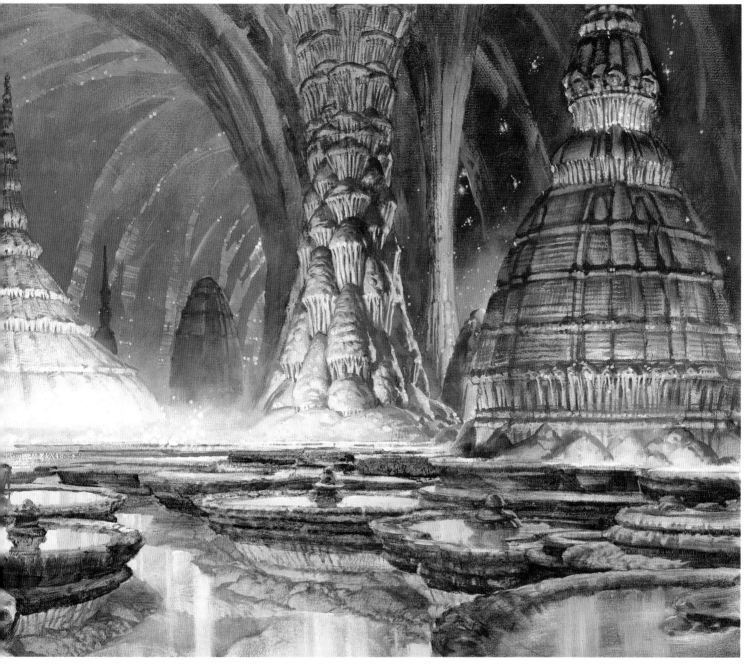

HIDDEN LIGHT SOURCES

There are at least three ways to light a scene: from a source shining from outside the picture, from a light inside the picture that you can easily see, or from a light inside the scene that's concealed from view.

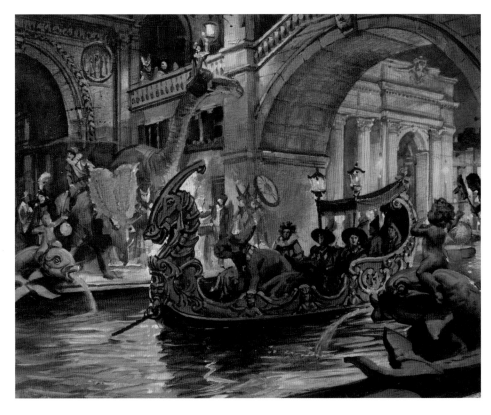

This last arrangement lends mystery, because the viewer is intrigued to explore further to find out where the light is coming from.

The painting opposite shows a large interior space where long-necked dinosaurs sleep beside parked carriages. It is lit by two sources. A pale blue moonlight shines in the doorway from the right, flooding the area near the doorway with light, and sending a shaft through the dust on the far side of the room.

The other source is much warmer in hue. It shines outward and upward from a source hidden below the balcony on the left. The contrast of a cool downward light and a warm upward light makes the scene more interesting than it would have been if lit by a single source.

The painting above has at least four different sources of colored light: blue in the right foreground, red-orange across the canal, blue-green through the arch, and a warm light touching the stern of the boat. The red-orange light is hidden behind the prow of the boat. This light helps dramatize the silhouette shape and intrigues the viewer about the festive group on the far bank, which is rendered in largely reddish and orange tones.

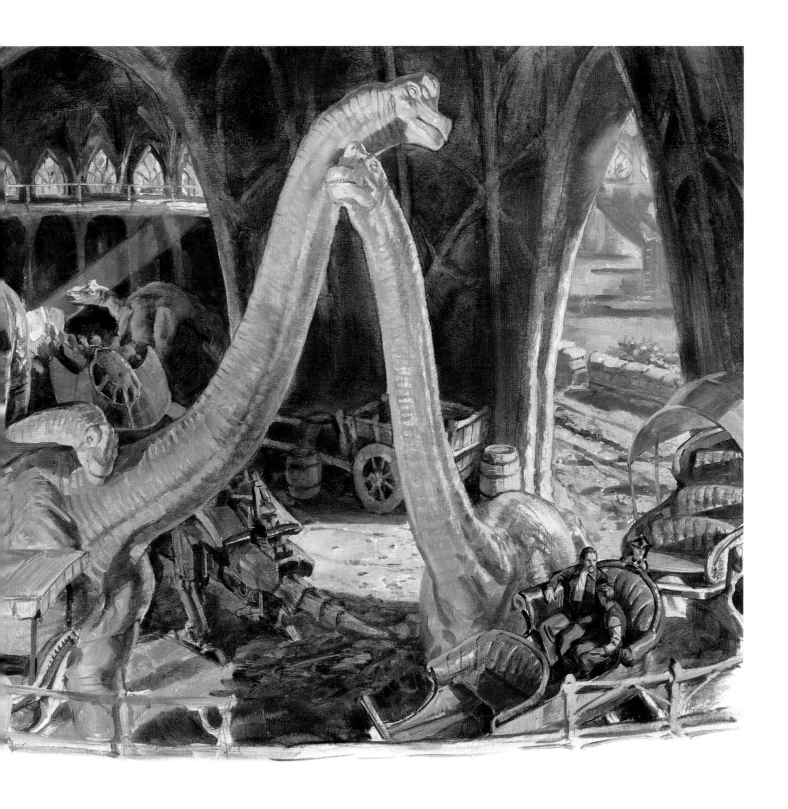

Above: Bonabba Barns, 1994. Oil on board, 10½ × 16 in. Published in *Dinotopia: The World Beneath*.

Opposite: Canals at Night, 1995. Oil on board, 8 × 10 in.

Desert Crossing, 2006. Oil on board, 14 × 28 in. Published in *Dinotopia: Journey to Chandara*.

LIGHT AND FORM

THE FORM PRINCIPLE

Light striking a geometric solid such as a sphere or a cube creates an orderly and predictable series of tones. Learning to identify these tones and to place them in their proper relationship is one of the keys to achieving a look of solidity.

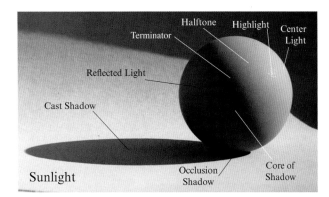

Halftone · Highlight · Terminator · Center Light · Reflected Light · Cast Shadow · Sunlight · Occlusion Shadow · Core of Shadow

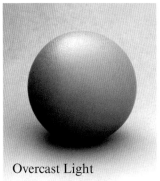

Overcast Light

The *form principle* is the analysis of nature in terms of geometrical solids, which can be rendered according to laws of tonal contrast.

MODELING FACTORS

The two photographs of the sphere above show two classic lighting conditions: direct sunlight and overcast light. Each has a different set of tonal steps from light to shadow, known as modeling factors.

In the direct sunlight, there's a strong division of light and shade. The light side includes the light and dark halftones, the center light, and the highlight.

THE TERMINATOR

The *terminator*, or "bedbug line," is the area where the form transitions from light into shadow. It occurs where the light rays from the source are tangent to the edge of the form. If it's a soft, indirect light, the transition from light to shadow at the terminator will be more gradual. The form shadow begins just beyond the terminator.

You can cast a shadow with a pencil on the object to test which areas are in light and which are in shadow. The cast shadow will show up only on the lighted side and not on the shadow side.

Within the shadow is not darkness but the effect of other, weaker sources. Outdoors, the blue light from the sky usually modifies the shadow planes, depending on how much they face upward. Reflected light often raises the tone of the shadow. It comes from light bouncing up off the ground surface or from other surfaces. The darkest parts of the shadow are usually at the points of contact, called the *occlusion shadow*.

CORE OF THE SHADOW

Another dark part of the shadow is the area just beyond the terminator. This area is called the core or the hump of the shadow.

The core of the shadow only forms if the secondary source of light (edge light, reflected light, or fill light) doesn't overlap too much with the main light. Keeping the core intact—or painting it in even if you can't see it—can give the form more impact. If you're setting up a model or maquette, you can place the primary and secondary lights just far enough apart so that you can see the core beginning to appear.

GROUPING PLANES

To simplify something as complex as the rocks along the coast of Maine, opposite, it helps if you organize groups of planes that are roughly parallel. The rock seemed to break along four definite fracture planes:

1. Top planes

2. Side planes in lighter halftone

3. Front planes in darker halftone

4. Side planes in shadow

The actual scene had a lot more complexity, detail, and randomness of tones. Grouping the planes makes it easier to sort things out. Regardless of the nuances and subtleties, always try to state the form in terms of the simplest truth: light and shadow. This makes the details read instantly, and it saves painting time.

TEXTURE AT THE TERMINATOR

A common mistake in painting a textural form in sunlight, such as a dinosaur, is to make the skin texture equally prominent throughout the form.

In digital images, the appearance of overall equal texture can result from

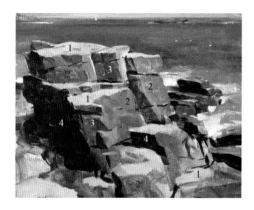

mapping a bumpy two-dimensional pattern equally over a form. The texture in the shadow should not just be a darker version of the texture in the light because that's not how the eye sees it. In fact, the texture is very difficult to see at all in the shadow region. It's much more visible in the fully lit areas, especially in the darker halftone, just before the line of the terminator divides light from shadow. This region is called the *half-light*, an area of raking light where an uneven surface stands out dramatically.

DIFFUSE LIGHT

In soft or diffuse light, such as overcast light, there is no distinct light side, shadow side, terminator, or core. All of the upward-facing planes tend to be lighter, since they receive more of the diffused light from the cloudy ceiling.

That was the quality of light falling on the satyr, below right. The planes of his head and horns become cooler on the forehead, the nose, and the cheekbones, where they face more toward the light sky.

The drapery study shows the effect of a primary light source coming from the left, and diffuse secondary sources filling the shadows from the right. The white fabric goes all the way to black in the deepest folds.

Above: Maine Coast, 1995. Oil on panel, 8 × 10 in.

Above right: Drapery Study, 1980. Graphite on bristol board, 20 × 18 in.

Right: Pan the Satyr, 2009. Oil on board, 8 × 10 in.

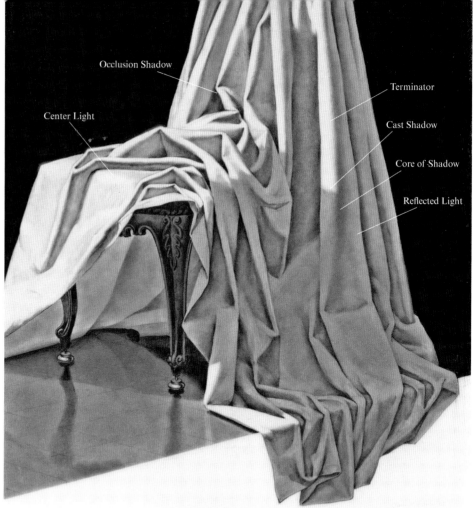

Occlusion Shadow

Center Light

Terminator

Cast Shadow

Core of Shadow

Reflected Light

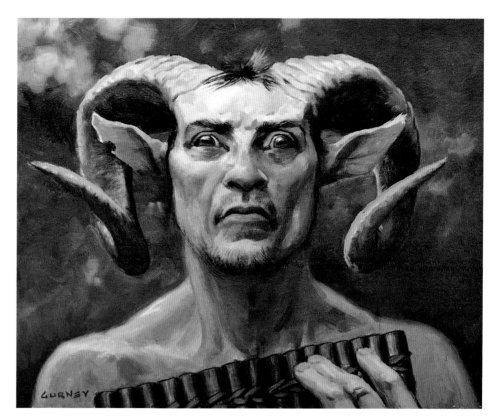

SEPARATION OF LIGHT AND SHADOW

In sunlight the light side and the dark side of the form can be separated by as many as five steps of the tonal scale. Just as musicians are always conscious of intervals between notes, artists must be aware of maintaining consistent tonal intervals.

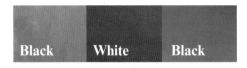

| Black | White | Black |

Are these swatches labeled correctly?

Of course not. The swatch on the left isn't black. It's a midrange gray, and so is the one on the right. The swatch in the middle isn't white. It's darker in value than the other two. The value of a color is a measure of its lightness or darkness in comparison to a scale of grays between pure white and pure black.

In fact, the swatch labeled #1 below is black acrylic paint, #3 on the far right is a jet-black dress shirt, and #2 in the middle is a white newspaper.

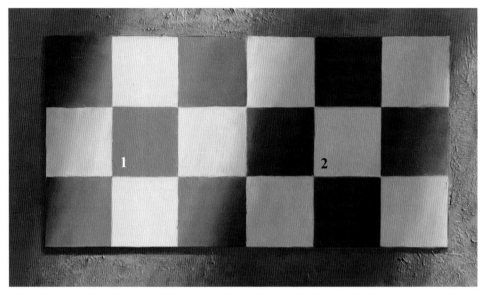

Checkerboard Illusion. Our visual system uses context cues to override the raw information our eyes receive. The light square in shadow (2) is equal to the dark square in light (1).

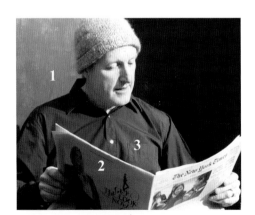

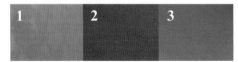

| 1 | 2 | 3 |

The X-factor is sunlight and shadow—and the tricks that our visual systems play on us. The samples were all lifted straight out of the single photo taken outdoors.

Even when the tones are adjacent, such as 2 and 3, our minds tell us that the "white" is lighter. It's good to keep this rule in mind: In bright sunlight, a newspaper in shadow is darker than a black shirt in the light.

LIGHTING RATIO

It's easy to underestimate the tonal separation between the light side and the shadow side in sunlight. When lighting experts set up artificial lights for a movie shot, they call this separation the *lighting ratio,* and they usually try to reduce it to cancel the unflattering effect of harsh or dark shadows.

As artists we may want to do the same, depending on the feeling we want to create. But most often, beginning painters tend to ignore the dominance of direct illumination and play up secondary sources too much.

If you're counting steps on a value scale from one to ten, you might typically see five steps of tone from sunlight to shadow, or two f-stops on a camera's aperture setting. The separation would be reduced if there were high clouds, hazy atmosphere, or a light-colored ground surface.

Gryposaurus, 2009. Oil on board, 18 × 14 in. Published in *Ranger Rick* magazine, October 2009.

CAST SHADOWS

When a form intercepts a parcel of direct light, it projects or casts a shadow onto whatever lies behind it. The resulting dark shape can be a useful design device to suggest depth or to tie together elements inside and outside your composition.

Below left: Dalleo's Deli, 2008. Oil on canvas mounted to panel, 9 × 12 in.

Below: Irish Bridge, 2002. Oil on panel, 10 × 8 in.

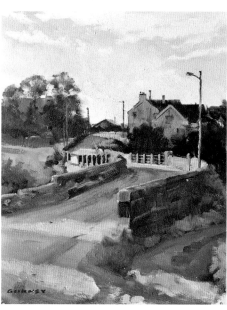

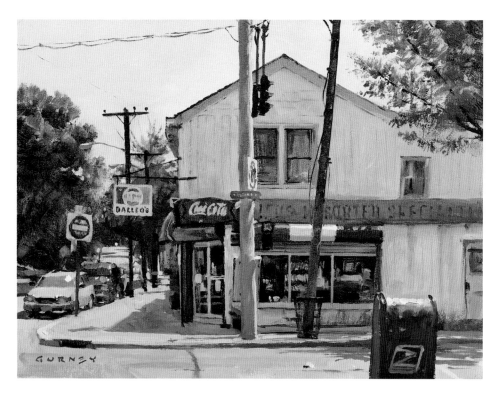

THE EYEBALL ON THE ANT

In outer space, shadows appear profoundly black. The lack of atmosphere means that there's no luminous glow to fill the shadows. But on Earth cast shadows are flooded by various sources. To understand those sources, try to imagine yourself as a little eyeball mounted on the back of an ant.

As you walk across the shadow, imagine yourself looking up at all the bright patches of light around you, not just the blue sky, but also white clouds, buildings, or other bright objects. Those patches of light determine the lightness and color temperature of your shadow.

On sunny days, cast shadows tend to be blue only because they look up to the blue of the sky. But the eyeball on the ant doesn't always see blue patches. On partly cloudy days, the light above is more white, and sometimes the blue sky patch is small and other sources are more dominant.

THE LIGHT AND THE SHADOW EDGE

The nature of the cast shadow is closely related to the nature of the light source. A soft light will cast a shadow with a blurry edge. A hard light will cast a shadow with a relatively sharp edge. Two side-by-side lights (such as car headlights) will cast two side-by-side shadows.

The edge of every shadow gets softer as the distance increases from the object that casts the shadow. If you follow along the edge of the cast shadow of a four-story building, it will go from sharp at the base to nearly six inches wide where the shadow is being cast onto the street below. This softening of the cast shadow edge is visible in the foreground of the painting opposite. The long shadow gets softer as it crosses the steps, and then even softer as it spreads over the building across the street.

In the painting of a bridge in County Kerry, Ireland, above, a series of cast shadows create parallel bands of light and shade that the viewer must cross to enter the village in the distance. This parallel pattern of light and shadow is an effective device to create depth in a painting.

Steep Street, 1993. Oil on panel, 17 × 18 in. Published in *Dinotopia: The World Beneath.*

HALF SHADOW

One way to create drama, especially with a vertical form, is to light the top half and leave the rest in shadow.

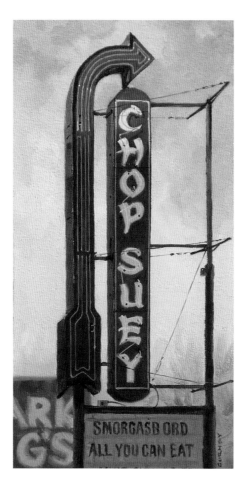

The plein-air study at right shows sunlight touching the top of an old neon sign. The color of the red sign is lighter in tone and more intense in color where it appears in the sunlight compared to the shadow. Likewise, the white letters had to be painted lighter and warmer where they appear in the light. In shadow they're really a dull blue-gray. The edge between light and shadow is soft, suggesting that something far away is casting the shadow.

The watercolor study of the minaret shows the bottom half of the tower in shadow. Both the golden brickwork and the white horizontal stripes had to be changed the same relative amount. Since I was using watercolor, it wasn't possible to premix the colors the way you could in oil. Instead I put a Payne's gray wash over the shadow areas before painting the rest of the colors. I painted the glowing passageways at lower left after the sun set. The sky is painted with opaque watercolor to get an absolutely even tonal gradation.

The painting opposite appeared in *Dinotopia: First Flight* in 1999. It shows Gideon Altaire, the first skybax rider in Dinotopia, standing beside his pterosaur named Avatar. They have just successfully vanquished the machine army of Poseidos after its invasion of Dinotopia in a failed attempt to steal the ruby sunstone power crystal. The shadow and light help accentuate the feeling of a conclusion to an epic story by suggesting the dramatic end of the day.

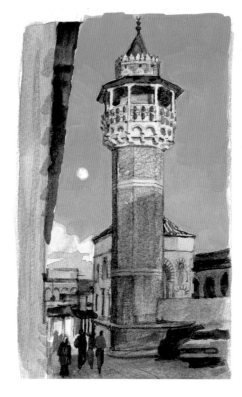

Top left: Chop Suey, 2005. Oil on canvas mounted to panel, 16 × 8 in.

Left: Minaret, 2008. Watercolor and gouache, 7½ × 4 in.

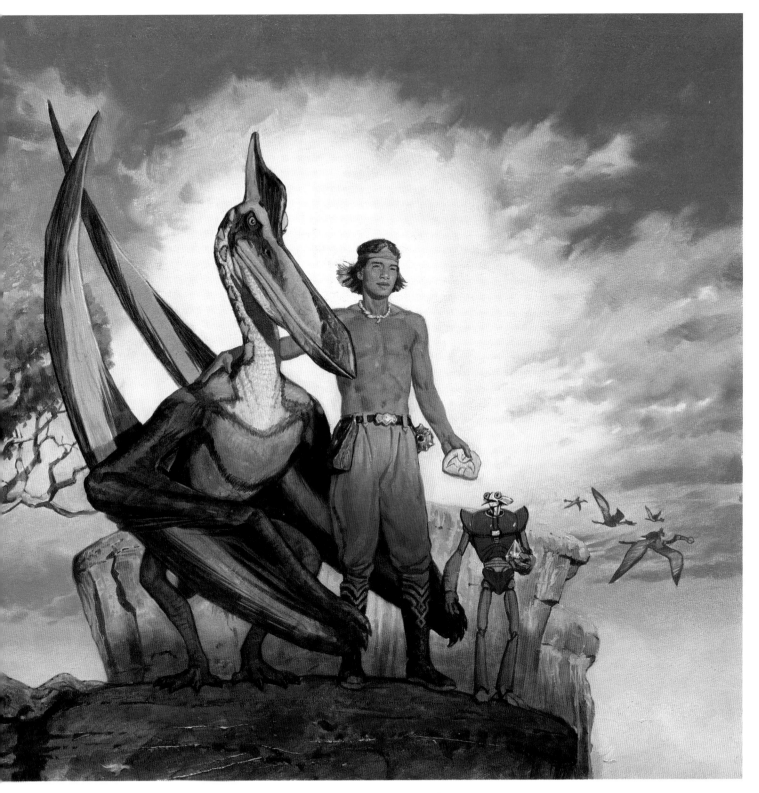

Gideon and Avatar, 1999. Oil on board, 13 × 19 in. Published in *Dinotopia: First Flight*.

OCCLUSION SHADOWS

Dark accents occur at places where forms come close enough to each other to crowd out the light, leaving a small, dense area of shadow. They're commonly seen where materials push together in folds or at points of contact with the ground.

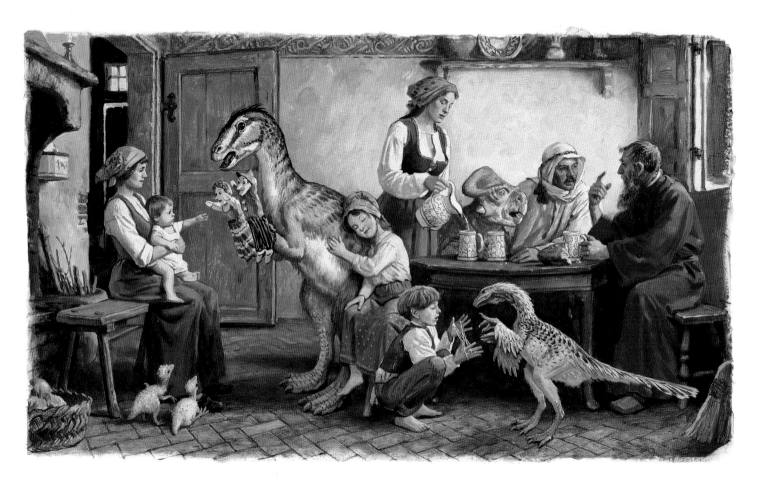

The Dinotopian domestic scene above has a variety of humans, creatures, and objects resting on horizontal surfaces. At each one of those points of contact, the light is occluded or interrupted, resulting in a dark accent.

These dark areas are called occlusion shadows or crevice shadows. They occur wherever two forms touch each other or wherever a form touches a floor. You can see the effect by pressing your fingers together and looking at the dark line where they touch.

Occlusion shadows also occur when objects get close enough to each other to interrupt the light, even though they may not actually be touching. This is often visible at the inside corner of a room where the walls meet.

Early computer-lighting programs didn't create this dark accent automatically. Until recently, it had to be added manually. But software pioneers have made lighting tools that can anticipate when the light will be occluded, and then such an accent will automatically appear.

Above: At Home, 2007. Oil on board, 10¾ × 18 in. Published in *Dinotopia: Journey to Chandara*.

Opposite: Locally Grown, 2004. Oil on canvas mounted to panel, 18 × 14 in.

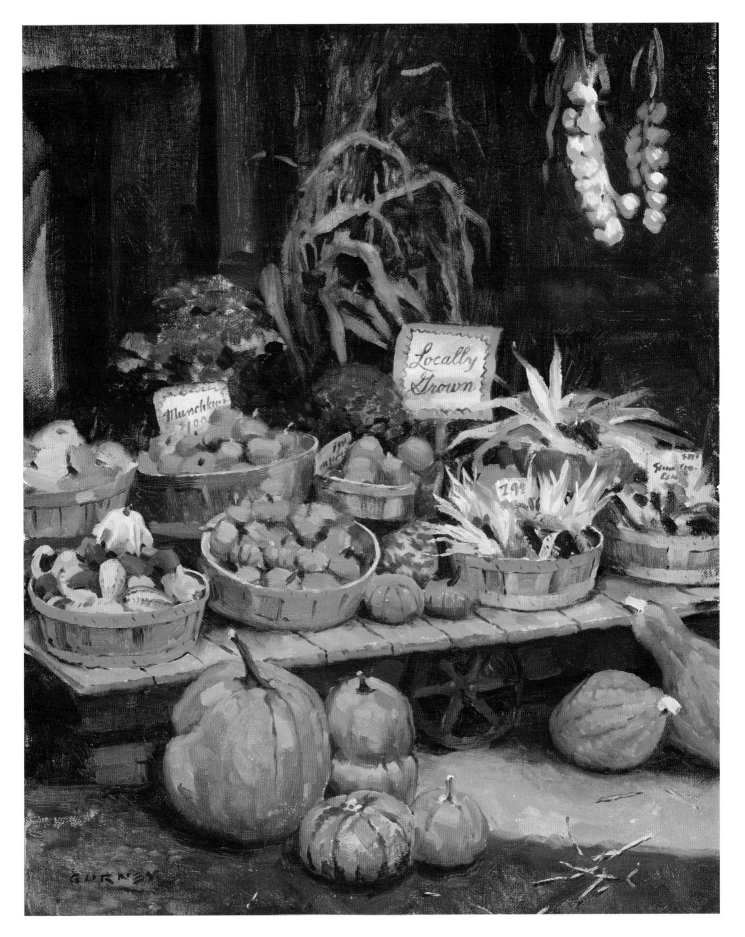

THREE-QUARTER LIGHTING

Most portraits are painted with light coming from about forty-five degrees in front of the model. The light reaches most of the visible form, leaving only a fraction of the form in shadow. The light is low enough to illuminate both eyes.

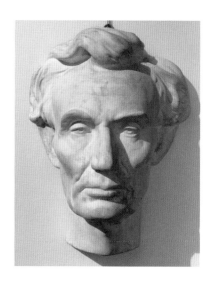

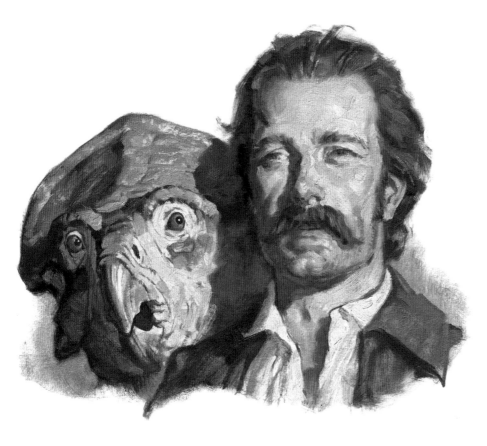

Above: Bix and Arthur, 1993. Oil on board, 5 × 6 in.
Published in *Dinotopia: The World Beneath.*

Right: Green Eyes, 1996. Oil on board, 12 × 9 in.

In the portrait of the man and dinosaur at left, the main light casts a shadow from the nose onto the cheek on the far side of the face, leaving a lighted triangle on the shaded cheek. This general pattern is called *three-quarter lighting.* The light emphasizes the nearer or broader side of the face, so it's also called broad lighting.

The sketch group study below called *Green Eyes* uses a low, broad, three-quarter light coming from the left. Photographers call this main light the *key light.* The shadow receives a weaker, second source of greenish light coming from the right. This light entering the shadow is called the *fill light.* In TV and movie lighting, a separate electric light usually provides the fill light. However, painters usually make do with natural reflected light for the fill.

The mountain man on the opposite page is lit with dramatic broad lighting to bring out character. The shadows help to define the wrinkles in the brow, and the low sun increases the squint. The side plane of the cheek on the left catches the blue light from the sky behind, tying the face to the background.

The portrait of the man on the bottom of the opposite page uses light on the "short side" of the face—the farther, foreshortened side. *Short lighting* can help make a face look thinner.

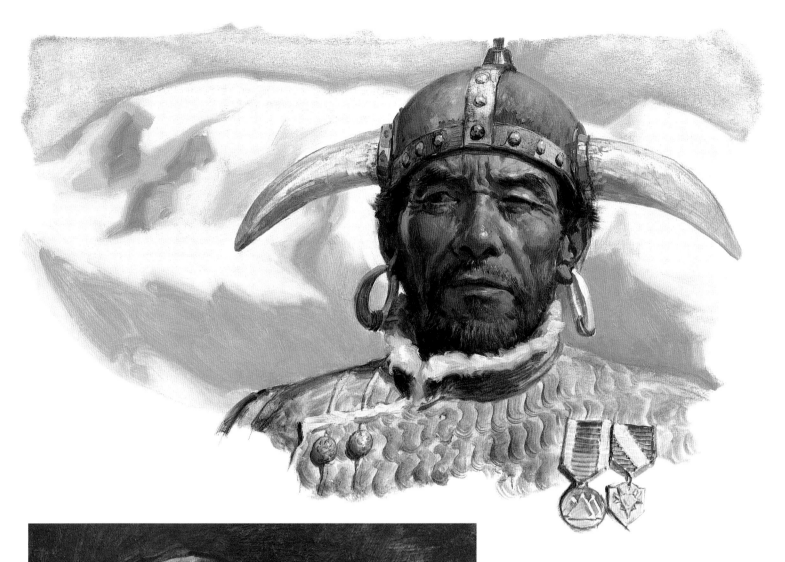

Above: Tribesman Portrait, 2007. Oil on board, 9 × 13 in. Published in *Dinotopia: Journey to Chandara*.

Left: John Luck, 1994. Oil on board, 11 × 14 in.

When short lighting is arranged so that the nose shadow merges with the shaded side of the face, it's called *Rembrandt lighting*. This lighting technique results in a lighted triangle on the cheek closest to the viewer.

All of these arrangements are flattering and unobtrusive, good reasons why artists have used them almost universally.

FRONTAL LIGHTING

Light that shines directly toward a model from the viewer's perspective is called *frontal lighting*. The light can be hard and direct, like a flashbulb, or soft and diffuse, like a north window. In either case, very little of the shadow is visible.

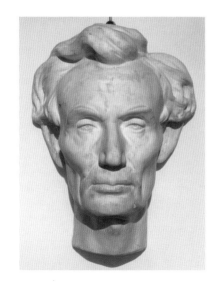

Frontal lighting occurs when you're sketching someone with your back to the light source. The subject of the pencil portrait at right was lit by an airplane window behind me. The thin line of illumination along his profile came from his window.

The profile portrait, opposite, has the key light shining from slightly to the left and above, leaving very little of the form in shadow. The shaded parts of the face are the planes below the nose, the lower lip, the chin, and the front of the neck. The illuminated side of the face is modeled in close values, using variations of reds and greens more than tonal changes. Using a flat, posterlike treatment helps the portrait to read strongly from a long way off.

In the Abe Lincoln bust, the planes get darker as they turn away. The shadows are narrow shapes just under the nose, chin, and hair. Frontal lighting can also be employed in landscape, as in the street scene below, where most of the scene receives direct illumination, and the shadows are minimized.

Frontal lighting emphasizes two-dimensional design instead of sculptural form. It's a good lighting to choose if you want to emphasize local color or pattern—to feature a fashion or costume, for instance. And it's one of the few times when outlines actually appear in real life. The outline is really the thin fringe of shadow that appears at the very edge of the form. That line deserves close study. It varies in weight in proportion to the width of the plane that is turning away.

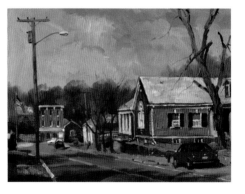

Above: Londoner, 2009. Pencil, 5½ × 6 in.

Left: Morton Library, 2004. Oil on panel, 8 × 10 in.

Right: Twenty-Minute Profile, 2005. Oil on panel, 12 × 9 in.

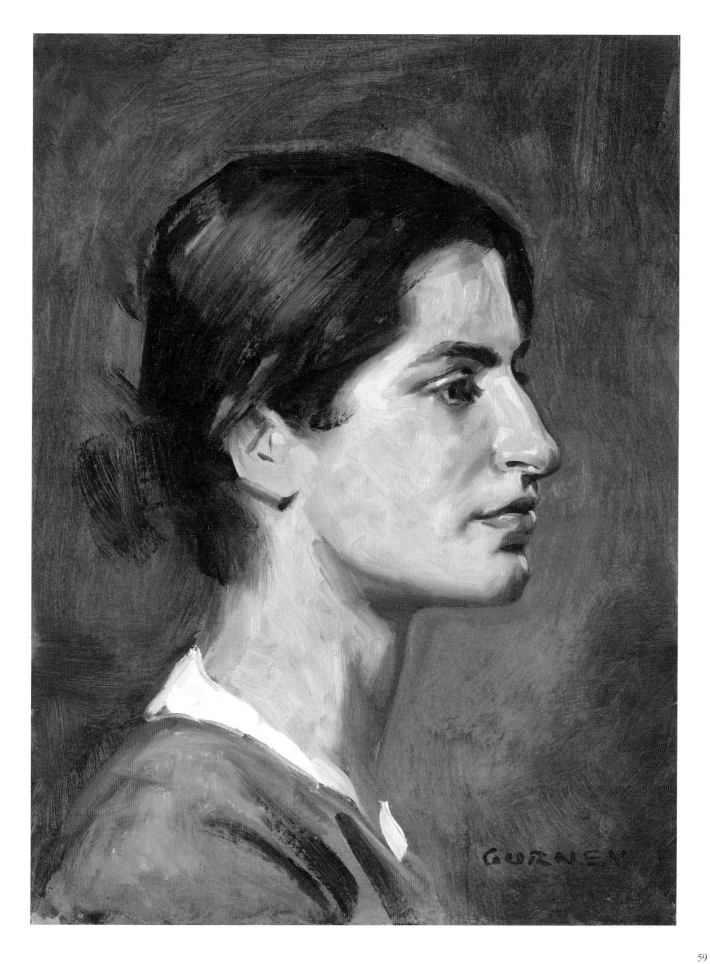

EDGE LIGHTING

Edge lighting comes from behind to touch the sides of the form, separating it from the background. It's also called a rim light or kicker in the film industry, and it usually requires a relatively strong source of light.

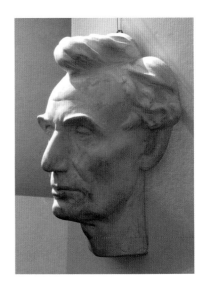

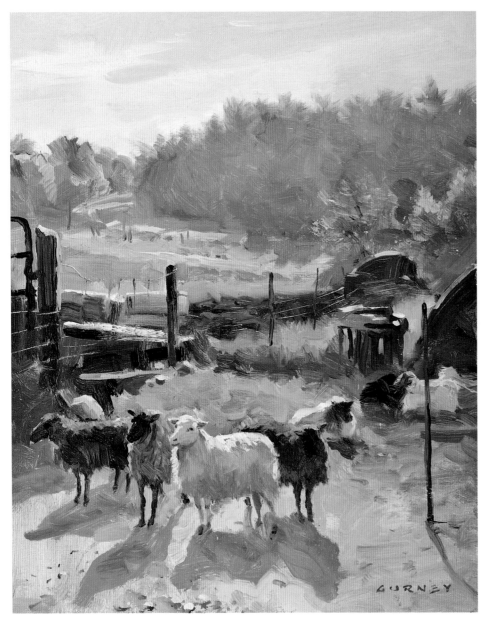

Shearing Day, 2008. Oil on panel, 10 × 8 in.

Edge lighting occurs outdoors when the sun is low in the sky and shining toward the viewer. The plein-air sketch, left, shows some Icelandic sheep waiting their turn for shearing. The sun was just above the top of the composition, casting shadows directly toward us, making this a form of backlighting.

A halo of warm light touches the top and side fringes of each ewe. The color of the brightly lit edge is a lighter version of the white or brown color of the wool.

The painting of the small dinosaur at right applies some of the lessons from the sheep sketch. The background is dark enough to allow the edge light to stand out dramatically, making each hairlike feather clearly visible. A star-burst of light radiates from the brow of the dinosaur, suggesting a hard, bony surface, which reflects a larger quantity of light, enough to create a flaring highlight.

The width of the rim light varies according to the size of the planes that face backward to the light. Edge light is not just a thin white line around the form. In the Abe Lincoln cast, above, the broadest plane and the widest part of the rim light is on the forehead.

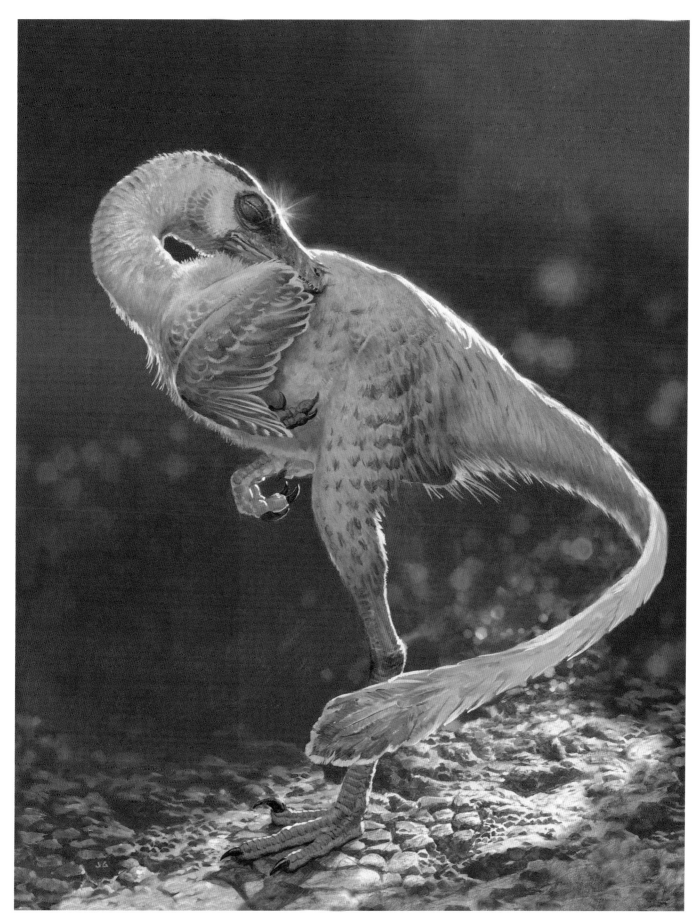

Mei Long, 2009. Oil on board, 18 × 14 in.

CONTRE JOUR

Contre-jour lighting is a type of backlighting where a subject blocks the light, often standing against a bright sky or an illuminated doorway. The field of light takes on an active presence, almost surrounding or infusing the edges of the object.

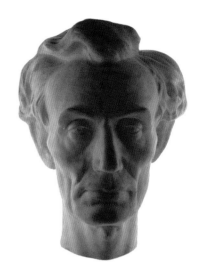

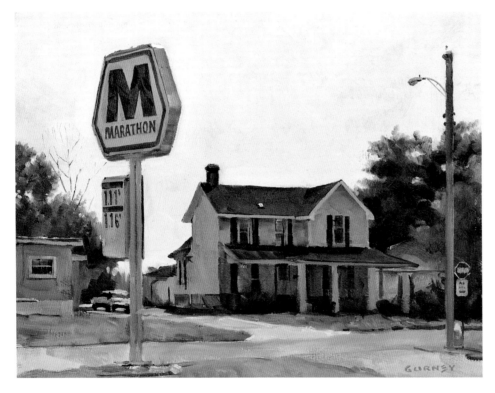

Above: Marathon Oil, 1996. Oil on board, 8 × 10 in.

Opposite: Asteroid Miner, 1982. Oil on panel, 24 × 20 in.

When a form is placed contre jour, its silhouette shape becomes prominent. The colors lose saturation, and shadows stretch forward. Details disappear as the glare of the light spills over the edges of the form. The sun itself often shines from inside the frame of the picture, making the viewer squint involuntarily.

One approach to contre-jour lighting is to think of the light area behind the subject not as flat white paint but as a sea of illuminated vapor, with light streaming out of the background, melting away the edges of the form. The portrait opposite shows the milky white light spilling over the edges of the man's shoulders, and lighting the side planes of his helmet and cheekbones. This can be an effective way to vignette a subject against the white of a page in a printed illustration.

The sketch at left shows a white house and a white sign against an even brighter sky. The air is extremely hazy, which has the same effect as pouring a little bit of milk into a glass of water. The nearer sides of the forms are cooler and darker.

It's often effective to keep a little color in the background haze, and to lower it a bit from white. The sky in this painting blends a light cool gray and a yellowish white together at the same value.

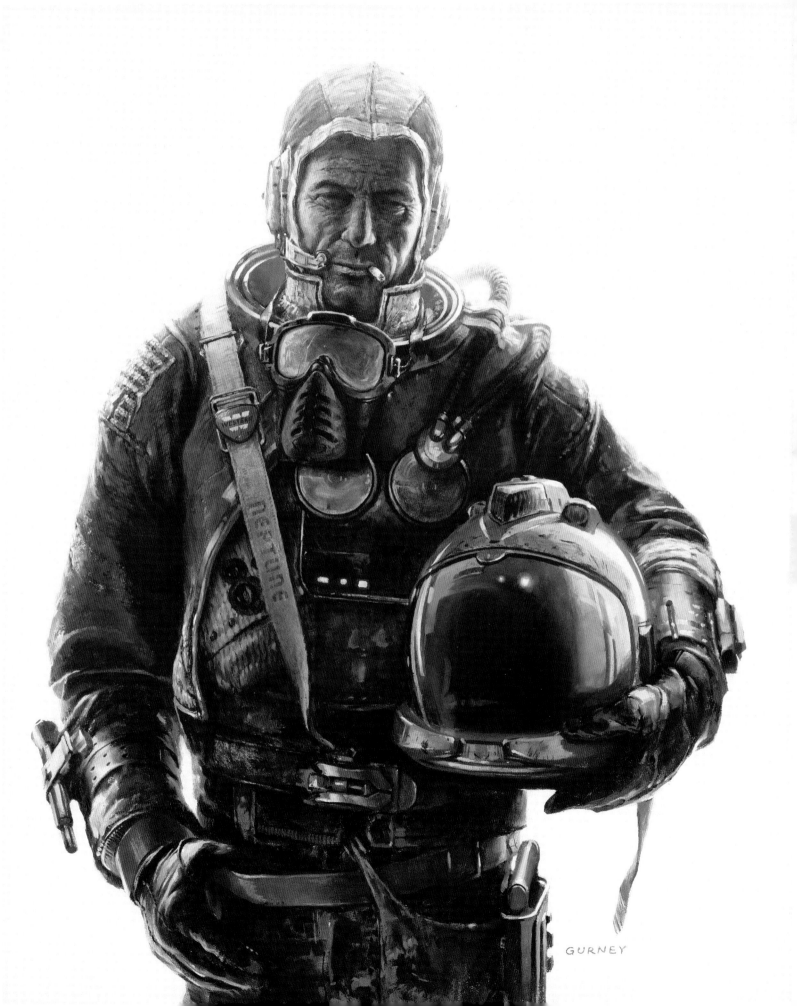

LIGHT FROM BELOW

Strong light doesn't usually come from below, so when you see it, it grabs your attention. We tend to associate underlighting with firelight or theatrical footlights, which can suggest a magical, sinister, or dramatic feeling.

Faces that are familiar to us—family, friends, and celebrities—nearly always appear lit from above. We hardly even recognize them when we see them with the light shining upward on their features.

Sources of light that shine upward are often strongly colored, either with the warm orange glow of firelight, or with the blue flicker of a computer screen.

The portrait of the character Lee Crabb from Dinotopia, below, shows him at a dramatic moment when he wants to take control of a powerful glowing sunstone. The ruby-colored light from the sunstone gives him a threatening, power-mad look. But not all upward light arrangements suggest evil. A person relaxing with a sun-flooded book might have her face lit mainly by the reflected light, which would have positive connotations.

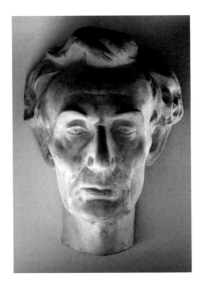

NIGHT SCENE

The scene on the opposite page was a poster for a science fiction festival in Nantes, France, the hometown of Jules Verne, who is visible in the lower left corner of the composition.

The scene takes place in 1893. A flying machine called a lepidopter is taking off at night from the town square. The action could have been staged in the daytime, but that wouldn't have been quite as magical.

Of course in real life, it would have been very difficult to light an actual outdoor set with this much light coming from a single source.

The source would be hidden on the far side of the fountain. The light is hitting the smoke and dust kicked up by the force of the wings. The cast shadows on the buildings on the right suggest that the aircraft is interrupting the lighting.

Note how the light is much stronger at the base of the wings, which draws the attention downward. One way to make something look large in a nighttime setting is to have the light shine on just part of the form and fall off rapidly. A very large object, such as a spacecraft, an ocean liner, or a skyscraper, will look even bigger if only parts of it are lit from below by small, weak lights shining upward at it. Building a small maquette or model, opposite, makes it easier to experiment with actual light.

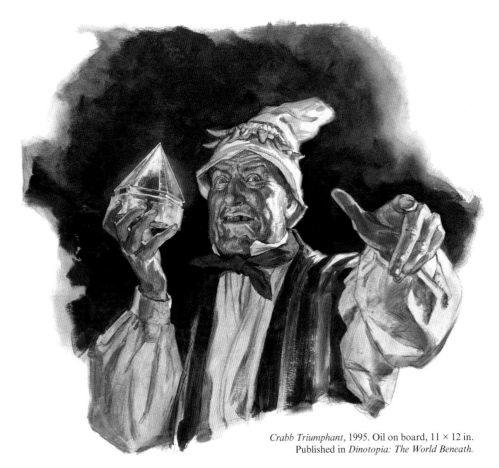

Crabb Triumphant, 1995. Oil on board, 11 × 12 in. Published in *Dinotopia: The World Beneath*.

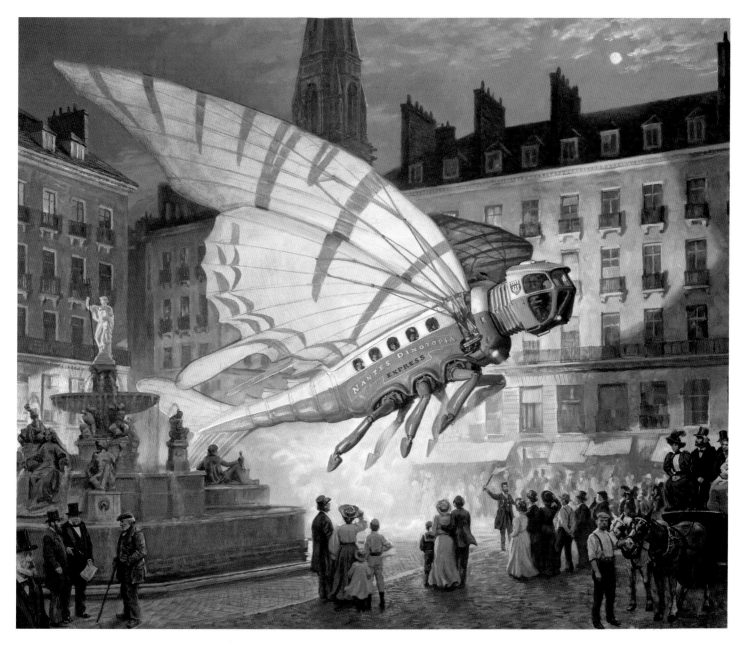

Above: Décollage Nocturne, 2009. Oil on board, 20 × 24 in. Poster design for Utopiales Science Fiction Festival. Collection Musée Jules Verne, Nantes, France.

Left: Lepidopter maquette, 2009. Mixed materials, 12-inch wingspan.

REFLECTED LIGHT

Just as the moon reflects the light of the sun into our night landscape, every object in a scene that receives strong light becomes its own source of light. Therefore, any nearby area of shadow will be affected by it.

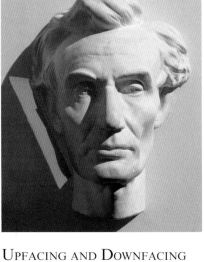

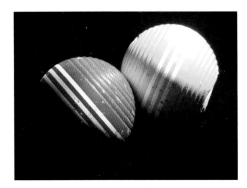

Figure 1. Photograph of two croquet balls.

Figure 2. Photograph of a green ball and a yellow ball.

What's wrong with the croquet balls in Figure 1? They are set up indoors in a shaft of sunlight, and they're resting on black velvet.

Figure 2 shows another photo, this time of a green ball and a yellow ball. Perhaps you've guessed that the images have been doctored in Photoshop.

The thing that's wrong with the croquet balls is the color of the reflected light. The left balls are switched in the two pictures. The ball that was there before the switch reflected its telltale color in the shadow of the yellow ball. The green ball shifted the shadow toward greenish yellow, and the red ball turned the shadow to orange.

Figure 3 shows what happens when we set the balls up in a shaft of sunlight and let their reflected light spill over to an adjacent piece of white board. The light bounces up and to the right. Its influence falls off rapidly as the distance increases from the balls, and the colors mix in the intermediate areas.

UPFACING AND DOWNFACING PLANES

Most of the time we think of shadows as blue. Surfaces in shadows do tend toward blue if they are facing upward beneath an open stretch of sky. We can make a general rule if we hedge it a bit: Upfacing planes in shadow are relatively blue on a clear, sunny day.

In the sketch of the library in Millbrook, New York, opposite, there's plenty of blue color in the cast shadows on the sidewalk, for example. But planes in shadow that face downward are different because they pick up the warm reflected color of illuminated surfaces below them. You can see this effect in the white pediment above the columns. Where the projecting forms face downward, they're distinctly warm, not blue at all.

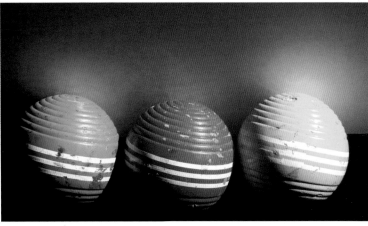

Figure 3. Photograph of three croquet balls reflecting sunlight onto a white surface in shadow.

Toledo Alley, 2002. Oil on panel, 10 × 8 in.

Millbrook Library, 2004. Oil on panel, 11 × 14 in.

This natural effect is exaggerated in the photo of Abe. The shadows are strongly colored from the reflected light bouncing up from an orange piece of cardboard held nearby in the sunlight, while the blue sky influences the upfacing planes.

In the painting of a narrow street in Toledo, opposite, the shadow side of the yellow building has taken on a strong orange color because of light reflected from an illuminated red building across the street. Normally you would expect the shadow side of a yellow building to be much lower in chroma, especially if it were lit mainly by light from the sky.

CONCLUSIONS ABOUT REFLECTED LIGHT

Let's review five general truths about color in reflected light.

1. In shadows, upfacing planes are cool, and downfacing planes are warm.

2. Reflected light falls off quickly as you get farther from the source, unless the source is very large (such as a lawn).

3. The effect is clearest if you remove other sources of reflected and fill light.

4. The color of the shadow is the sum of all the sources of reflected illumination, combined with the local color of the object itself.

5. On a sunny day, vertical surfaces in shadow usually receive two sources of illumination: warm ground light and blue sky light.

SPOTLIGHTING

In theatrical illumination, the light is almost never completely uniform. Less important areas of the stage fall into shadow, while the spotlight rivets the attention of the audience on the most important part of the action.

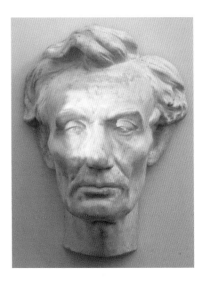

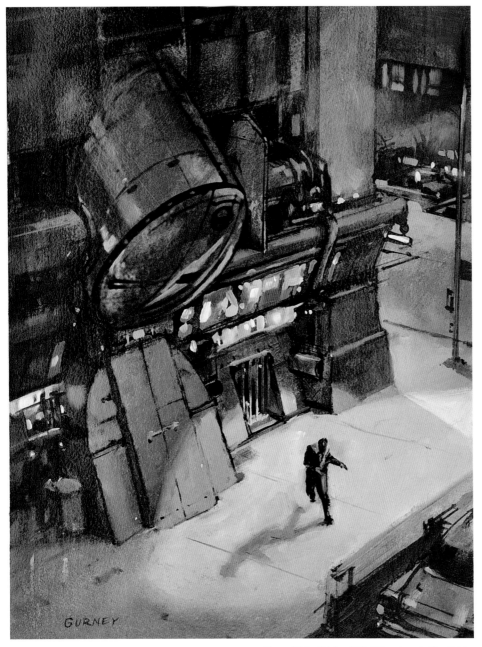

Above: Night Fright, 1983. Oil on board, 10 × 6½ in.

Opposite: Warrior on Ledge, 1984. Oil on canvas mounted to panel, 16 × 9½ in.
Published as *Witches of Kregen,* DAW Books.

Here are two imaginary scenes. Both are set at night. In each picture a spotlight picks out the central figure, leaving the rest in shadow.

In the quick concept sketch, left, the light is coming from the right, casting a long shadow from the running man. The shadow should match the color of the sidewalk ahead of the spotlight beam, because it is receiving the same ambient light as the rest of the scene. *Ambient light* is the light left over when the key light is removed.

The shape of the spotlight implies that it comes from a circular source, given the way it wraps across the forms of the building. It subconsciously gives the impression that the man is being followed and is evading capture.

The painting on the right shows a man on a ledge standing in a slanting bar of light that shines from below. The cast shadow from his arm is red on the bottom and blue above. The colored shadows give the feeling that there are actually two adjacent spotlights, a red one below and a blue one above. This is typical of theater lighting, where adjacent colored spotlights cast shadows with chromatic edges.

A spotlight effect can be used on a small form, too, such as the face above. "Eyelights" were common in classic cinema to concentrate the viewer's attention on the eyes.

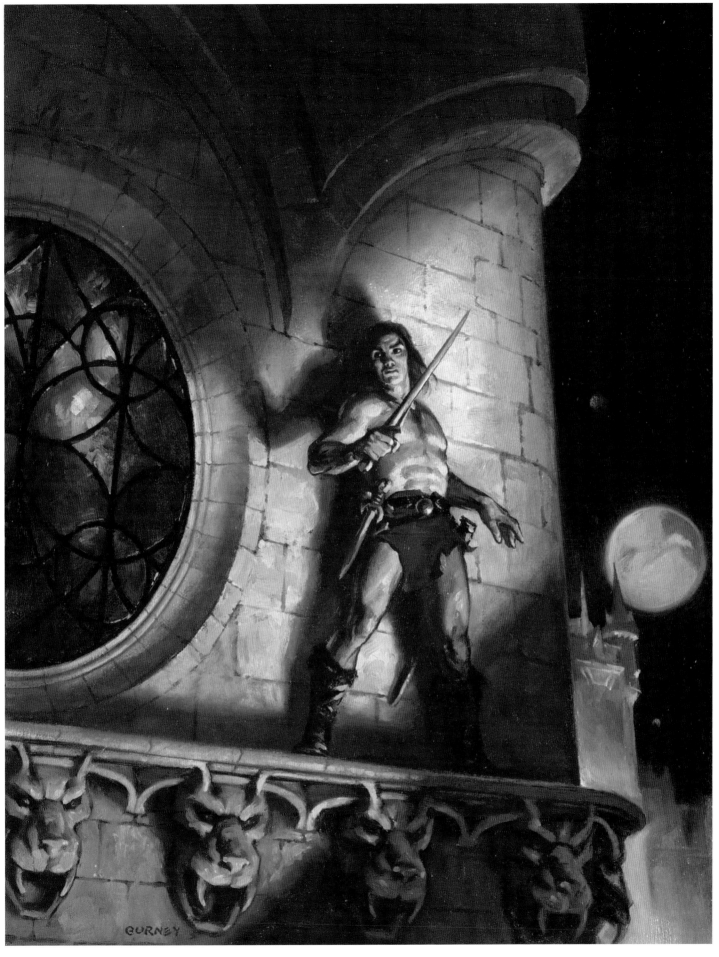

LIMITATIONS OF THE FORM PRINCIPLE

Solid objects with a matte finish behave predictably in strong light, with a light side, a shadow side, and reflected light. But other materials, such as clouds, foliage, hair, glass, and metal, respond to light differently and require a flexible approach.

Clouds are so variable in density, thickness, and composition that it's hard to make general rules about how light interacts with them. Even in direct sunlight, sometimes there's a definite light side and shadow side, and sometimes there just isn't.

But it's safe to make the following statement: Clouds transmit a greater quantity of light to the shadow side through internal scattering than the volume of light they pick up from secondary sources.

The scene below shows a single cloud mass rising above the ranks of shadowed clouds to receive the first morning sun, which penetrates the cloud and lights up the near side. If you try to make clouds follow the form principle, they risk looking like hanging lumps of plaster.

Foliage, too, is extremely variable in

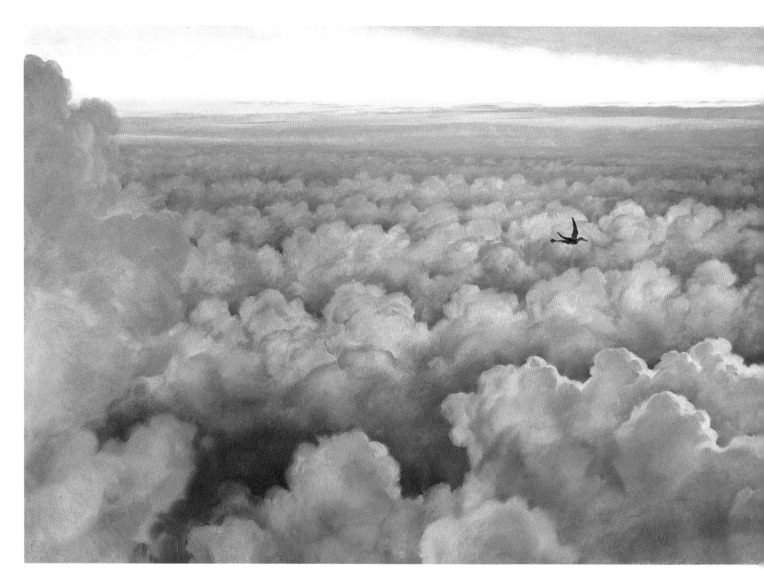

the way light interacts with it. The old elm tree at right was dense and opaque enough that you could begin to see a light side and a shadow side. But the trees behind it were thin enough to let the light pass completely through them.

The form principle, with its analysis of light, halftone, shadow, and reflected light, is just a starting point. The world is not made of plaster. It's composed of a wide variety of materials and surfaces, which we'll explore further in Chapters 9 and 10.

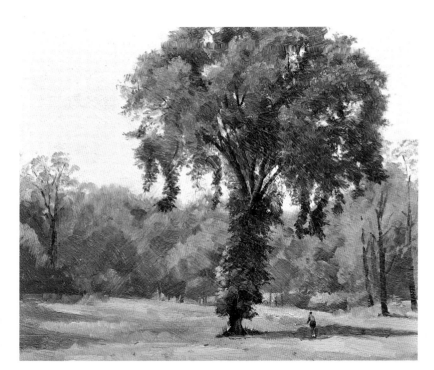

Right: Elm, 2004. Oil on panel, 8 × 10 in.

Below: Lost in the Clouds, 1998. Oil on panel, 9 × 28 in. Published in *Dinotopia: First Flight*.

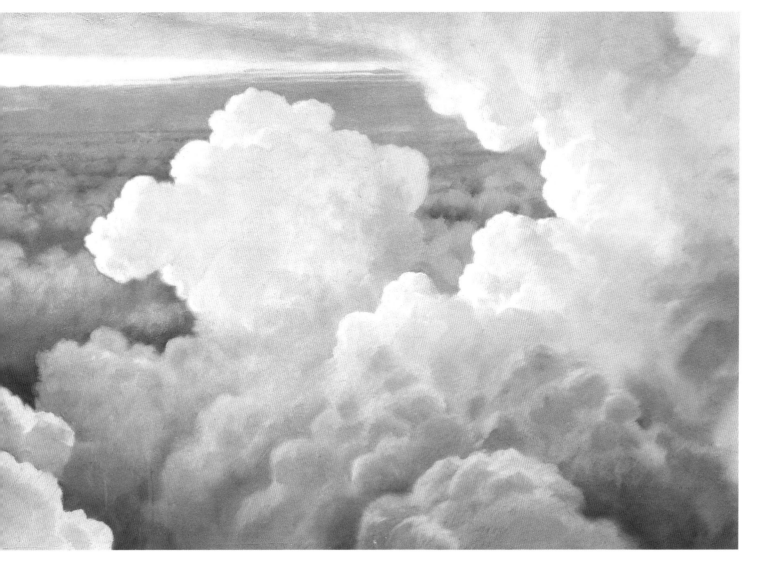

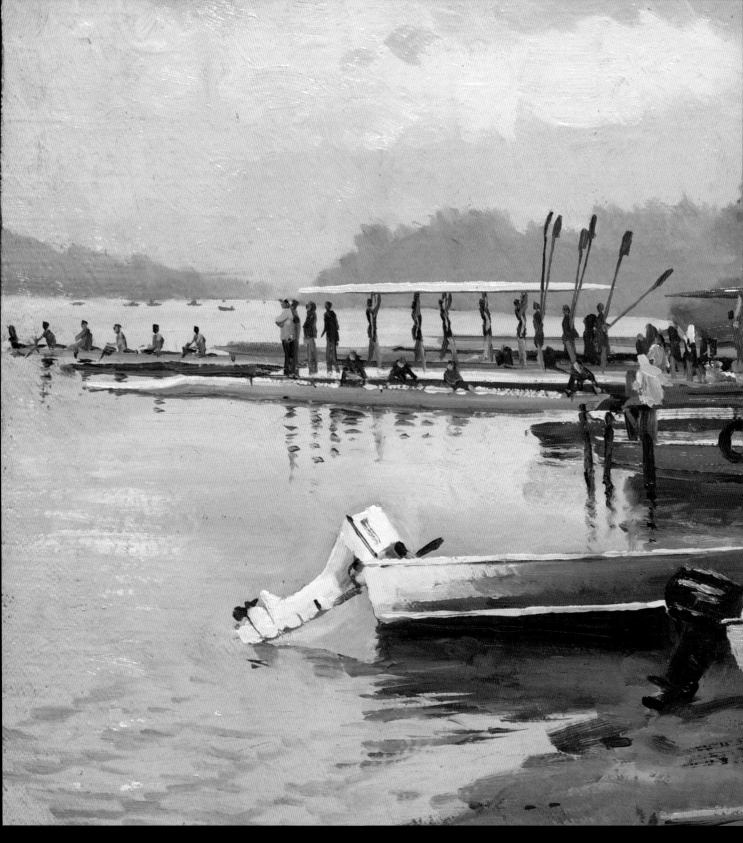

Crew Race, Saratoga, 2005. Oil on canvas mounted to panel, 8¼ × 16 in.

RETHINKING THE COLOR WHEEL

When white light is bent or refracted by a prism or a rainbow, it separates into a continuous gradation of colors. Wrapping those colors around a circle creates a hue circle, better known as a color wheel.

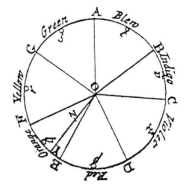

Figure 1. Sir Isaac Newton's hue circle.

How we name and separate the colors is a matter of discussion, related to physical science, visual perception, and artistic tradition. In the continuous spectrum produced by a prism, there's no clear division between the colors. Sir Isaac Newton (1642–1727) proposed wrapping the spectrum around the circle by merging the two ends of the visible spectrum, red and violet. He observed that the hues gradate smoothly into each other (Figure 2), but in his diagram (Figure 1) he identified the seven colors known as ROYGBIV (red, orange, yellow, green, blue, indigo, and violet). The tradition among artists has been to drop the indigo and to concentrate on six basic colors.

THE ARTIST'S PRIMARIES

Artists generally regard red, yellow, and blue as the most basic colors. But from Greek and Roman times to the Renaissance, most people thought green should be included, too.

The idea of a *primary color* is that it should be possible to mix every other color out of the three primaries. If you ask most people to select three tubes of paint to match their mental image of the primary colors, they will most likely pick something like cadmium red, cadmium yellow, and ultramarine blue.

You may have noticed that with those colors you can mix clear oranges, but the greens and violets are very dull. The traditional artist's color wheel, (Figure 3) presents yellow, red, and blue spaced at even thirds around the color wheel, about

in the position of 12 o'clock, 4 o'clock, and 8 o'clock. Mixtures of the red, blue, and yellow primaries create secondaries. The *secondary colors* are violet, green and orange. They appear between the primaries at 2, 6, and 10 o'clock on the traditional color wheel.

COMPLEMENTS

Any color that holds a position directly across the wheel from another is known as a *complement*. In the world of pigments and color mixing, the color pairs are: yellow-violet, red-green, and blue-orange. When pigmentary complements are mixed together, they result in a neutral gray, that is, a gray with no hue identity. In the realm of afterimages and visual perception, the pairings are slightly different. Blue is opposite yellow, not orange.

CHROMA

The wheels in Figures 2, 4, 5, and 6 include the dimension of grayness versus intensity, known as chroma. *Chroma* is the perceived strength of a surface color, seen in relation to white. (*Saturation*, a related term, properly refers to the color purity of light.) As the color swatches progress outward from the hub to the rim of the color wheel, the colors increase in chroma. At the center is neutral gray.

THE TRADITIONAL WHEEL

There are a few problems with the traditional wheel in Figure 3. First, the idea that red, yellow, and blue are primaries is not set in stone. Any of the infinite hues on the outer rim of the gradating wheel could make an equal claim as a primary.

Figure 2. Gradating hues around a circle.

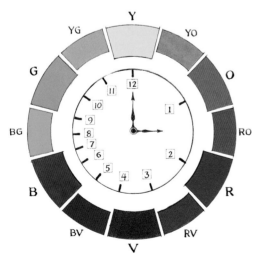

Figure 3. The traditional color wheel.

In addition, none of the hues are secondary or composite by their nature. Green is no more secondary than blue is.

The third problem is that the spacing of colors on the traditional wheel is out of proportion, like a clock face with some of the numbers bunched up in one corner (center of Figure 3). It expands the yellow-orange-red section of the spectrum too much, so that red is at 4 o'clock instead of 2, and blue is at 8 o'clock instead of 6. This uneven distribution came about partly because our eyes are more sensitive to small differences among the yellow/orange/red hues, and partly because pigments are more numerous for warm colors, compared to cool ones. There have always been many available pigments for the oranges and reds, but few for the violets and greens. The precious pigments vermilion and ultramarine became our mental image for red and blue.

THE MUNSELL SYSTEM

Many contemporary realist painters use the system developed by Albert Munsell about a century ago. Instead of divisions of threes and twelves, the structure is based on ten evenly spaced spectral hues. In deference to Munsell, the diagram here shows the reds on the left.

This is a much more useful wheel than the traditional artist's color wheel because it allows for exact numerical descriptions of color notes. Students of the Munsell system must become accustomed to the ten basic hues: yellow (Y), green-yellow (G-Y), green (G), blue-green (B-G), blue (B), purple-blue (P-B), purple (P), red-purple (R-P), red (R), and yellow-red (Y-R).

CYAN, MAGENTA, AND YELLOW

In the world of printing and photography, the three colors that mix the widest range of high-chroma colors are cyan, magenta, and yellow. These printer's primaries, together with black (K), are known by the shorthand CMYK. They are used throughout the industries of offset lithography, computer printing, and film photography.

If all other industries use different primaries from the yellow-red-blue primaries we artists are accustomed to, why have we kept them? One reason is simple force of habit. Cyan and magenta don't match our mental image of the blue and red color concepts we've accepted since early childhood.

RED, GREEN, AND BLUE

At right is a corrected wheel, first in digital form, and then painted in oil. Note that the halfway mixtures between yellow, magenta, and cyan are red (really orange-red), blue (really violet-blue), and green. These three colors (RGB) are significant, because they are the primary colors of light, as opposed to pigment. Lighting designers and computer graphics artists consider RGB as their primaries, and CMY as their secondaries. Mixing red, green, and blue lights together on a theatrical stage or a computer screen results in white light.

Until recently it was hard to find chemical pigments that would match up with CMY primaries, and it's still impossible to find pigments that have all the properties that artists want. The pigments cadmium yellow light (PY 35), quinacridone magenta (PR 122), and phthalo cyan (PB 17) come close, but the latter two are unsatisfactory if you like opacity.

THE "YURMBY" WHEEL

Placing RGB on the wheel evenly between CMY creates a universal color wheel, useful in many different settings. Think of these as the six equal primaries: yellow, red, magenta, blue, cyan, and green. Counting clockwise from the top of the wheel, they are YRMBCG. You can remember them as "Yurmby" or "You Ride My Bus, Cousin Gus."

Should painters adopt this six-primary color wheel? It's good to learn this mental image of the ideal color wheel, regardless of what pigments you actually use as primaries. What's important is that you know where the colors you're using actually belong on a mathematically accurate color wheel.

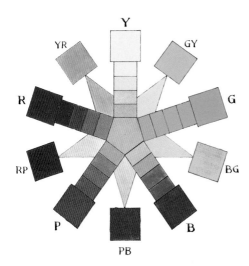

Figure 4. The Munsell wheel.

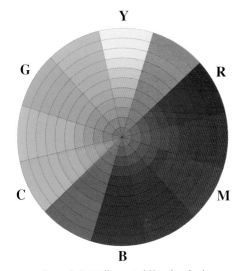

Figure 5. Digitally created Yurmby wheel.

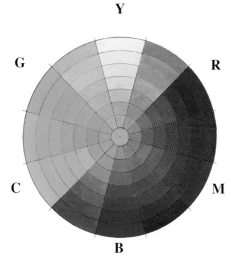

Figure 6. Hand-painted Yurmby wheel.

CHROMA AND VALUE

Whenever you paint directly from observation, you have to translate the wide range of tones that meet your eye. The colors on the palette often can't match the wide range of tones in a given scene.

As we saw on the previous page, every color can be defined in terms of two dimensions: hue—where it appears around the edge of the color wheel, and chroma—how pure or grayed-down it appears.

The third dimension to consider for any color mixture is the value or lightness. This value dimension is generally represented along the vertical dimension above and below the color wheel, creating a spherical, cylindrical, or double-cone shape. Since it's a three-dimensional volume, it's also called a color space or color solid.

One of Albert Munsell's contributions to the understanding and practical use of color was his numerical classification system for all possible colors according to these three dimensions: hue, value, and chroma. Instead of trying to describe a given color as a "beige" or a "maroon," one could unambiguously define them as a YR 7/2 or a R 3/6. The letters "YR" stand for yellow-red. The first number stands for value, ranging from black (0) to white (10). The second number refers to chroma, counting upward to the strongest intensity possible.

Many painters have adopted Munsell's color notations to help them accurately observe, select, and mix any color. Artists trained in Munsell notation become accustomed to navigating in a three-dimensional color space each time they think about a color.

PEAK CHROMA VALUE

Munsell observed that a given hue reaches its greatest chroma at one particular value, called the home value or the peak chroma value. That peak value varies from color to color. Yellow, for example, is most intense at a very light value, while blue is strongest when it is very dark. Red reaches maximum chroma at a middle value.

The hand-painted chart below takes those three hues through all possible degrees of chroma and value. Chroma is constant along a vertical line, while value is constant along a horizontal line

RED NEON

Red neon was the subject of the rainy-day plein-air painting opposite. The neon presented a problem because the effect on the eye couldn't be mixed with pigments.

The neon color was one of the lightest values in the scene. The red-orange color was also extremely saturated. The only paint that could simulate that high value was pure white oil paint—but then it would have no hue character at all. Likewise, any light tint of the red was noticeably weak in chroma, and looked orange or pink. And a bright red as it came from the tube wouldn't work because peak chroma value was far too dark compared to white.

The compromise was to paint the neon bulb in a pure tint of red-orange and to surround it with a flood of red-orange at midvalue. The digital photo, above, which has its own limitations, also failed to capture the full effect of the neon light, but it did a better job than the painting.

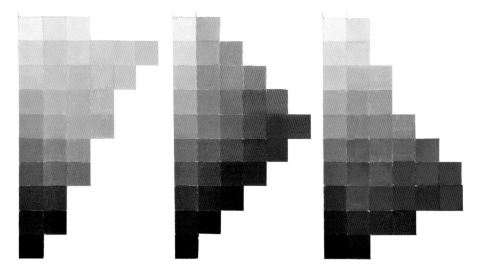

Peak chroma value charts showing yellow, red, and blue charted by value (top to bottom) and chroma (right to left). Oil on board, 7 × 12 inches.

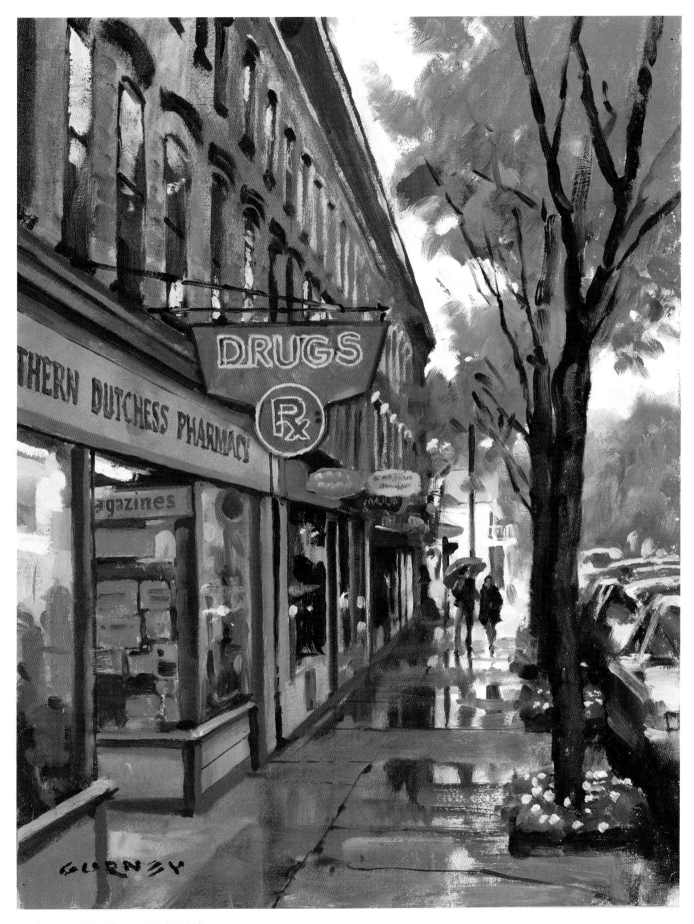

Market Street, 2003. Oil on canvas, 18 × 14 in.

LOCAL COLOR

Local color is the color of the surface of an object as it appears close up in white light. If you held up a matching paint swatch right against it, that swatch would be the local color. However, the color you actually mix to paint that object will usually be different.

Maltese Bus, 2008. Watercolor, 4½ × 6½ in.

All the buses in Malta are painted in bands of yellow, red, and white. When I sat down to paint the sketch above, my job wasn't too different from the task of filling in a coloring book. The colors on my painting resembled the actual paint colors used on the bus.

But even in this simple sketch, I had to make a few modifications to the local color. I lightened the yellow in the plane above the wheel where the body projected outward. The red band also

had to be lighter at the top where it angled back to pick up the light and color of the sky. The reflection of the blue sky into the red band resulted in a light violet color.

One of the reasons I painted the gumball machine in the coin laundry, opposite, is that I was interested in how each gumball had a light edge where it caught the glare of the window. I also noticed how the colors darkened on the

side facing me. There was a little high-light in the center of each ball caused by the fluorescent lights above me.

Generally the colors you actually mix in a painting will involve some modulation of the local color. You might lighten or darken the color to model the form, gray it down to push it back through layers of atmosphere, or shift the hue to account for reflected light from other objects.

7/17/95

MAHONE BAY LAUNDROMAT, NOVA SCOTIA

25¢

GURNEY

Gumball Machine, 1995. Oil on panel, 10 × 8 in.

GRAYS AND NEUTRALS

Grays or neutrals are the opposite of intense colors. We some-
times associate grays with blandness or dullness, but they are
actually an artist's best friend. More paintings fail because of
too much intense color rather than too much gray.

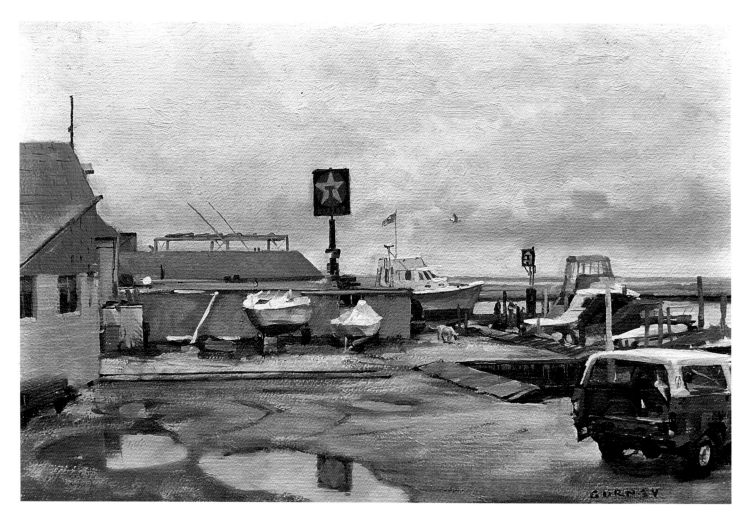

Paul's Boatyard, 2001. Oil on board, 8 × 12 in.

Grays can provide a setting for bright
color accents. They give space and scope
to a composition, and they can create a
quiet, reflective mood. In the painting
above, they connect the contrasting blue
and red accents by providing transitional
notes of soft violets and browns.

There is no single gray color. To the
careful observer, gray comes in many
subtle variations. It might have a hint of

blue or a touch of orange. Recognizing
hue identity in these grayed-down mix-
tures takes a bit of training and practice.

A gray can be mixed from various
combinations of colors. To preserve
pleasing variations in grays, it's a good
idea to mix them from complementary
pairs, rather than from white and black
pigments. Try mixing grays from blue
and orange, red and green, or violet

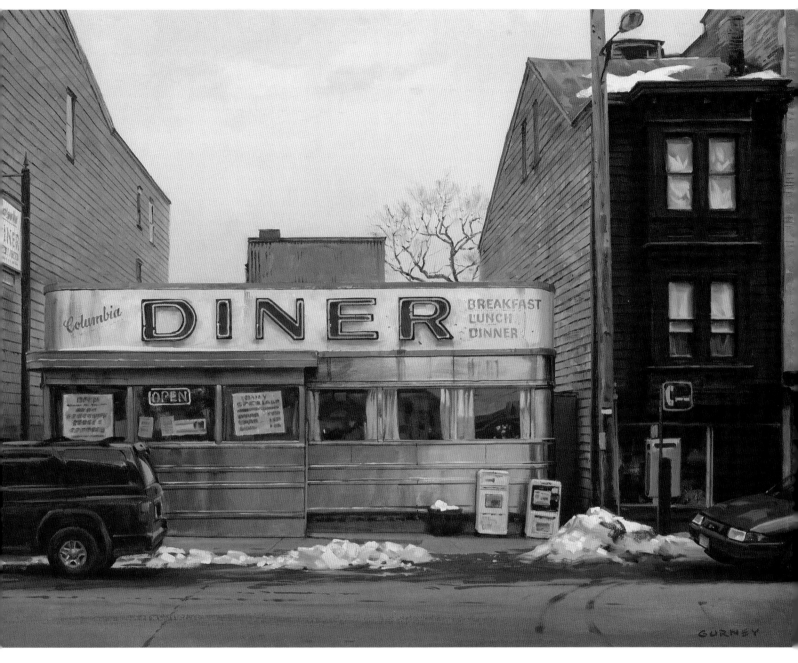

Columbia Diner, 2004. Oil on linen, 18 × 24 in.

and yellow. You can then place those color accents near the gray, and they'll harmonize, because the gray contains an element of each of them. For example in the painting at left, the grays in the sky contain some cadmium red and cobalt blue, which also appear as color accents in the boats, car, and sign.

An otherwise dull area can be enlivened by shifting the value and hue across its surface. In the big dark building on the left of the diner scene, above, the colors move from a relatively dark, cool gray to a lighter, warmer gray at the far back end of the building.

Gray is the sauce of the color scheme. It's easier to live with a subdued painting than with one that is highly saturated throughout. As Jean-Auguste-Dominique Ingres (1780–1867) said, "Better gray than garish."

THE GREEN PROBLEM

Green is one of the most common colors in nature, but it has presented such a perennial challenge to artists and designers that many have banished it from the palette. Why is green a problem, and how can you solve it?

Strutter in the Swamp, 1994. Oil on board, 12½ × 19 in.

Along Landsman's Kill, 1985. Oil on panel, 8 × 10 in.

There is no doubt that green is a fundamentally important color. Many modern psychologists and color theorists regard it as a primary color. The word "green" occurs more than twice as frequently as "yellow" in modern written English. The human eye is more sensitive to yellow-green wavelengths than to any other; that's why the spectrum or the rainbow looks lighter in that section.

Yet in the field of book cover design, there's an old saying that "green covers don't sell." Among the flags of Europe, 79 percent contain red, but only 16 percent contain green. Costume designers have said that green often looks ghastly in stage lighting. Gallery directors have reported that clients aren't attracted to paintings with a strong greenish cast unless it is handled carefully.

Evidently this was an issue even 150 years ago, when Asher Brown Durand commented on "the common prejudice against green." He said, "I can well understand why it has been denounced by the Artist, for no other color is attended with equal embarrassments." Durand chided his contemporaries for painting so many autumn scenes instead of summer ones to avoid the problem altogether.

In late spring and early summer, the leaves have not developed their full waxy cuticle layer, and the chlorophyll has an electric yellow-green. When light shines through new leaves or blades of grass, the green is particularly strident. To faithfully match that color, some artists mix a color they call "vegetable green," a highly chromatic yellow-green, which they use in foliage mixtures.

Even the most die-hard truth-to-

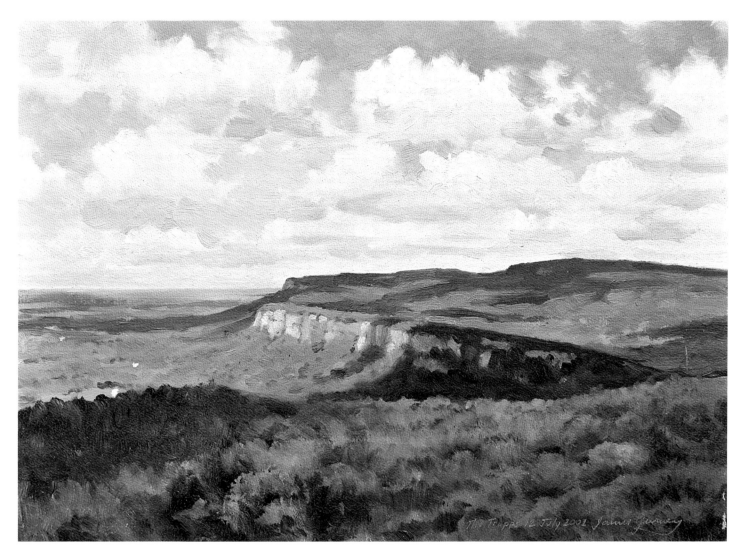

The Trapps, 2001. Oil on board, 11 × 14 in.

nature plein-air aficionados cut back on the strength of green in the spring landscape. Above is a plein-air study that tries to match the observed colors without modifying them. Would it have been better with grayer greens? Perhaps it's a matter of personal taste.

TIPS FOR HANDLING GREEN

1. You can banish green pigments from the palette and mix them from various blues and yellows. The resulting mixtures will be weaker and more varied, both qualities that you want.

2. Avoid monotony. Vary your mixtures of greens at both the small scale (leaf to leaf) and the large scale (tree to tree).

3. Mix up a supply of pink or reddish gray on your palette and weave it in and out of the greens. Painter Stapleton Kearns calls this method "smuggling reds."

4. Prime the canvas with pinks or reds, so that they show through here and there to enliven the greens.

GRADATION

Like a glissando in music, a color gradation transitions smoothly from one note to another. The shift can occur from one hue to another, or from a light color to a dark color, or from a dull color to a saturated one.

West Point from Osbourne's Castle, 2003. Oil on canvas, 12 × 16 in.

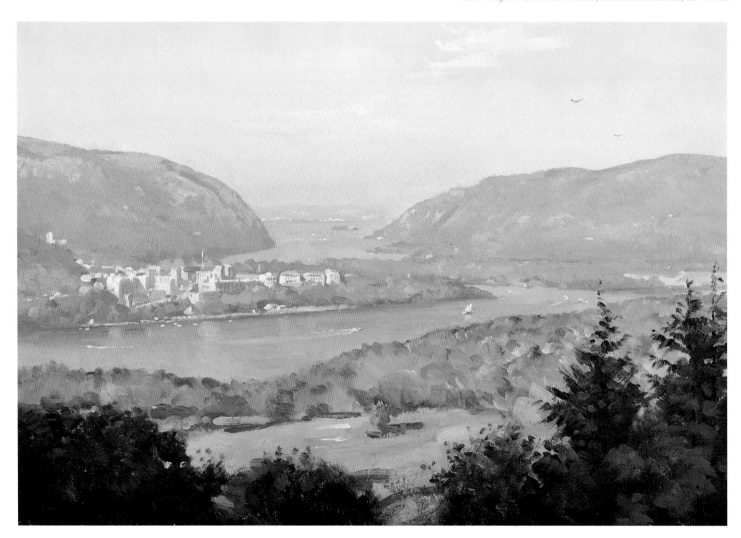

The painting above has several systems of gradations going on. The colors change from a light blue at the top of the sky to a rosy gray below, and a thin band of rosy color along the horizon. Gradations don't just happen. They take planning. Usually you'll need to mix the colors carefully before you begin applying paint.

The scene with the rising sun, opposite, also uses a gradation to convey the brilliance of the sun. From the sun outward to the edges of the picture, the colors gradually change in value, hue, and chroma.

John Ruskin observed in his landmark book *Modern Painters* (1843) that a gradated color has the same relationship to a flat color as a curved line has to a

straight line. He noted that nature contains movement or gradation of color both on the large and the small scale, even down to the smallest brushstroke or pebble: "Nature will not have one line nor color, nor one portion nor atom of space without a change in it. There is not one of her shadows, tints, or lines that is not in a state of perpetual variation."

The Clove from Haine's Falls, 2004. Oil on canvas, 24 × 20 in.

TINTS

Adding white to a color raises it to a tint or a "pastel" color. This quality of lightening is typical of distant hues on a hazy day. Mural painting typically succeeds best with paler ranges of colors, which convey a feeling of light.

Catskills from Blithewood, 2003. Oil on canvas mounted to panel, 9 × 12 in.

In music, a melody can be transposed upward in pitch, or it can move from the brass section to the strings. A set of colors can undergo a similar transposition upward in value thereby giving a pleasing airiness or delicacy to a picture.

In both the landscape painting above and the fantasy painting opposite, the bold colors of the foreground get lighter as they go back in space. To make these high-key tints appealing, it helps to use darker-toned colors in other parts of the picture for the sake of contrast.

A tint can be made in two ways. One is by adding white, which will often make hues bluer. Whitened reds, for example, usually become more magenta. The other way to is to apply the color as a thin, transparent layer over white. This usually leads to a more highly chromatic tint.

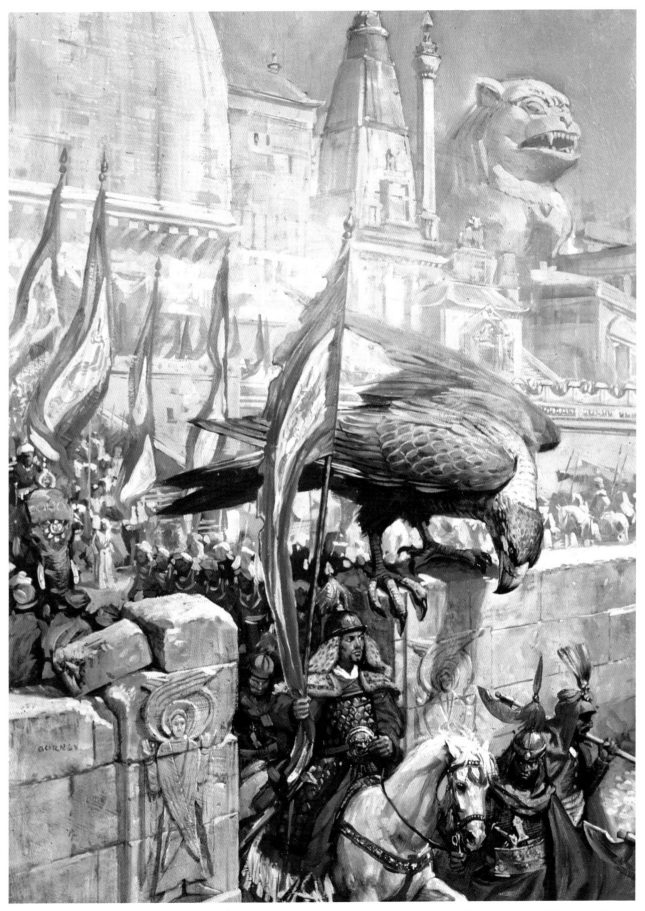

Avian at the Gate, 1988. Oil on canvas mounted to panel, 24 × 16 in. Published as *Realm of the Gods*, Ace Books. Collection Jane and Howard Frank.

Rhinecliff Hotel, 2003. Oil on board, 9 × 18 in.

PAINT AND PIGMENTS

THE SEARCH FOR PIGMENTS

For thousands of years, people have scoured the earth looking for brightly colored materials to make into paint. Most intense colors in plants and animals fade immediately. An ideal pigment must be permanent, plentiful, and nonpoisonous.

Swatches to test a set of watercolors.

PREHISTORIC PIGMENTS

Pigments are insoluble, powdery, dry materials that selectively absorb and reflect wavelengths of light to produce color.

Since art's beginnings, a few reliable color ingredients have been readily available to artists. Blacks, reds, and yellows were easy to find; that's why they appear in all "primitive" art. Black paint made from charcoal or burnt bones dates back to prehistoric times. The brownish reds and oranges of iron oxides have been dug out of natural open pits. Siena, Italy, gave its name to ore-based pigments that were used burnt or raw.

MORE RARE THAN GOLD

Reliable violets, magentas, and blues were rare. The togas of Roman emperors used a pigment known as Tyrian purple, made from a color-producing cyst from a whelk. It took 12,000 mollusks to make 1.4 grams of pure dye. The rarity of purple made it the color of royalty. The crimson color used in the red coats of the British military, Catholic cardinals' robes, and in many modern lipsticks originates from a fluid in tiny insects that live as parasites on cactus plants. Those bugs were worth more than their weight in gold to the Spanish, and the processes were kept absolutely secret.

The most expensive pigment of all was a fine blue from lapis lazuli, a mineral mined in Afghanistan. Getting a supply required a long voyage *ultramarinus*, or "beyond the sea." For this reason, the old masters reserved ultramarine for the Madonna's robes.

TOXICITY

Other pigments made excellent paints, but they were toxic. Art historians speculate that lead-based white paints sent many artists to an early grave. Vermilion owed its red-orange color to deadly mercury. Emerald green, a form of arsenic, was so poisonous that it was also used as an insecticide.

Cadmium remains a popular pigment for reds and yellows, with especially good opacity. But it's also a suspected carcinogen and must be handled with care. You can protect yourself from dangerous pigments by wearing latex gloves and avoiding airbrushing. Be especially careful when handling pastels and dry pigments, which can be inhaled into the lungs.

INTRODUCED PIGMENTS

The nineteenth century brought a flood of new pigments. Some were invented in the chemistry lab, such as Prussian and phthalo blue. The heavy metals cobalt and cadmium arrived in the early 1800s and soon found their way into paintings.

Most rare or dangerous traditional pigments have been substituted with synthetic formulations. The lapis lazuli of ultramarine was replaced by a chemically identical formulation in the 1820s, allowing it to keep the traditional name for the affordable, lightfast, and useful blue.

COLOR NAMES

To avoid the confusion of common names like "peacock blue," paint manufacturers have adopted an international shorthand for identifying pigments called the Color Index Name. The first letter "P" stands for pigment, followed by a letter such as "B" for the hue, and a number coded to the coloring agent. So ultramarine is known universally as "PB 29." But not all manufacturers are consistent in linking common names to Color Index names, so there's still some confusion when it comes to generic colors like "permanent green."

Some color names, such as "cadmium yellow light" need decoding. "Light" doesn't mean higher in value; it means leaning toward yellow. "Deep" means leaning toward red. The word "hue," when used in a color name, refers to a mixture of at least two different pure pigments, usually to replace an outmoded or costly historical pigment.

BINDERS

The material that holds the finely ground pigment together is called the *binder*. Traditional painters used gums from acacia trees (gum arabic), oil from the lin plant (linseed oil), or protein from chicken eggs (egg tempera). Recent chemistry has offered a variety of replacements, including alkyds (based on soya oils), acrylic resins, and other formulations. The painting at right was made with oil paints together with a compatible alkyd-based medium marketed under the name Liquin, which helps with fine detail.

Note the sign painter standing on a ladder to repaint a shop sign, presumably using one of the modern, lightfast pigments.

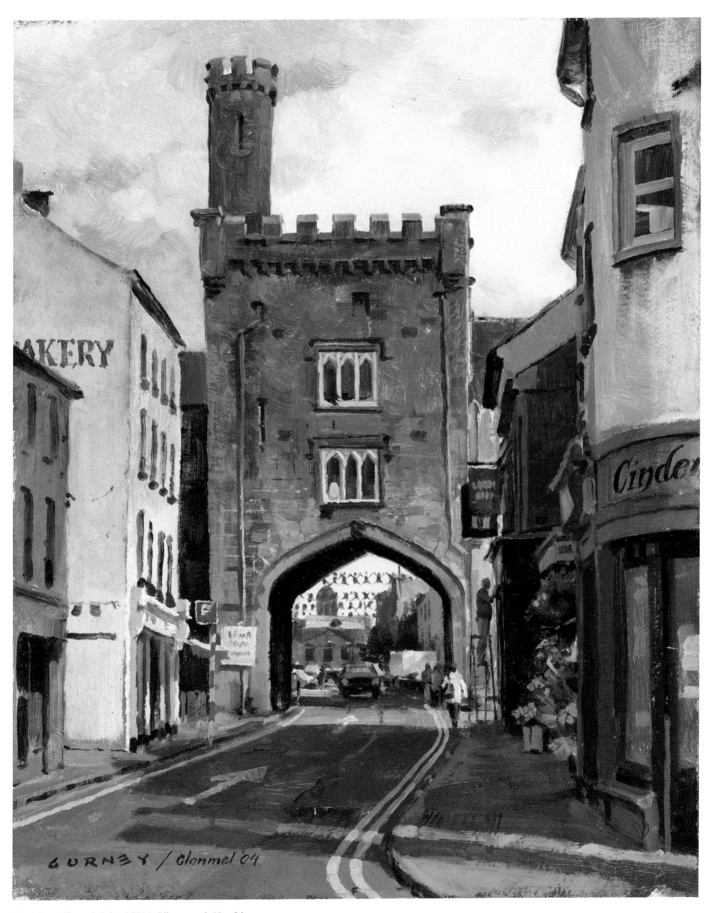

West Gate, Clonmel, Ireland, 2004. Oil on panel, 10 × 8 in.

CHARTING PIGMENTS

Each pigment has the three attributes of hue, value, and chroma. It also has other properties, including transparency, drying time, and compatibility with other pigments. Experience and experimentation are the way to get to know your materials.

Figure 1. Swatches to test undertones and tints in oil for ultramarine blue, Venetian red, and terre verte.

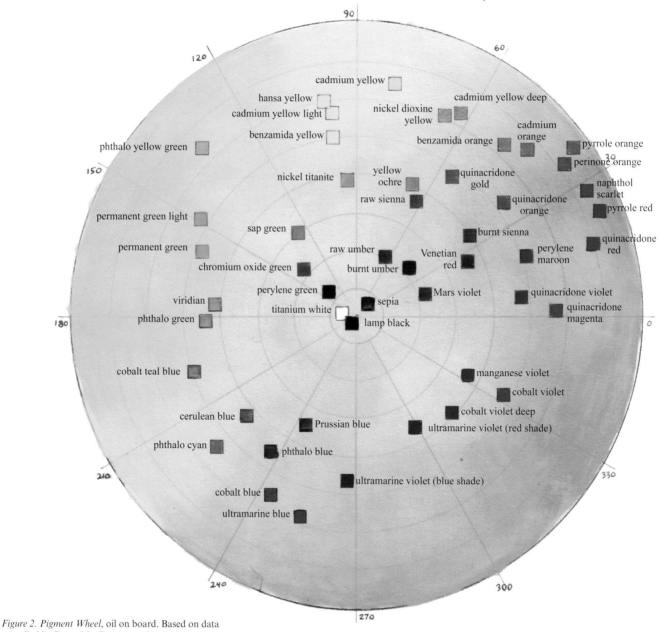

Figure 2. Pigment Wheel, oil on board. Based on data compiled by Bruce MacEvoy, www.handprint.com. Numbers around perimeter reflect CIECAM hue angles.

Every pigment occupies a specific position on the ideal color wheel, a combination of its hue and chroma. The chart, opposite, shows where many familiar pigments would appear. Many fall short of the maximum possible chroma, and there are gaps where no pigments are available.

CONVENIENCE MIXTURES

Some pigments are blended to make recognizable colors such as "mauve." *Convenience mixtures* also fill gaps by offering intermediate mixtures for which no pigment exists, such as phthalo yellow-green. In watercolor, Payne's gray is a blue-black made from black and ultramarine or other blends.

TINTING AND TRANSPARENCY

Tinting strength refers to the ability of a pigment to maintain chroma with the addition of white. Pigments can also be rated according to their transparency or opacity, or covering power. The cadmium red used in the saddle blanket in the painting at right is a very opaque red. A good way to test your paints is to spread a thick layer, called a *masstone*, across a white gessoed surface. Next to that, spread a thin, transparent film, called an *undertone*, with a dark mark on the board behind it to test opacity.

ORGANICS AND INORGANICS

Pigments are divided into *organic* (containing carbon) and *inorganic* (without carbon). Inorganic pigments include such metals as cadmium, cobalt, iron, and zinc. They are more opaque, denser, and generally weaker in tints. Synthetic organic pigments tend to be more transparent, lighter in weight, and higher in tinting strength. Organic pigments tend to hold their purity and brilliance better when mixed with other organics, and they sometimes get murky when mixed with inorganics. You just have to try them out and see how they behave in various combinations.

Alpine Princess, 1982. Oil on panel, 16 × 24 in.

Combination of permanent alizarin crimson and ultramarine blue.

Figure 3. Chart of watercolor pigment combinations. The starting colors, on the diagonal from lower left to upper right, are: Winsor yellow, Winsor red, permanent alizarin crimson, ultramarine blue, cerulean blue, and Winsor green. You'll find each possible mixture at the intersection of a horizontal row and a vertical column. The colors are combined as overlaid washes.

LIGHTFASTNESS

Some colors and some media fare better than others when they sit for a long time in direct sunlight. You can protect your artwork from fading by using pigments with good permanence ratings and by keeping it out of strong light.

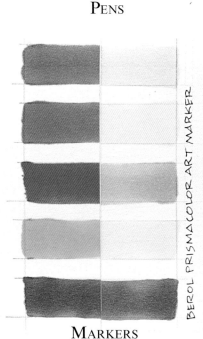

PENS

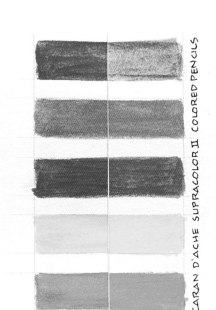

COLORED PENCIL

CARAN D'ACHE SUPRACOLOR II COLORED PENCILS

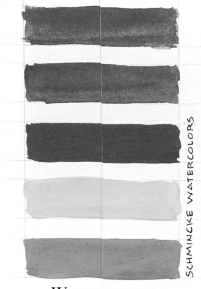

WATERCOLOR

SCHMINCKE WATERCOLORS

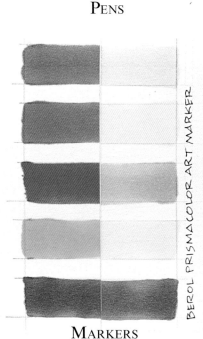

MARKERS

BEROL PRISMACOLOR ART MARKER

Lightfastness is the resistance of a given pigment to fading as a result of exposure to light. Blue jeans, tattoos, leather stains, and house paint will all fade—and so will some of your paints.

The color strips on this page give a sense of how different media and different colors can change, while others stay remarkably stable. Each strip was cut in half after it was painted. For about eight months, one half of the strip stayed in a dark, cool drawer, and the other half faced the sun in a south window.

WHY DO COLORS FADE?
The reason colors fade is that the colorant molecules break down when they are exposed to light, especially to the shorter wavelengths of ultraviolet light, which pack more energy. UV light

breaks the chainlike color molecules into pieces, like a hammer smashing a necklace. The molecular fragments bond with oxygen to form new molecules that no longer have the same color-absorption properties.

Some pigments are stable enough to withstand the ravages of light. The iron oxides and the heavy metals such as cobalt and cadmium are composed of solid particles of material unaffected by UV light.

DYES
Dyes differ from pigments because they dissolve easily in the vehicle or they are liquids themselves. They are used in markers because their solubility helps them disperse through the felt tip by means of capillary action.

Many dyes are susceptible to fading. The molecules in older synthetic aniline dyes were especially *fugitive,* or susceptible to fading. In the test strip on the opposite page, the violet color completely disappeared. However, recent technological advances have improved dyes. Many now use micronized pigments rather than the more vulnerable synthetic anilines.

In the test swatches at the far right, highlighter markers fared very poorly. Fluorescent highlighters use relatively unstable colorants that convert invisible UV light into light that you can see. The conversion of UV to visible light is why a yellow highlighter stripe can be lighter than the white of the paper. But the effect lasts only as long as the molecules hang together.

Which Colors Should Be Avoided?

The industry standards for light-fastness have been established by the American Society for Testing Materials (ASTM). The ratings range from Class I (very lightfast) to Class V (very fugitive).

Alizarin crimson (PR 83), for example, has been a popular pigment in many art media since it was first

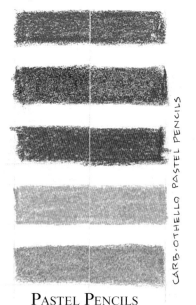

PASTEL PENCILS

synthesized in 1868. But it has received an ASTM rating of III or IV, and will eventually fade out of any painting that is exposed to the light. There are several replacements, which nearly match alizarin crimson's hue and transparency. They tend to come from the quinacridone, pyrrole, or perylene families, and include such numbers as PR 202, PR 206, PR 264 and PV 19.

As you can see from the marker and dye swatches, the yellows, magentas, and violets tend to be more fugitive than other colors. But it depends on each individual pigment. The quinacridone family of reds were developed for the automotive industry, which needs pigments that can stand up to years of brutal exposure to the sun. Pyrrole red, also called Ferrari red for its use

on sports cars, is the same bright and reliable pigment in the oil paint called Winsor red.

What Does "Permanent" Mean?

The word "permanent" appears on many different art products, but it's a confusing term. On some graphic art products, such as inks or felt-tipped markers, it really means "waterproof,"

OIL

rather than "lightfast." Many calligraphy or fountain pen inks, such as the brown inks at right, are not waterproof, but they're reasonably lightfast, considering that most handwriting isn't usually subjected to light for long periods.

Safeguards

To be sure your art will last as long as possible without fading:

1. Buy paints that have ASTM ratings of II or I. If they don't show ratings, assume they're not lightfast.

2. Keep art in a dark place, such as a drawer or a dark hallway.

3. Use UV-filtered glass.

4. Don't hang it in direct sunlight.

HIGHLIGHTER PENS

DYES

FOUNTAIN PEN INKS

WARM UNDERPAINTING

Instead of beginning a painting on a white canvas, there are several reasons why artists pre-tone the surface before painting in opaque media. This initial color is called the underpainting or imprimatura.

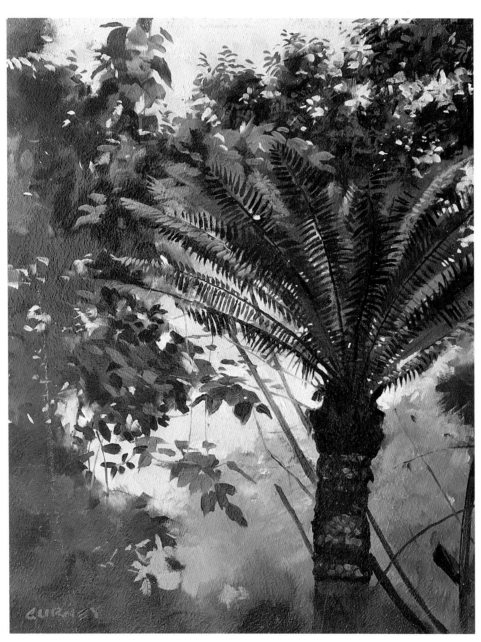

Arboretum, 1982. Oil on panel, 10 × 8 in.

If you prime your panels with a tint or a transparent undertone of Venetian red or burnt sienna, you can get a good base for many kinds of paintings. All of the paintings here were begun in this way.

An insistent warm underpainting will force you to cover the background with opaques, thereby requiring you to make mixing decisions. It is especially helpful for paintings of skies or foliage, or any painting with a blue or green tonality. The little bits of color that peek through the strokes will make blues or greens sparkle by complementary contrast.

For plein-air painting you might want to prime the canvas or panel with oil priming. Oil priming is different from acrylic gesso because it makes the final paint layers tend to float on the surface, rather than sink in. Both kinds of priming are equally valid; try them both and see which suits you better.

You can buy oil priming in a quart tin, and mix up a tint using a palette knife on a scrap of palette paper. If you're preparing for a painting trip, you can use a drop or two of an accelerant like cobalt drier the night before. This will allow you to set up the priming overnight.

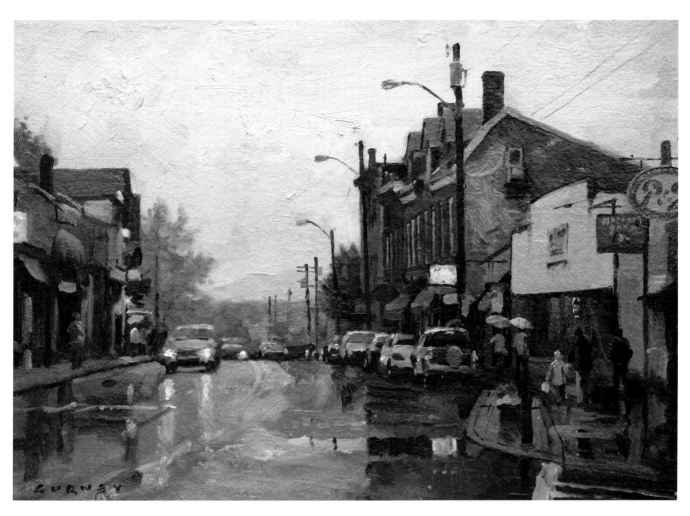

Top: New Paltz in the Rain, 2005. Oil on canvas mounted to panel, 11 × 14 in.

Bottom: Descent, 2006. Oil on board, 8 × 13½ in. Published in *Dinotopia: Journey to Chandara.*

Sky Panels

A *sky panel* is a surface prepared with a sky gradation as a base layer for future painting. Painters before the advent of impressionism would typically paint a sky first, let it dry, and then paint the trees, clouds, and other elements over dry passages.

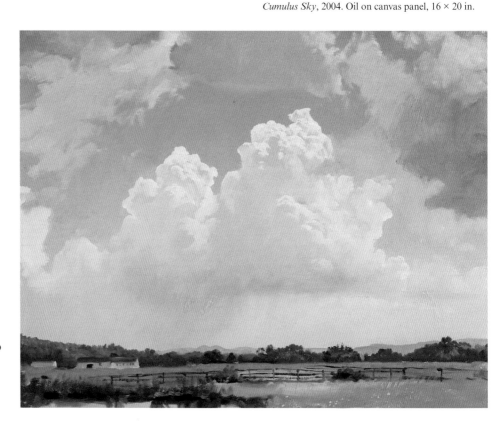

Cumulus Sky, 2004. Oil on canvas panel, 16 × 20 in.

We take it for granted that all landscape painting in oil should be undertaken *alla prima*, that is, starting with a blank canvas and completing the entire statement in one session, keeping all the adjacent areas wet together.

Alla prima is an excellent method if you want a soft, painterly handling, but it can be unsuitable for describing intricate details against a light sky, because the wet paint of the sky interferes with the dark strokes placed on top.

Painters before the nineteenth century generally didn't paint alla prima, at least not in the studio. They usually rendered the details over a dry sky. The tree study, opposite, was done in this way. The sky was painted first in the studio, allowed to dry, and then brought into the field.

Sky panels are useful in situations where your chief interest is the complex middle-ground tracery: road signs, telephone poles, sailing ships, trees, or intricate cloud formations.

Norrie Park, 2004. Oil on panel, 8 × 10 in.

The cloud study, above, was painted over a prepared cloud-free sky panel. Before starting the painting session, the board was first *oiled out*. Oiling out is like greasing a cookie sheet. Rubbing the surface of a dry painting with a thin layer of medium makes it more receptive to paint. You can then paint the details of trees or foliage without any danger of the sky color lifting up and mixing with the dark colors of the branches or leaves.

Since clear skies are fairly standard and predictable, you can create a range of different sky panels a few days in advance of an outdoor painting session and let them dry completely. If you don't remember or can't anticipate which colors to use for the sky gradation, spend a couple of sessions just painting a variety of clear skies from observation and keep those color notes available for when you prime new sky panels.

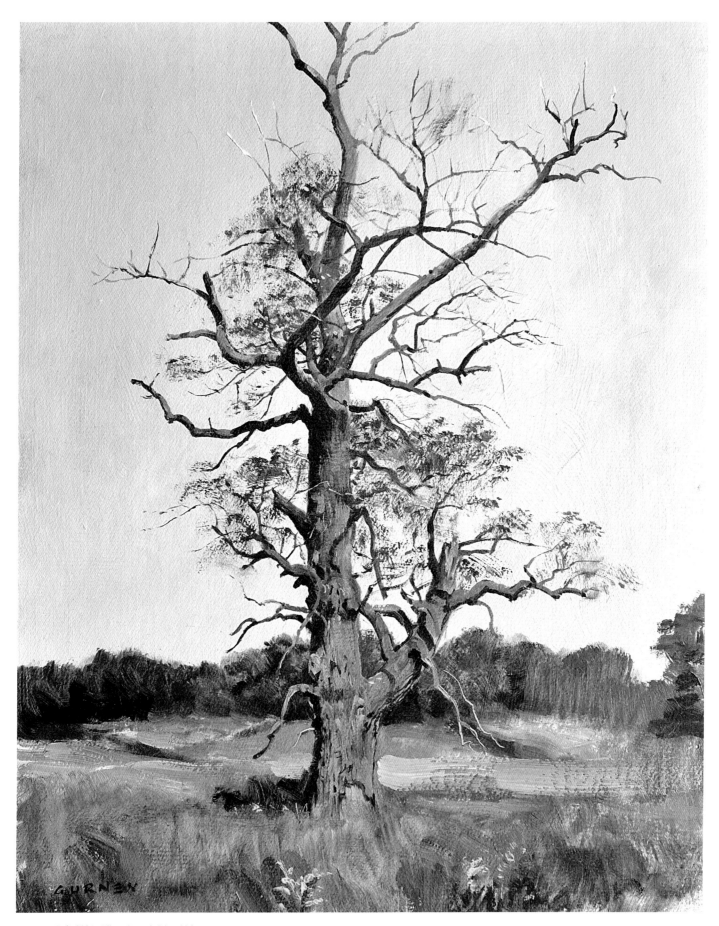

Ancient Oak, 2004. Oil on board, 14 × 11 in.

TRANSPARENCY AND GLAZING

Paint that is transparent allows light to pass through it. The light travels though the paint layer, reflects off the white surface underneath, and travels to the eye of the beholder with some of the wavelengths absorbed.

Store your watercolors in jars to keep them from drying out.

TRANSPARENT PAINTING

Most kinds of paints include some pigments that are opaque—that is, they obstruct the passage of light—and some that are transparent. These transparent pigments act like stained-glass windows. They filter out some of the wavelengths of light that pass through them, sending back the wavelengths that yield their characteristic colors.

Transparent paints are usually applied to a white ground, the whiter the better. The brilliance of the colors depends on the amount of light that is able to bounce off the surface. The value or lightness of the color is controlled by the thickness or density of the paint layer.

Grays and intermediate mixtures can be produced in several ways. One way is to blend complementary colors on the palette and apply the mixture directly. Another way is to paint complements on top of each other, allowing the light to pass through both paint layers. A blue layer and a magenta layer will yield violet when superimposed.

GLAZING

A *glaze* is a transparent layer applied to an existing dry passage of paint, usually to intensify, deepen, unify, or otherwise change the color. A blue sky or a red cheek can be made richer by glazing. The glaze is distributed in a transparent medium.

Above: Dinosaur Nanny, 1991. Oil on board, 14 × 14 in. Published in *Dinotopia: A Land Apart from Time*.

Left: Sousse Harbor, 2008. Watercolor, 4¼ × 7½ in.

Opposite: Maison d'Ailleurs, 2003. Watercolor, 7 × 5 in.

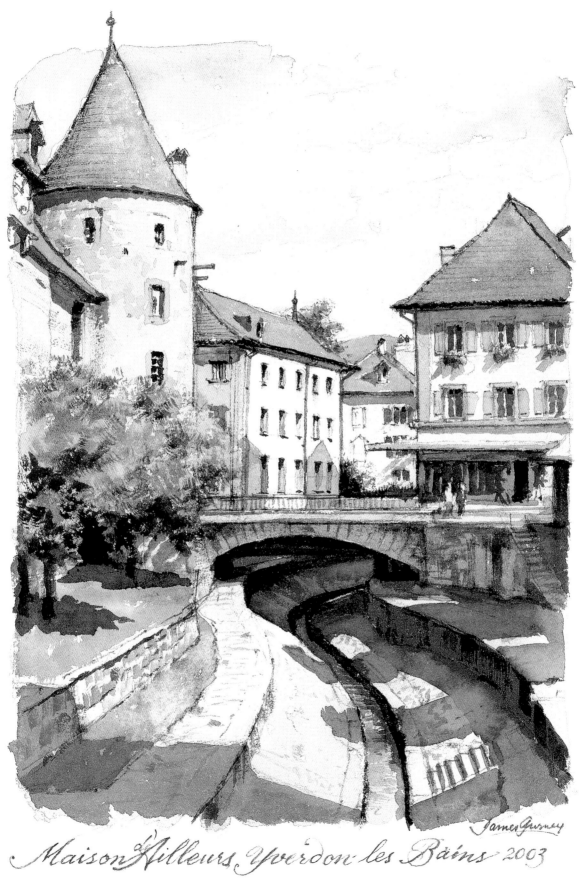

Maison d'Ailleurs, Yverdon les Bains 2003

James Gurney

PALETTE ARRANGEMENTS

When you prepare a palette of colors, you have three big choices to make: the surface (glass, wood, or paper), the colors (large or limited assortment), and the arrangement (warm to cool or light to dark).

THE HISTORY

In the Middle Ages, artists kept their paint in shallow containers like shells or saucers. The first reference to a mixing palette was from an account by the Duke of Burgundy in the 1460s, where he described "trenchers of wood for painters to put oil colors on and to hold them in the hand." Palettes were often set up by assistants, which helped standardize the procedure for laying out the colors. The practice of mixing colors on a palette was common in the early 1500s. By 1630 it was a lively topic. Vasari said that Lorenzo di Credi "made on his palette a great number of color mixtures."

References to palette knives show up around 1650. Elaborate premixed tints became a common practice by the late 1600s. During the next century artists more frequently used a "loaded" or premixed palette with fully developed gradations of tints and variations. A Swiss painter's manual in the 1820s compared the gradations on the palette to the notes of a piano keyboard. James McNeill Whistler was said to spend an hour preparing his mixtures. Eugène Delacroix's assistant reported that it sometimes took days to set up his master's palette.

THE SURFACE

Many oil painters use a tabletop- or taboret-mounted palette. The taboret palette, below right, is mounted on a hinged surface that can tip up to any angle. The tube colors are squeezed out on a color bar, a piece of plywood along the left edge. The paint is mixed on white plastic-coated freezer paper, which hangs on a roll behind the color bar.

Some studio painters prefer to mix on a plate-glass surface. As the palette fills up with blended paint, it can be scraped off with a razor blade. White or gray paper placed behind the glass provides a background for judging mixtures.

Instead of mounting the palette on a table, you can carry one in your non-painting hand. The traditional material is wood, typically a walnut plywood. A wooden palette develops a wonderful patina from the oil and the bits of color that remain after years of service.

THE COLORS

The word *palette* refers not only to the mixing surface, but also to the full range of tube colors available for a given painting. A full palette might include as few as a dozen or as many as twenty or even thirty colors. It can be a challenge

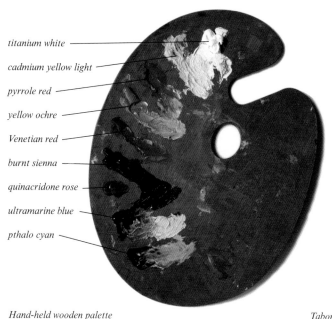

titanium white
cadmium yellow light
pyrrole red
yellow ochre
Venetian red
burnt sienna
quinacridone rose
ultramarine blue
pthalo cyan

Hand-held wooden palette

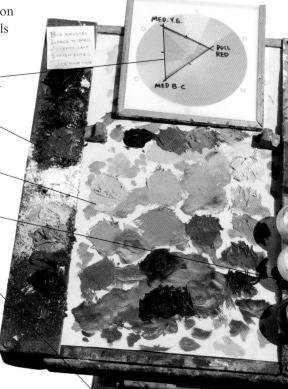

MED. Y.G.

PULL RED

MED B.C

Color wheel with gamut mask to define color range.

Tube colors on a piece of ¼-inch plywood.

Mixing surface of plastic-coated freezer paper, which sits behind plywood.

Palette cups containing odorless turpentine and alkyd painting medium.

Mounted to the top of a taboret with door hinges and a friction lid support (not visible) so that it can tip upward to any angle.

Taboret-mounted palette

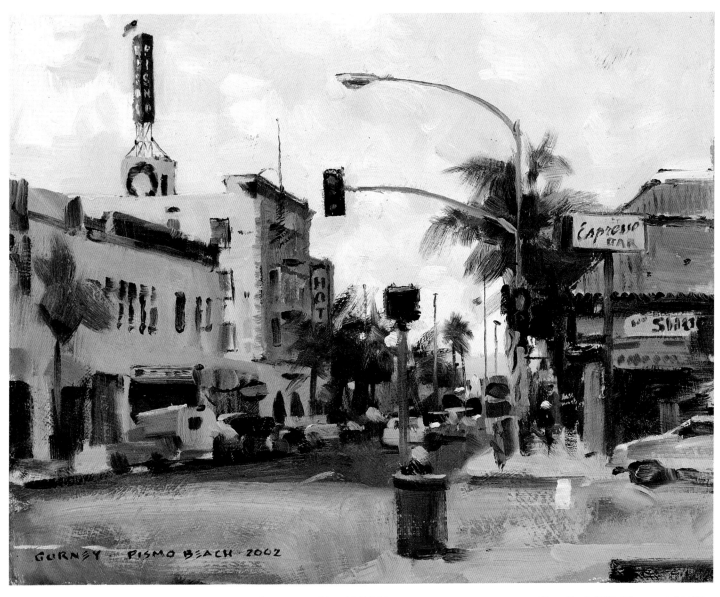

Pismo Beach, 2002. Oil on panel, 8 × 10 in.

to keep such a large orchestra under control. For experienced painters, a large palette offers shortcuts and conveniences. But for beginning painters, it's better to start off with a small number of pigments and to learn each of their properties and their combinations. Here's a manageable list:

Titanium white (PW 6)
Cadmium yellow light (PY 35)
Yellow ochre (PY 43)
Burnt sienna (PBr 7)
Venetian red (PR 101)
Pyrrole red (PR 254)
Quinacridone rose (PV 19)
Ultramarine blue (PB 29)
Pthalo cyan (PB 17)

THE ARRANGEMENT

The traditional way to lay out a hand held palette is to squeeze out some paint on the outer edge, away from the body. The light, warm colors go at the top, that is, near the thumb hole, with the darker and cooler colors away from the thumb.

On the taboret palette at left, the cool colors are grouped above the white, and the warm colors, descending from yellow, below it. On a rectangular plein-air palette, you can put white in the corner, with warm colors across the top and cool colors down the side.

LIMITED PALETTES

Going on a color diet can keep your color schemes lean and strong. A *limited palette* (also called a restricted palette) is a small selection of pigments, often resulting in a painting with a more unified or harmonious effect.

More colors don't make a better color scheme. In fact the opposite is usually true. Instead of stocking the palette with a wide range of intensely chromatic colors, it's often effective to limit the range of pigments that you use on any particular painting. There are at least three good reasons to limit your palette.

1. Paintings from limited palettes are more harmonious. Old masters used limited palettes by default because they just couldn't get the range of pigments we have now.

2. A limited palette forces you out of color-mixing habits. If you don't have a color called "grass green," you'll have to mix it from scratch, and you're more likely to get the right green that way.

3. Limited palettes are compact, portable, and sufficient for almost any subject. In fact you can paint almost anything in nature with just four or five colors.

The painting below was done at a sketch group using:

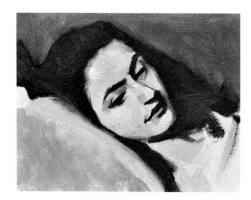

Blue Girl. Oil on board, 6 × 8 in.

Titanium white (PW 6)
Ultramarine blue (PB 29)
Burnt sienna (PBr 7)

Here's a vibrant two-color combination:
Phthalo blue (PB 15)
Perinone orange (PO 43)

The dinosaur, right, is a transparent oil wash over a pencil drawing, using:
Raw umber (PBr 7)
Burnt sienna (PBr 7)
Cobalt blue (PB 28)

The following colors can mix a wide range of colors in oil and watercolor. This palette meets the needs of a compact plein-air set up:
Titanium white (PW 6)
Cadmium yellow light (PY 35)
Pyrrole red (PR 254)
Permanent alizarin crimson (PR 202, PR 206, or PV 19)
Burnt sienna (PBr 7)
Ultramarine blue (PB 29)
Viridian (PG 18)

Sometimes it's fun to jettison even more colors from this already spartan palette. The painting of the shop fronts (opposite) takes away three colors, leaving:
Titanium white (PW 6)
Pyrrole red (PR 254)
Ultramarine blue (PB 29)
Burnt sienna (PBr 7)

A landscape palette doesn't need too much chromatic firepower, unless you're painting flowers or sunsets. The following four will give you pleasing muted harmonies, good for a lay-in:
Titanium white (PW 6)
Venetian red (PR 101)
Yellow ochre (PY 43)
Ultramarine blue (PB 29)

For figure painting in the studio, you can get by with the palette that served old masters from Rembrandt van Rijn to Anders Zorn:
Titanium white (PW 6)
Yellow ochre (PY 43)
Cadmium scarlet (PR 108)
Ivory black (PB 9)

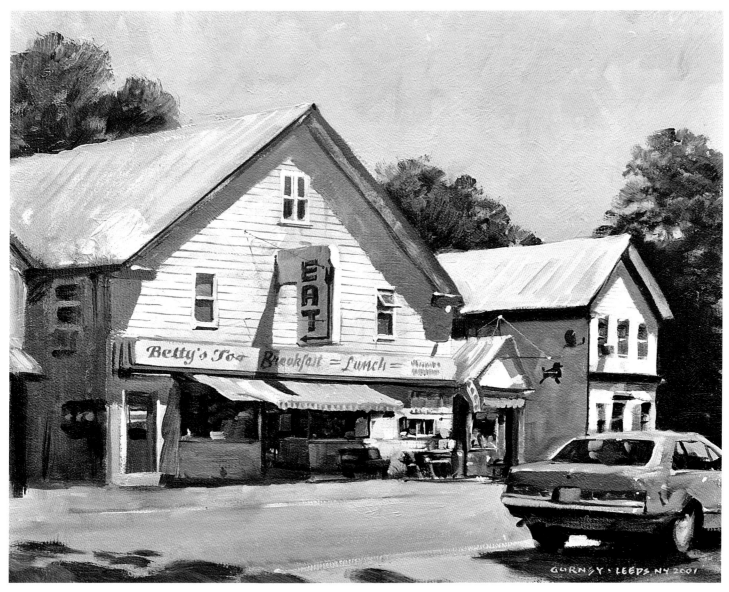

You can make color wheel tests to preview the range of possibilities with limited palettes. The color wheels at right were created with only three or four colors each, plus white.

It's often a good idea to pick one full-chroma color and combine it with two weaker colors from across the center of the spectrum. A lower chroma pigment like yellow ochre instead of cadmium yellow corresponds with a point well inside the margin of the color wheel. You can also experiment with combinations of transparent and opaque colors.

Above: Leeds, N.Y., 2001. Oil on board, 11 × 14 in.

Below: Limited Palettes, 2000. Oil on board, each 5 inches across.

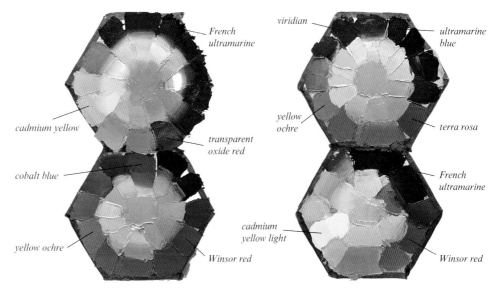

French ultramarine

cadmium yellow

transparent oxide red

cobalt blue

yellow ochre

Winsor red

viridian

ultramarine blue

yellow ochre

terra rosa

French ultramarine

cadmium yellow light

Winsor red

THE MUD DEBATE

Is there such a thing as a muddy color? There are two different schools of thought on this issue, with great painters and teachers on both sides of the fence. Try both ideas on for size and see which yields the best results for you.

THE "BEWARE OF MUD" SCHOOL

Some watercolorists use only primary pigments laid over each other transparently to achieve all other colors. They use no browns, blacks, or grays at all, and never blend the colors on the palette.

Some oil painters are wary of overmixing to avoid colors that look "dead" or "dirty." In his 1903 book, *The Painter in Oil,* Daniel Parkhurst, a student of Bouguereau, wrote: "Overmixing makes color muddy sometimes, especially when more than three colors are used. When you don't get the right tint with three colors, the chances are that you have got the wrong three. If that is not so, and you must add a fourth, do so with some thoughtfulness, or you will have to mix the tint again." Partially mixed colors, he says, are more apt to yield harmonious variations in the final painting. He goes on to recommend that the artist keep the palette scrupulously clean and use a lot of brushes.

THE "MUD IS A MYTH" SCHOOL

On the other hand, there's a group of equally sensitive colorists who argue that there's no such thing as a muddy color mixture: There are only muddy relationships of color in a given composition.

A given color either looks right in its pictorial context or it doesn't. The effect of drabness or dullness comes from poor value organization more than from bad mixtures or bad mixing practices. "Give me some mud," said Eugène Delacroix, "and I will make of it the skin of Venus, if you leave to me the choice of the surroundings."

Figure 1. Three colors blended into a warm gray, or "mud."

Some painters scrape up unused paint on the palette, stir it together into a generalized gray, and put it into empty paint tubes. They use these tubes of mud, or sauce, as they call it, for mixing a medium-value color and for reducing the chroma of mixtures.

These artists point out that a given gray or brown can be mixed from many different constituent colors. An identically appearing neutral gray can be blended from red and green, or from blue and orange, or from all the colors on the palette. It really doesn't matter how you arrive at a given mixture. What matters is where you put it and what you surround it with.

According to this view, you don't necessarily have to wash your brush all the time or use a lot of different brushes unless the painting calls for intense tints. A dirty brush is infused with unifying grays that can add mellowness to a picture and tie it together.

Both schools of thought have good advice to offer. The beware-of-muddists are right in advocating practices that lead to efficient mixing. Grays come to life if they're made of partial mixtures, where some brushstrokes still have some component hues visible. Having to mix grays and browns from more chromatic ingredients makes an artist much more conscious of the particular color note needed for a certain shadow or a skin tone. But one must resist the tendency to see grays or browns as dirty, because they're not: They're the chef's sauce of the picture.

More paintings suffer from the "fruit salad disease" of too much pure color

Humboldt on the Orinoco, 1985. Oil on canvas mounted to panel, 21 × 27½ in.
Published in *National Geographic* magazine, September, 1985.

rather than from murky mud. The cure for either problem is good value organization, in other words, good planning before the final colors are mixed. You can't go wrong with a simple color scheme, with perhaps one strong chromatic color, such as the scarlet of the spoonbills, above, supported and opposed by a range of neutrals and complements, in this case, gray-greens and browns. A well-placed gray makes pure color sing.

COLOR RELATIONSHIPS

MONOCHROMATIC SCHEMES

A *monochromatic* color scheme is composed of any single hue taken through a range of value or chroma. There is a long tradition for artwork made only in grayish, brownish, or bluish tones.

Any drawing tool, such as a pencil or a stick of Conté crayon, automatically makes a monochromatic image. Painters have rendered figures or scenes in *grisaille*, which literally means in gray. Grisaille painting was most often used as a preliminary step to plan the tonal values, or as a part of the process in painting, before the colors were overlaid in transparent glazes.

But apart from those exceptions, most painting through history has been created in full color. The nineteenth and early twentieth centuries saw the invention of several image-making technologies, including photography, halftone printing, motion pictures, and television, all of which began in black and white. It wasn't until well into the twentieth century before these media changed to full color. The *New York Times* didn't run a color photo on its front page until 1997.

As a result, people living through the early part of the last century got accustomed to seeing the world interpreted in black and white or sepia tones. Now, of course, full color is universal, and black and white has become an artistic choice rather than an economic one. Monochromatic schemes often draw attention for their very uniqueness and understatement. In today's graphic novels or illustrated books, monochromatic schemes immediately suggest historical photos, as in these examples, where they're meant to lend credibility to the imaginary world of Dinotopia. In full-color comics, flashback sequences are often presented in sepia.

To create a monochromatic scheme with dry media or transparent paint such as watercolor, all you need is one tool or pigment. For opaque paints, you can prepare your palette by mixing the dominant color into a scale of grays.

Will and Arthur, 1990. Oil on board, 7 × 5 in. Published in *Dinotopia: A Land Apart from Time.*

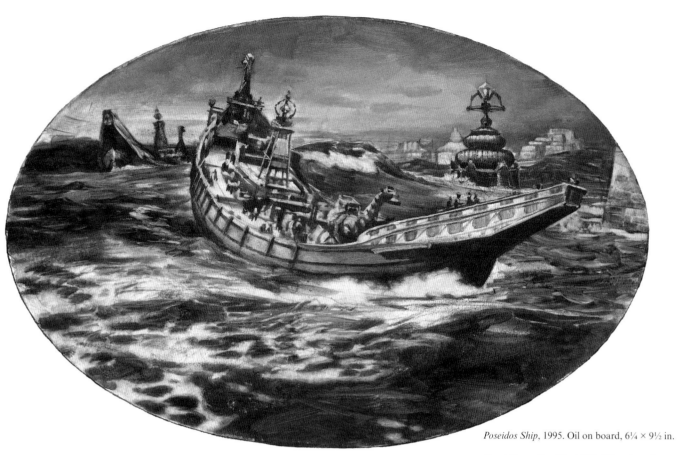

Poseidos Ship, 1995. Oil on board, 6¼ × 9½ in.

Street Scene, Poseidos, 1995. Oil on board,
6¼ × 9½ in.
Both published in *Dinotopia: The World Beneath.*

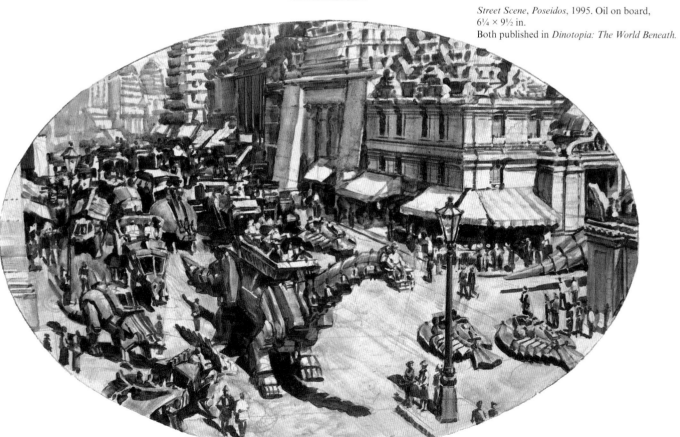

Warm and Cool

You can't measure the temperature of a color with a thermometer. The idea of warm and cool color is all in our minds, but the effect of color temperature on the viewer is real anyway.

Below: Ebulon at Twilight, 2006. Oil on board, 11 × 18 in. Published in Dinotopia: Journey to Chandara.

Opposite above: Ancient Mountain Mammals, 1991. Oil on board, 13 × 15 in. Published in Dinotopia: A Land Apart from Time.

Opposite below: Montreal, 2001. Watercolor, 5 × 7½ in.

Warm colors

Cool colors

Let's take the color wheel and chop it in half. On the top half are all the warm colors, ranging from yellow-greens to oranges and reds. On the bottom half are the cool colors: blue-greens, blues, and violets.

Someone might argue about where to divide the wheel. The greens and violets seem to have divided loyalties. But if you consider the heads of the families, blue and orange, there seems to be some basic psychological difference between them.

The cool colors seem to evoke feelings of winter, night, sky, shadow, sleep, and ice. The color blue suggests quietness, restfulness, and calm. Warm colors make us think of fire, hot spices, and blood. They connote energy and passion. Orange and yellow are ephemeral colors. We see them fleetingly in nature: in sunsets, flowers, or autumn leaves.

Origins of Color Terms

This basic perception of the two families of color seems to be woven into the fabric of our human existence. The anthropologists Paul Kay and Brent Berlin have studied the evolution of color terms in languages around the world. In European languages we have

about eleven or twelve basic terms to describe colors.

But some so-called primitive languages, like the New Guinean language Dani, have only two basic terms. Kay and Berlin wrote: "One of the two encompasses black, green, blue, and other 'cool' colors; the other encompasses white, red, yellow and other 'warm' colors." Primitive peoples didn't have poor vision—far from it. Rather, anthropologists suggest that as language evolved, it developed its first word concepts around the most psychologically important groupings.

How Artists Use the Terms

Artists mean different things when they speak of color as warm or cool. A swatch of paint standing alone can be described as either a warm color or a cool color. Alternately, some artists

use color temperature more as a relative concept to distinguish two closely related colors. A green mixed with more yellow might be regarded as warmer than a green that leans more toward blue-green. This relative approach to assigning color temperature can be confusing when someone is talking about blue, which could be made warmer with the addition of either red or yellow.

How to Use Warms and Cools

You can create a whole painting using the cool family of colors if you want to suggest mystery, darkness, or gloom. But you can also develop interest by placing warm color notes adjacent to cool ones.

The painting of the seated colossus above uses an overall golden tonality to suggest the exotic romance of the desert. The cool blue-green note along the horizon keeps the composition from

Place Jacques-Cartier Montreal, Québec James Gurney

becoming tiresome or monotonous. That color also appears on the top of the sky, and on the upfacing planes on the shadow side.

Warm and cool colors can be used to complement each other in very grayed-down ranges of browns and blue-grays. This quick sketch of Montreal at left was made on location using sepia and lampblack watercolor. The painting above does the same thing in oil, with warm colors for the foreground, and cooler colors farther back.

COLORED LIGHT INTERACTIONS

When two different colored lights shine on a form, the lit areas mix to create a new color. These mixtures of light behave a little differently from pigment mixtures. It's called *additive color mixing* because one light is added to another.

ADDITIVE COLOR MIXING

In the oil sketch of a white head maquette, left, a light modified with an amber *gel*, or color filter, shines from below left, while a blue light comes from almost the opposite angle.

There's almost no overlap between the regions lit by each of the lights. One light or the other covers almost every surface of the head. There are just a couple of small places untouched by either light: the dark area where the nose meets the eye socket, and the hollows above and below the ear.

Two colored lights illuminate the maquette below. One is yellow-green and the other is magenta. The lights are placed closer together so the illuminated areas overlap on the top of the head, the brow, and the cheekbone plane. In these shared areas, the colors mix to a pale yellow color, brighter in tone than the lightest tones in each of the two regions that are lit by one light only.

Additive mixing is the blending of color in the eye rather than in pigments. It occurs when colored lights are blended, or when a disk painted half in blue and half in yellow is spun at a high speed.

Unlike the subtractive color mixing of pigments or gels, the mixture results in a blended area with a higher value than either light can give alone. The resulting hues of additive mixtures differ, too. Green and red light mix to make yellow. In pigments they'd mix to a dull brown or gray.

COMPLEMENTARY SHADOW COLORS

In the large painting above, a warm

Studies of Plaster Heads, 1980s. Oil on panel, each 5 × 5 in.

light from below and to the left of the observer shines up at the figures. Meanwhile, there's a bluish light that shines toward us from the open doorway, lighting the edges of the figures and also casting shadows toward us.

Since the cast shadows on the floor are only receiving the direct illumination of the warm light, they take on a decidedly warm cast. If you have two light sources of different colors shining on the same form, the cast shadow from each light source will be the color of the other source.

Arthur in Sauropolis, 2006. Oil on board, 10½ × 18 in. Published in *Dinotopia: Journey to Chandara*.

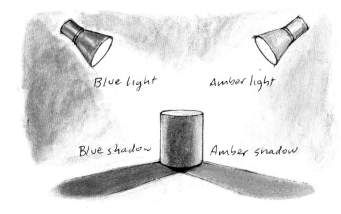

The cast shadow from each colored light source is the color of the other source.

TRIADS

A *triadic scheme* is composed of any three basic colors, but not necessarily full-chroma colors. For example, the painting below is built mainly from cool reds, blue-greens, and dull yellows.

Figure 1. Triad swatches with intermediate mixtures.

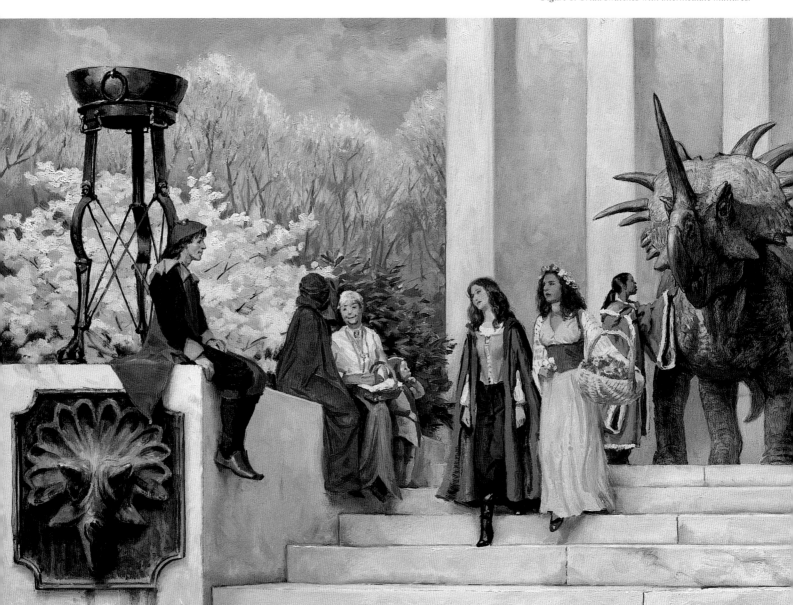

Saurian Steps, 2006. Oil on board, 16 × 34 in. Published in *Dinotopia: Journey to Chandara*.

To build a triadic color scheme, begin by choosing three colors. They could be red, yellow, and blue. Or they could be something like cyan, magenta, and yellow. Or they could be any other three colors. They don't have to be tube colors. You can mix any pigments to get your starting points. Perhaps two are full chroma, and the third is somewhat muted. Whatever they are, think of them as the three instruments of your musical trio: guitar, keyboard, and flute, let's say.

You want to do as much as possible with those three musical instruments.

In the case of the painting below, the three starting colors are blue-green, cool red, and dull ochre. Each one of those colors goes through a whole set of variations in the picture. The blue-greens appear in light tints, in dark bronzy colors, and in bright foliage. There are brownish reds, bright pinks, and dark maroons. The gold colors turn up in the sunlit trees, in the girl's vest, the

man's jacket, and on the lute and harp. Each of the three colors appears in a full range of shades (mixed with black), tones (mixed with gray), tints, and intermediate mixtures.

There are a few touches of other colors that slipped into the scheme—a bright orange under the sun standard, for example—but the goal was to keep those other hues out.

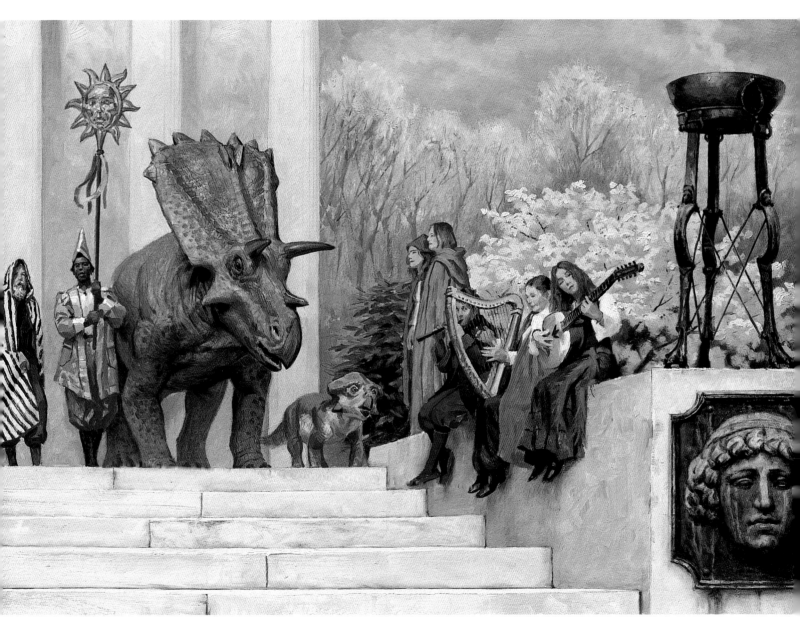

COLOR ACCENT

You can spice up a black-and-white sketch or a gray painting with a little dash of color. An accent attracts the eye to the center of interest.

A *color accent* is any small area of color that is noticeably different from the rest of the colors in the composition.

In the sketch above of a corner market in Rincon, Puerto Rico, the yellow touches in the fire hydrant and the escuela sign give a welcome change from the grayness of the pencil and ink wash. In the larger painting, the yellow speeding vehicle stands out from the background of the gray harbor.

Color accents are usually a complement or near complement, and usually more highly chromatic than the rest of the picture. If you restrict the entire image to something close to a monochromatic scheme, anything different will jump out and grab the viewer's attention. In the context of a forest scene, for example, a red shirt will rivet our attention.

Color accents don't have to be used only for the main focus of interest. They can also be added as a seasoning throughout a picture, to provide relief from large areas of unrelieved hues. If you have a picture with a strong purple cast, it can help to sneak in a little yellow or orange here and there—just a set of floating dots or an outline, or a weird reflection in a window. This becomes a matter of taste and of momentary inspiration, keeping your color scheme from being too mechanical or predictable.

118

Above: Escape from Poseidos, 1998. Oil on panel, 13 × 28 in. Published in *Dinotopia: First Flight.*

Opposite: Rincón, 1992. Pencil, 8 × 11 in.

PREMIXING

MIXING COLOR STRINGS

A *color string* is a group of prepared paint blobs of a given hue mixed with a palette knife in a set of steps from light to dark values. A big advantage of premixing color strings is that it saves time when you're painting observationally.

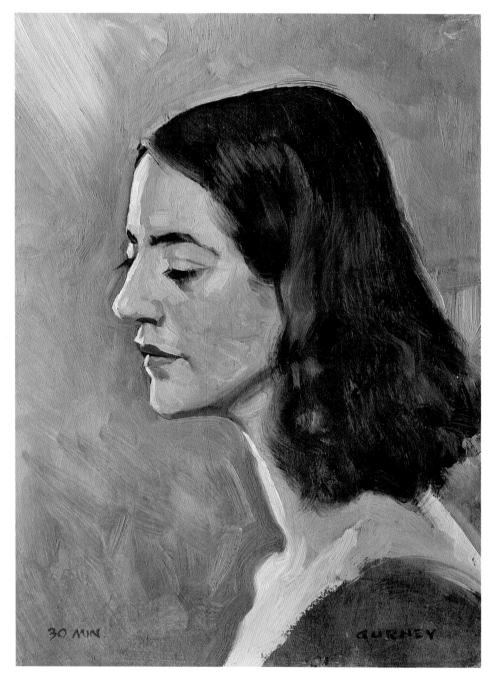

Sketch Group Study, 1996. Oil on board, 12 × 9 in.

Each stroke of paint that you apply to a given painting is almost always blended on the palette from the raw tube colors before it can be used in your composition. Your palette-mixing strategies have a lot of influence over your final painting.

FREE MIXING AND PREMIXING

There are two basic approaches: *free mixing*, where you use the brush to mix each new stroke from the tube colors, and *premixing*, where batches of colors are prepared in advance.

Premixed color doesn't mean using tubes of some standardized flesh color, or cooking up preconceived colors in the studio. Rather, it means colors that are carefully mixed from observation at the outset of a given painting session.

The portrait at left was painted from a premixed palette prepared at the beginning of a three-hour sketch session. The premixed colors matched this particular model and this particular lighting condition. I mixed strings for four separate color groups: the hair, the skin tone in the key light, the skin in the cool edge light, and a loosely mixed range of grays for the background. I spent the first thirty-minute session premixing. With this preparation completed, it was possible to paint a complete portrait in each of the remaining thirty-minute sessions.

ADVANTAGES OF PREMIXING

1. Premixing uses less palette surface area than does free mixing. The colors for the painting of the mountain hotel, opposite, were mixed entirely on a single 9 × 12-inch sheet of palette paper, with

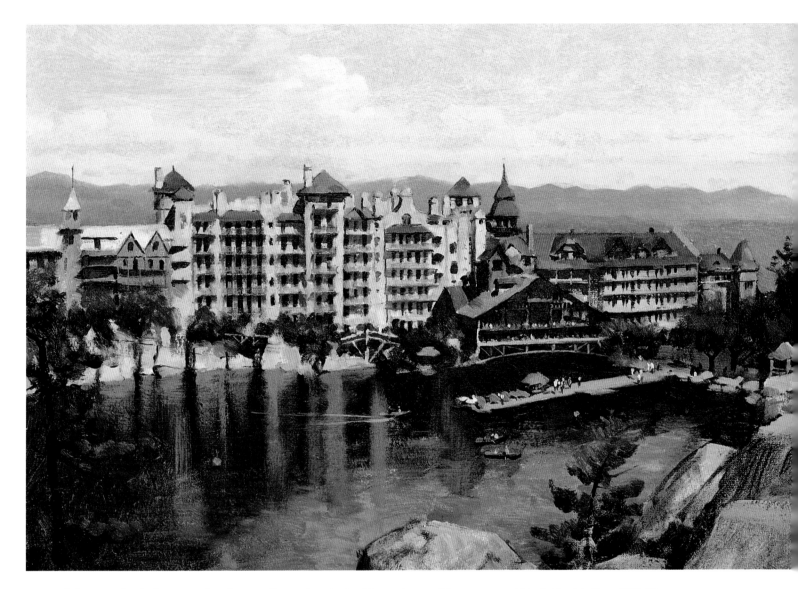

no need for scraping it down or cleaning it midway through.

2. You can premix generous batches with a palette knife instead of using the brush both for mixing and paint application, which can lead to skimpy mixtures.

3. Premixing saves time in the long run because you don't need to waste precious minutes repeating the same mixtures over and over again.

THE REILLY METHOD

One of the proponents of premixing was the Art Students League instructor, Frank Reilly. He is known today mainly from the teachings and artworks of his students. Mr. Reilly had his students mix several color strings for each painting, and he recommended ten tonal steps for each principal hue, along with a corresponding scale of grays.

Ten value steps are more than you really need for most paintings. Mixing four or five steps gives you plenty of control for intermediate values. Two or three steps in the light, and two steps in the shadow for a given hue are plenty, because you can blend anything between those steps.

As you can see on the palette at right, there's a light, medium, and dark value for the red of the rooftops, and there are strings for a dull yellow, a warm gray, and a couple of blue hues. The greens came from mixing the blue and yellow strings. Those are the principal colors in the scene. If I needed a color that didn't exist in the strings, I just free mixed it.

Mohonk Mountain House, 2004. Oil on canvas mounted to panel, 11 × 14 in.

GAMUT MAPPING

The entire group of possible colors for a given painting is called the *gamut*. It's shown as a polygon superimposed over the color wheel. Good color comes not just from what you include in a composition but from what you leave out of it.

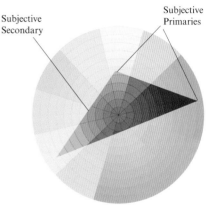

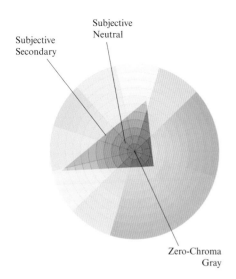

Outside Black Fish Tavern, 1994. Oil on board, 11 × 19 in. Published in *Dinotopia: The World Beneath.*

Gamut map for *Outside Black Fish Tavern*

When we looked at triadic color schemes on page 116, we explored the idea of limiting ourselves to just three hues and their variations and relationships. Whatever colors you start with, those are the parent colors for your scheme. Everything else that you mix will derive from them.

The gamut for a triadic scheme would be a triangle. *Gamut mapping* is the practice of marking the boundaries of such a shape on top of the color wheel in order to describe or define the range and limits of a color scheme. The gamut map shows exactly what's inside and outside.

For example, the painting opposite has strong cyan and magenta, with weaker yellows, violets, and some dull greens. The night scene above has an even narrower range of colors. It includes only yellow-green, blue-green, and a touch of dull red-violet. There are no

yellow-oranges, high-chroma reds, purples, or browns.

SUBJECTIVE PRIMARIES

The gamut for the birdman painting is mapped on the color wheel above. The outer lines represent the cleanest mixtures between any two of the starting colors, called *subjective primaries*. Halfway along the straight connecting lines are the purest secondaries possible within your composition. Whatever colors are outside the gamut cannot be mixed from the starting ingredients.

SUBJECTIVE NEUTRAL

The color note that appears in the geometric center of the gamut is the subjective neutral for that given color scheme. It's the mixture midway between all the extremes. In the painting at left, the subjective neutral is different from a zero-chroma gray. It is shifted slightly to the green. The *subjective neutral* is the same as the color cast. In the tavern scene, a greenish gray paint stroke will look neutral, and a gray will look slightly reddish in the context of that particular color scheme.

SATURATION COST

Note that the secondaries of any triadic gamut will be lower in chroma than the primaries. In other words, the halfway point along each side of the triangle is closer to the gray center, and therefore more neutral than the corners of the triangle. This phenomenon of the lessened chroma of intermediate mixtures is called the *saturation cost* of a mixture.

Birdman, 2009. Oil on panel, 15 × 12 in.

CREATING GAMUT MASKS

If you can describe a color scheme by drawing the gamut shape on top of a color wheel, why not cut a mask of that shape out of a separate piece of paper or plastic? Then you can slide it around on top of the color wheel to generate new schemes.

Will with Scroll, 1998. Oil on panel, 12½ × 6½ in. Published in *Dinotopia: First Flight*.

To make sure we understand gamuts, let's look at two more pictures to see which colors are included and excluded from the color scheme.

On the left is a painting of a young man in a warm-colored interior. The painting uses high-chroma red, orange, and yellow, with a low-chroma blue-gray as a complementary accent. There are no greens or violets.

The color scheme opposite is also very limited. The strongest hue is cyan, with some duller greens and dull yellows/browns. There are no reds, violets, greens, or high-chroma yellows.

Now let's see if we can define the gamuts. The first color scheme is fairly easy. It can be represented by a triangle shifted way over to the warm side. The digital mask is created in Photoshop. The analog mask is cut out of tracing vellum and laid over a painted Yurmby wheel. You can make a gamut mask whichever way you please.

As we saw on page 124, the outside corners of the triangle represent the subjective primaries for this composition. Not all of those primaries go all the way to the outer edge of the wheel, because not all of the basic colors appear in their full-intensity form. The colors inside the perimeter include all the intermediate mixtures that come from blending the subjective primaries.

The gamut mask for the *Oviraptor* painting, opposite, is fairly simple, too. It's just a slot from bright cyan to dull yellow-orange, with no strong yellow-greens, reds, or violets.

GENERATING NEW SCHEMES

The mask is a valuable tool not just for describing existing color schemes, but also for inventing new ones. It sets you free to choose exactly the colors you want, and it disciplines you from reaching outside the gamut.

It offers you the following advantages:

1. You're not limited to the haphazard choices of pigment-based limited palettes (see pages 104–105). You can use whatever primaries you want to start with, and get exactly the gamut you want.

2. By rotating the gamut mask around the color wheel, you can invent and preview new color schemes that you might not have thought of otherwise.

3. When taken as a whole, the colors within the gamut with their subjective primaries and neutrals feel sufficient for a complete color scheme, even though a lot has been left out. The effect is similar to what photographers achieve with color filters, but here your control is even better.

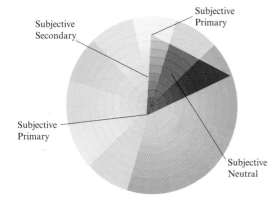

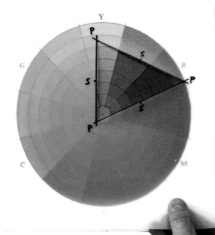

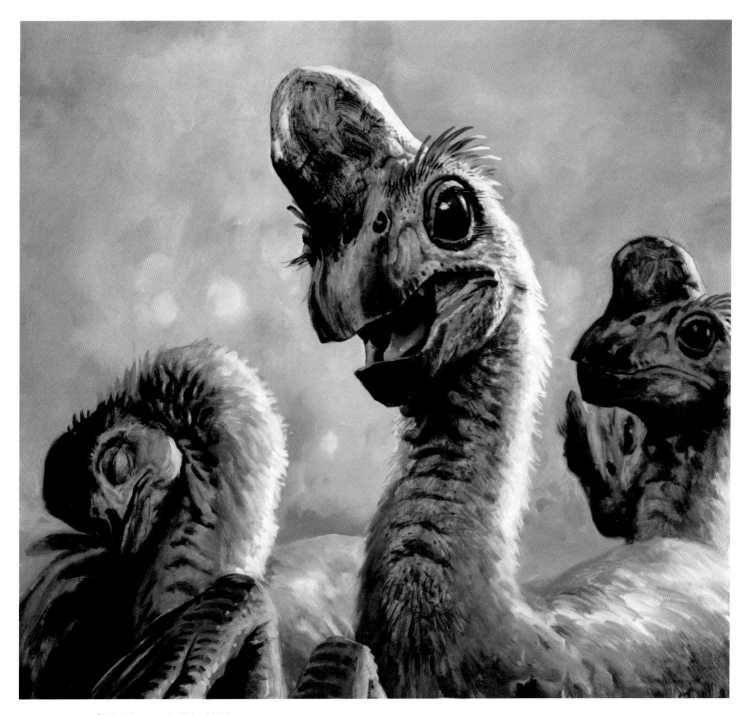

Oviraptor Portrait, 2006. Oil on panel, 12½ × 13½ in.
Published in *Dinotopia: Journey to Chandara*.

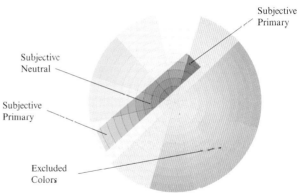

Subjective
Primary

Subjective
Neutral

Subjective
Primary

Excluded
Colors

SHAPES OF COLOR SCHEMES

Each of the gamut maps we've seen describes a polygonal shape. That shape might be a triangle, a diamond, or a square. It might include colors from only one side of the color wheel, or it might span a wide range of colors.

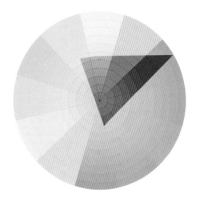

Figure 1. Gamut map for Fire Equipment, right.

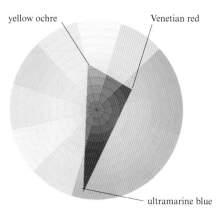

Figure 2. Gamut map for a limited palette.

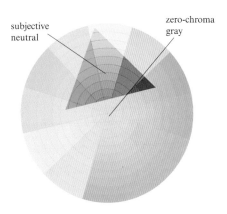

Figure 3. Gamut map for an atmospheric triad.

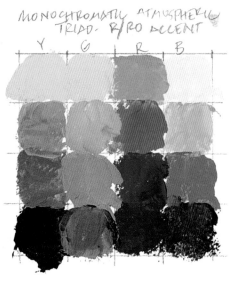

What other shapes are possible for color gamuts, and what sort of schemes do they describe?

As we've seen, the most common shape for a gamut map is the triangle. It usually has a dominant full-intensity hue and two subordinate, lower-chroma colors to balance it. In the painting above of Dinotopian firefighting, the dominant color is red, and the weaker colors are yellow-green and gray-violet (Figure 1).

Let's review another example of the limited palettes discussed on page 104: ultramarine blue, Venetian red, and yellow ochre. The gamut map for this palette (Figure 2) is a fairly narrow triangle because the red and yellow are close to each other.

A useful gamut mask is an equilateral triangle that is shifted over to one side of the wheel without overlapping the center at all. It's called an *atmospheric*

triad (Figure 3). Atmospheric triads are moody and subjective, ideal for color scripting a graphic novel or a film.

A complementary gamut looks like a long diamond stretching across the middle of the wheel (Figures 6 and 7). Although it pits opposites against each other, it's fairly stable, because its neutral coincides with the center of the wheel.

Another gamut mask, opposite, shows the "mood and accent" scheme (Figure 5). Most of the picture is in one color environment, with just one accent area from across the wheel and no intermediate mixtures.

What happens when you create a complementary gamut shape that shifts the color balance off the central axis? An example would be a near-complement scheme using violet and orange. Throwing the balance a little off-center can make a scheme attractive, but it can also be a little unsettled and jarring.

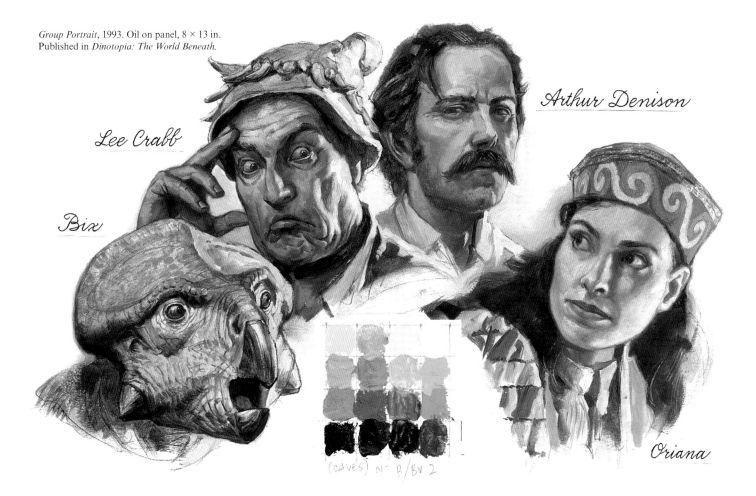

Group Portrait, 1993. Oil on panel, 8 × 13 in.
Published in *Dinotopia: The World Beneath*.

Lee Crabb

Bix

Arthur Denison

Oriana

(CAVES) N= B/BV 2

Hues that are adjacent to each other along the rim of the color wheel are called *analogous* colors. They are automatically related and harmonious. When you begin to rotate a paper mask above a painted wheel, there's no limit to the kinds of masks you can create and the infinite combinations you can generate (Figure 7).

On the next page, we'll look at how to take a gamut you've selected and prepare the paints on your palette so that you can use those exact colors in your own painting.

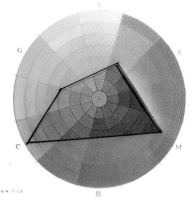

Figure 4. Gamut map for painting above.

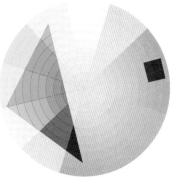

Figure 5. Mood and accent scheme.

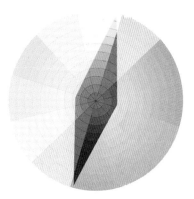

Figure 6. Complementary scheme on digital Yurmby wheel.

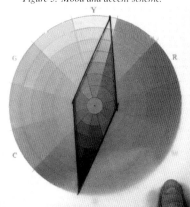

Figure 7. Acetate gamut mask over painted Yurmby wheel.

MIXING A CONTROLLED GAMUT

Once you have chosen a gamut, you can mix strings of the colors defined by it. These strings become the source colors for the entire painting. The method guarantees that you stay within your gamut and make the most of it.

Figure 1. Color wheel with starting tube colors.

Figure 2. Gamut map for an atmospheric triad.

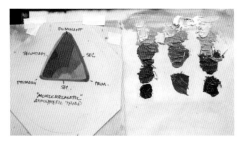

Figure 3. Darker and lighter values are mixed above and below the subjective primaries to yield a string of values for each of them.

We've learned how gamut masks can help to analyze color schemes, and how we can imagine color schemes based on other gamut shapes. Now how do we use this system to actually mix colors and generate a new painting?

STARTING COLORS

To start with, Figure 1 shows the color wheel taped to the palette with some tube colors of oil paint to start with. You can use as many tube colors as you want at this stage, but in this case, it's just pyrrole red, cadmium yellow, cadmium lemon, ultramarine blue, and titanium white.

Let's say you want a triad with the dominant high-chroma color in the red-orange range (Figure 2). Use your palette knife and mix a batch of each of the three colors that you see in the corners of the triangular gamut. In this case, it's a high-chroma red-orange, a low-chroma red-violet, and a low-chroma yellow-green.

MIXING COLOR STRINGS

Now you've created the subjective primaries, which are the sources of the color scheme. The next step is to extend each of those colors into four different values (Figure 3). Try to keep the hue and the chroma consistent for each color as you do so.

Look again at the color wheel mask. Halfway along the edge of the triangle are little marks indicating the subjective secondaries. These are your in-between colors, which you may want to mix as well. You may end up mixing anywhere from three to six color strings.

REMOVING TUBE COLORS

Before you start painting, remove all the tube colors that you squeezed out on your palette, except for white. This is important, because these colors are outside your gamut. You don't want to have access to them anymore during the painting process. You can make an exception if you want, but for now it's better to stay within the range you've chosen.

The portrait on the opposite page shows the Dinotopian character Oriana in moonlight. I wanted the colors to suggest a cool, magical ambiance, so I used an atmospheric triad shifted toward blue-green. With the colors in this gamut, it's impossible to mix any intense warms, even if you wanted to. But as your eyes adjust to the color mood, it feels complete. The relative warm colors appear warm enough in the context of the picture.

REACHING FOR ACCENTS

Using this system will make you more careful to keep the brushes clean and to push against the outside of the gamut. When you mix color from a full palette of tube colors, the color-mixing mind-set is the reverse: You're always neutralizing mixtures. With this method, you will be thinking more about reaching for accents. Harmony and unity are a given, because they're built into the process.

TECH TIP

Be sure to disable the white balance setting on your camera before you photograph your painting, or it will cancel out the color cast that you have carefully created.

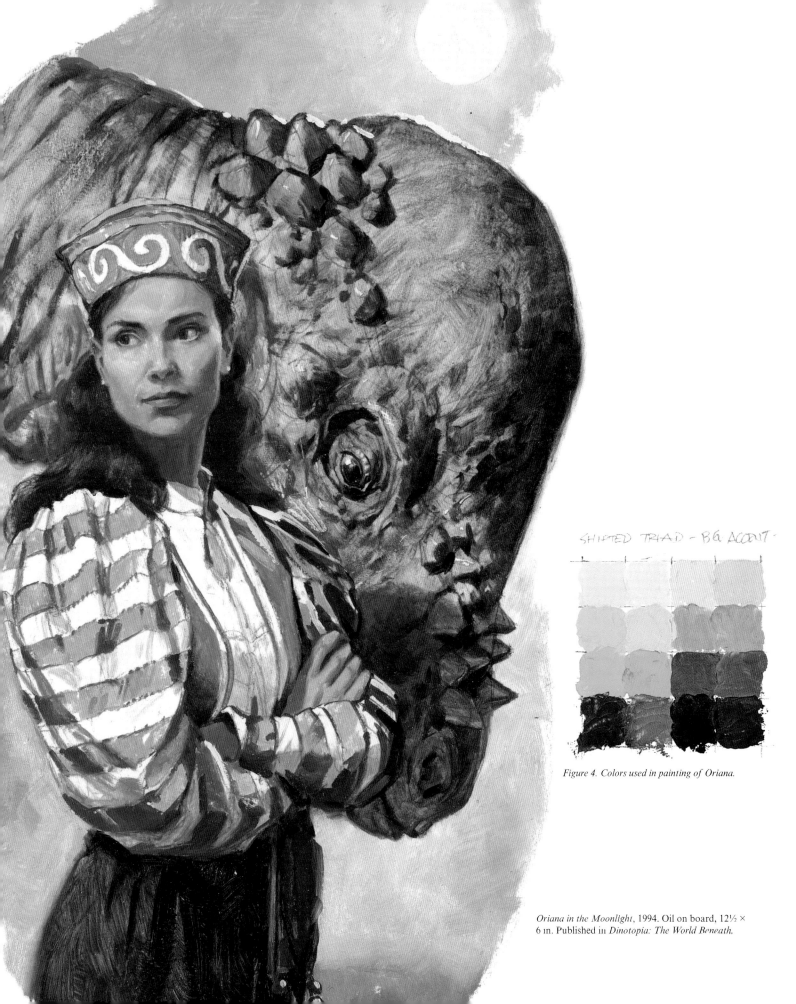

SHIFTED TRIAD - BG ACCENT

Figure 4. Colors used in painting of Oriana.

Oriana in the Moonlight, 1994. Oil on board, 12½ ×
6 in. Published in *Dinotopia: The World Beneath*.

COLOR SCRIPTING

In a sequential art form, such as a graphic novel, illustrated book, or animated film, no color scheme stands alone. Every page, panel, or frame must be seen in relation to the one that precedes and follows it.

Color Storyboard, 1993.
Marker, each panel 1½ × 3½ in.

The job of the color stylist of a film or game is to consider the changing color moods throughout a narrative sequence. Above is a color script for the book *Dinotopia: The World Beneath*. The story takes place in various settings, such as a network of caverns, a pod village, a jungle, and a city on a waterfall.

The color script shows, in semiabstract form, a series of consecutive page spreads. Each sequence, or story unit, is held within a given gamut, which shifts throughout the sequence.

For example, the cave sequence, above, begins with magentas and cyans to suggest a magical, otherworldly quality. As the story leads to the discovery of the sleeping vehicles, the gamut shifts to duller greens and browns. The adventure moves aboveground where the gamut changes to pale orange, yellow, pink, and red.

Poseidos Underwater, 1995. Oil on board, 12½ × 19 in. Published in *Dinotopia: The World Beneath.*

You can plan a color script with the aid of a color wheel and a set of gamut masks that you can move around the wheel. If you need to jump from one sequence to another, making a sudden shift of gamut will immediately signal the cut to the viewer. You can change not only the location of a gamut on the wheel, but also the type of gamut: for example, switching from an almost monochromatic blue moonlight sequence to a wider gamut for a colorful festival.

As we'll see in the next chapter, the response to changes of colored illumination are deep-seated and tied to the emotions. One of the reasons that sequential art forms are color scripted is to lead the audience through these changing moods. It's not just the colors, but also the *change* in colors that creates the effect.

High Dive, 1994. Oil on board, 15 × 23½ in. Published in *Dinotopia: The World Beneath.*

Doorway to Mystery, 1994. Oil on board, 14½ × 22 in. Published in *Dinotopia: The World Beneath.*

VISUAL PERCEPTION

A WORLD WITHOUT COLOR

What does color add to a picture? How does it affect us? One way to find out is to drain all the color out of an autumn landscape. It is still possible to understand what's going on, but much of the emotional flavor is missing. It's like eating pancakes without the maple syrup.

From late September to early October nearly 4 million people visit Vermont to see the color of the fall foliage. The favorite trees are maples, oaks, and birches. The number of visitors is almost seven times the state's population. They spend almost a billion dollars.

Why do we make such a fuss over color? What would we miss if we were blind to it? How is our experience of color different from our experience of tone?

COLOR BLINDNESS

Color blindness affects about 10 percent of males. Most of those are dichromats, people who have difficulties distinguishing red and green. Less than 1 percent experience completely monochromatic color blindness. In almost all cases, people with color deficiencies can distinguish blue and yellow.

Among those with normal vision, most humans are trichromats, meaning they have three kinds of color receptors, which note contrasts of red-green and blue-yellow, as well as light-dark. But some creatures, including birds and insects, are tetrachromats, with four kinds of retinal receptors. This additional endowment allows some of them to respond to ultraviolet or infrared light.

A small percentage of people are tetrachromats, too, though it is difficult to know if their experience of the world is really different from the rest of us. We can't know for sure how one person sees the world compared to another, even if both have normal color vision.

TONE AND COLOR

The light-sensitive layer of the eye's retina is divided into two kinds of receptors: rods and cones. The rods detect lightness and darkness, but they are entirely color-blind, and they function better at lower light levels. The cones respond to color and tone, and they work at relatively high light levels.

Under normal light conditions, the rods and cones cooperate to create an interpretation of reality. But according to Dr. Margaret Stratford Livingstone, a professor of neurobiology at Harvard University, the visual brain processes tonal information separately from color information.

The two streams of information are kept separate from the level of the retina all the way to the vision centers of the brain. According to Livingstone, the area of the brain that interprets tone is several inches away from the area that interprets color, making tonal processing and color processing as distinct anatomically as vision is from hearing.

Neuroscientists characterize the tonal pathway as the "where" stream. This capacity, which we share with all mammals, is adept at motion and depth perception, spatial organization, and figure-ground separation. The color capacity is called the "what" stream. It is more concerned with object and face recognition and color perception.

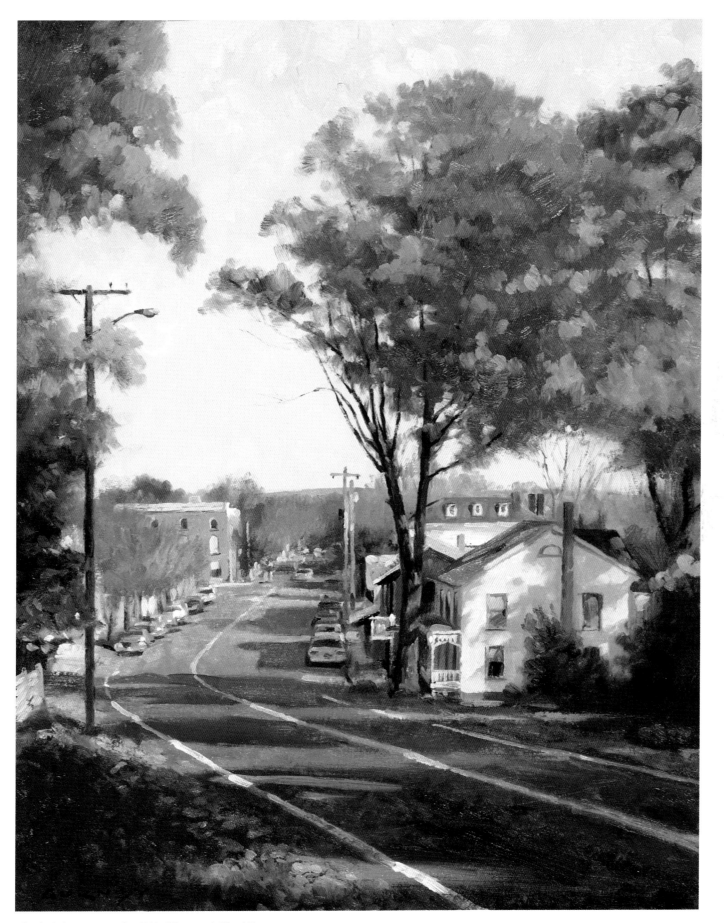

Rhinebeck from West Market, 2003. Oil on panel, 20 × 16 in.

IS MOONLIGHT BLUE?

According to a recent scientific hypothesis, moonlight isn't really blue. It's actually slightly reddish. It just looks blue because our visual system plays tricks on us when we look at things in very dim light.

The light of the full moon is about 450,000 times weaker than direct sunlight. It's so dim that the color-receptive cones can barely function. In moonlight the color-blind rods are most active.

Moonlight is simply the white light of the sun reflecting off the gray surface of the moon. There is nothing in that interaction to give the light a bluish or greenish quality. In fact, scientific instruments have shown that the light from the moon is very slightly redder than the average color of direct sunlight.

These facts added together suggest a mystery. If moonlight is neutral or

Figure 1. Colored cards in daylight.

Figure 2. Above photo manipulated to suggest the subjective experience of moonlight.

reddish colored light, and if it is close to the minimal threshold of our color receptors anyway, then why do so many artists paint moonlight with a blue or green cast? Do we really see it that way? Is it some kind of illusion, or perhaps is it just an artistic convention?

When you look at paintings by master painters of moonlight and compare them to your own experience of colors at night, you can decide whether they match up. There's no way to be sure that you see moonlight the same way I do, or that either of us sees it the way another artist does. Since we can't escape the prison of our own senses, paintings by artists are the best way for us to share our personal perception of moonlight.

Some of the artists known for painting moonlight include J.M.W. Turner, James McNeill Whistler, Frederic Remington, Maxfield Parrish, Atkinson Grimshaw, and John Stobart.

COLOR RESPONSE IN MOONLIGHT

Do the cones function at all in moonlight? Contrary to what some authorities have claimed, most people can make very basic color judgments by the light of a full moon. But how much variation in color can we really see?

Here's how you can test how your cones actually respond to color in moonlight. Paint a set of separate, unmarked color swatches or find a half dozen sheets of colored craft paper. They should all be at about the same value. Take them into full moonlight and let your eyes adjust about fifteen minutes. Shuffle the cards, and while you're still

outdoors, mark on the back what colors you think they are.

This photo of the swatches, Figure 1, was shot in overcast daylight. In Figure 2, I manipulated the image in Photoshop to simulate how the colors appeared to me under the full moon. Everything is duller, darker, and more blurry. I could easily identify the basic hue family of each swatch. But beyond that basic classification, I wasn't sure, and the gray swatch confused me.

When I looked at the same swatches in the much dimmer light of a half moon, or in a moon shadow, I found that my cones went subthreshold and shut down completely. The swatches now became monochromatic.

PURKINJE SHIFT

Although the rods of the eye can't actually see color, scientists have shown that they are most sensitive to greenish wavelengths of light. As a result blue-green hues appear lighter in tone in dim conditions. This phenomenon is called the *Purkinje shift*. It's a different phenomenon from, and often mistaken for, the perception of moonlight as blue. You can demonstrate the Purkinje shift by comparing a red swatch and a green swatch that start out indoors at the same value. If you take them outdoors in moonlight, the green one will seem lighter in tone. Many observers have noticed that red roses look black in the moonlight.

In the digitally manipulated version of the moonlight color swatches at left, I have adjusted the values of the red and

Black Fish Tavern, 1994. Oil on panel, 18 × 24 in.
Published in *Dinotopia: The World Beneath*.

green swatches to simulate the way they looked to me as a result of the Purkinje shift.

THE KHAN/PATTANAIK HYPOTHESIS

Saad M. Khan and Sumanta N. Pattanaik of the University of Central Florida have proposed that the blue cast is a perceptual illusion, caused by a spillover of neural activity from the rods to the adjacent cones.

A small synaptic bridge between the active rods and the inactive cones touches off the blue receptors in the cones, like an insomniac turning over in bed and rousing a sleeping spouse. This

influence of rod activity on the adjacent cones tricks the brain into thinking we're seeing blue-colored light, even though we're really not.

As the authors put it: "We hypothesize that the rod cells predominantly synapse onto the S-cone (the cone cells sensitive to bluish light) circuitry resulting in the visual cortex perceiving a tinge of blue."

How can we use this information to paint more effective nocturnes? Direct plein-air painting with any hue discrimination is virtually impossible in moonlight. And the subjective effect can't be photographed. Every artist must train the memory and imagination. The best thing you can do is to observe carefully, remember what you see, and reconstruct it in a brightly lit studio. Painting a moonlight scene involves translating a rod experience into a cone experience.

Edges and Depth

Edges refers to the painterly control of blurriness, especially along the boundary of a form. Using edges effectively will help you communicate a sense of depth or of dim illumination.

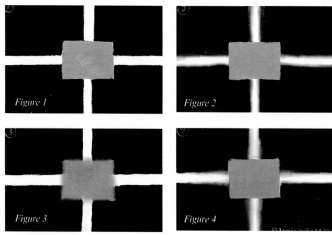

Figure 1

Figure 2

Figure 3

Figure 4

Giant Rodent (Josephoartigasia), 2009. Oil on panel, 18 × 14 in.

Depth of Field

If you look at almost any portrait or wildlife photograph, you'll notice that the background is out of focus. The same is true of sports or action photos. Yet most artists use sharp edges to paint everything in the scene.

Oversharpness in paintings happens because our eyes naturally adjust their focus to both near and far objects when we look around at the real world. As a result, our minds construct the impression that everything is equally crisp.

A camera produces an image in which normally only one plane of distance is in focus at a time. This shallow *depth of field* is most obvious with telephoto lenses typically used by wildlife photographers. Everything that's not on the focal plane is blurry. The blur increases as objects get farther from the plane of focus.

The painting of the extinct giant rodent, left, uses depth of field to make the image seem real. If you're painting in oil, you can use larger brushes and a wet-into-wet handling in the soft areas to achieve this impression. The painting of the dinosaur on the opposite page also uses this technique.

Intersecting Contours

When one object sits in front of another in space, what happens at the location where the contours intersect each other? How can you create a sense of space between the object in front and the one behind?

Figure 1 shows a gray rectangle in front

of a cross of white lines. All the edges are kept sharp. The result is that the rectangle appears to be sitting on top of the lines, but it lies on the same two-dimensional plane. If you soften all the edges of the white lines to an equal degree, as in Figure 2, the gray rectangle floats upward. This is how a camera would interpret two objects on different planes of focus.

Figure 3 softens the edges of the rectangle and keeps the white lines sharp. It looks like the camera has shifted its focus to the back plane. This creates a perceptual ambiguity. The gray rectangle still comes forward because it is superimposed, but the white lines also want to come forward because they're in sharper focus.

Figure 4 is an attempt to simulate our human visual perception. It's similar to the photographic mode in Figure 2, but this time the lines get progressively more out of focus as they pass behind the rectangle, suggesting the continual focal adjustment our eyes make while surveying a scene.

EDGES IN MOONLIGHT

When you go out on a moonlit night away from streetlights, you can't see the cracks in the sidewalk, the blades of grass, the clapboards on a house, or the small twigs and branches. Unless you're a cat or an owl, these smaller details melt into the larger shapes. Everything looks blurry. The reason we can't see fine details at night is because the fovea, the central point of vision where we see small detail, is filled with cones, and these photoreceptors respond well only in bright light.

I painted the street scene, right, outdoors in the gathering twilight of a rainy evening. To simulate my impression, I softened the edges and suppressed the detail everywhere except along the roofline and in the brightly lit windows where the light levels are higher.

If I had kept all the edges sharp, I would have put things into the painting that I really couldn't see at the time. If you use night photography as reference, remember that the camera does not see as the eye sees, particularly at night.

Giganotosaurus Portrait, 1994. Oil on panel, 11 × 12 in. Published in *Dinotopia: The World Beneath.*

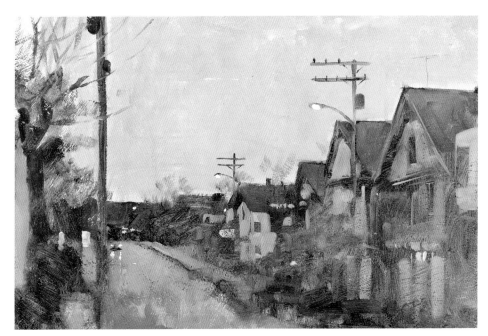

Tannersville, 1986. Oil on panel, 8 × 12 in.

141

COLOR OPPOSITIONS

Complements suggest an opposition of elemental principles, like fire and ice. Blue opposes yellow; magenta challenges green. These antagonistic pairings seem to correspond to the way our visual systems are wired.

Wolfgang von Goethe's color wheel, showing complementary relationships.

Johann Wolfgang von Goethe's book *Theory of Colors (Zur Farbenlehre)* was published in 1810. Goethe's theory of color was based on his personal observations about the experience of color vision. Following on ancient ideas since Aristotle, he believed that color arose from the interaction between light and darkness. Darkness is not the absence of light, but rather its rival or counterpart. Blue, he believed, is a lightening of black. Yellow is a darkening of white. All other colors are grouped between them.

Goethe looked for chromatic effects at places where light and dark edges intersect, such as along the edges of dark mullions crossing bright windows. He noticed that if we stare at a strong red color and then look at a white wall, a green afterimage emerges.

Goethe's color wheel, left, has the symmetrical six-color spacing that we're familiar with today. Opposing pairs of hues line up across the center. Yellow and red were at the "plus" side of the color wheel, and they represent "light, brightness, force, warmth, and closeness." Color schemes where yellow, red, and purple predominate, he believed, bring forth feelings of radiance, power, and nobility.

Blue, he believed, stands for "deprivation, shadow, darkness, weakness, coldness, and distance." The colors on the cold or "minus" side evoke feelings of dread, yearning, and weakness. "Colors are the deeds of light," he declared, "its deeds and sufferings."

Goethe challenged the theory of color proposed by Sir Isaac Newton a century earlier. Although most of Goethe's conclusions have been discredited from a purely scientific perspective, his ideas can be seen as a complement to Newton's rational and objective analysis of color. His focus was more about color in psychological, moral, and spiritual terms.

In particular, the emphasis on the

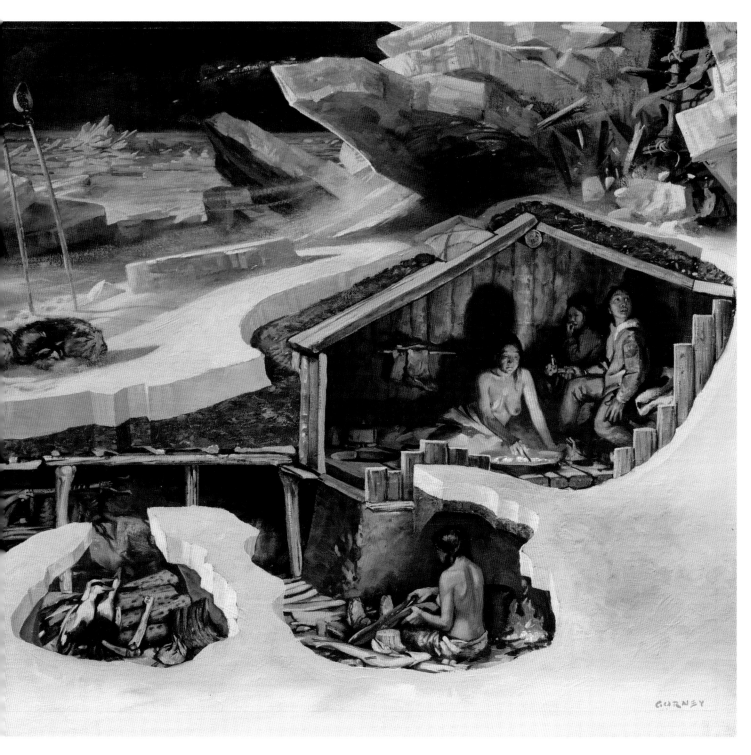

oppositions of blue/yellow, green/red, and light/dark have been echoed in the modern *opponent process theory* of color vision, which states that all colors that we see are the result of interactions between opposing pairs of color receptors. But his greatest contribution was to inspire generations of artists, including J.M.W. Turner, the Pre-Raphaelites, and even Ludwig van Beethoven.

In the painting above, I used this thinking to guide my colors for an archaeological restoration for *National Geographic*. The scene depicts a true story: Eskimos in their dwelling were about to be buried by storm-driven ice.

Eskimo Tragedy, 1986. Oil on canvas mounted to panel, 16 × 24 in. Published in *National Geographic* magazine, June 1987.

COLOR CONSTANCY

Color constancy refers to our automatic habit of interpreting local colors as stable and unchanging, regardless of the effects of colored illumination, the distraction of cast shadows, and the variations of form modeling.

A fire truck looks red, no matter whether we see it lit by the orange light of a fire, the blue light of the twilight sky, or the blinking light of an ambulance. If the truck were parked halfway in shadow, we would still believe it to be a single, consistent color. If the fender were dented, the tones of red reaching our eyes would vary, but we would still believe that the red remains the same.

Our visual systems are constantly making such inferences. When we look at a scene, we don't see the colors objectively. Instead we construct a subjective interpretation of those colors based on context cues. This system of processing happens unconsciously, and it's almost impossible for our conscious minds to override it.

The colored cube illusion, below, illustrates how our brains alter what we actually see. The large cube with colored surfaces appears consistent, despite being lit by reddish or greenish light. The small red-colored surfaces on the near corner seem to be the same from one picture to another, and it's very distinct from the greenish square below it.

But in fact, the paint mixture used to render the green square in the red-lit scene is the same neutral gray paint used to render the red square in the green-lit scene. The context of each picture tricks us into thinking the actual color notes are different. This presents a problem for art students as they learn to mix colors while painting from observation. Is it possible to switch off the context cues so that you can see colors as they really are?

COLOR ISOLATION STRATEGIES

There are various methods for isolating a particular spot of color. One way is to look through the hole in a half-closed fist. Another is to hold up two fingers spread slightly apart.

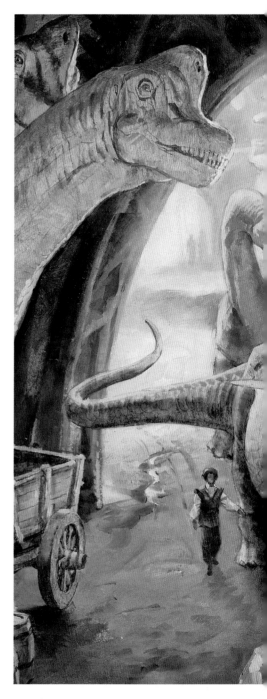

Figure 1. Colored Cube Illusion. The square marked "A" is painted with the identical color mixture as the square marked "B." Both are a neutral gray. You can test the illusion by isolating the squares with strips of paper.

Opposite: Sauropod Barns, 1994. Oil on board, 12 × 18 in. Published in Dinotopia: The World Beneath.

Other artists have developed special viewing scopes for isolating colors. You can make one yourself. Paint a card half white and half black and then punch a hole in each corner. When you look through the holes, you can isolate a given color against white or black. You can also compare two different nearby colors through the side-by-side holes. You can test a mixture by putting a daub of paint next to the hole. The limitation of any such device is that the illumination on

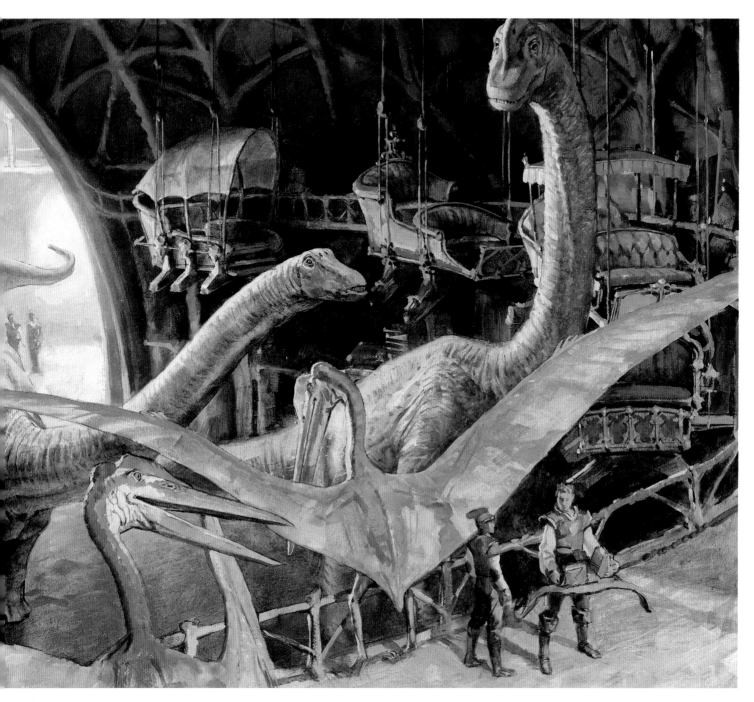

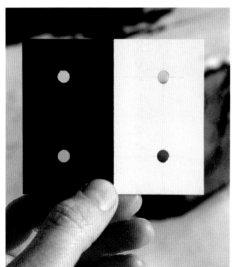

the scene may so far exceed the range of your pigments that no single one-to-one match is possible. Also, the tone of the white card changes as the illumination on the card changes.

For imaginative painting, you can't just match what you see. Instead, you have to create colors based on your knowledge of the color of the light

source and the color of the object. In the painting above, the yellow-orange light streaming into the foreground pushes the red colors toward orange. The red color of the hanging carriage on the far side of the barn had to be grayed down to look right in the foggy light that streams in the doorway.

Adaptation and Contrast

When we look at a scene, the experience of one color affects the way we perceive other colors. This happens both two-dimensionally, as flat colors influence each other, and in the 3–D realm as well.

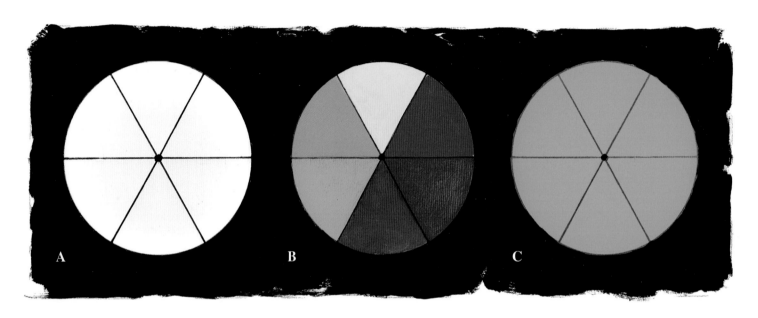

Afterimages and Successive Contrast

Stare at the central circle (B) above under strong light for about twenty seconds, and then look at the center of the white circle (A). Complementary afterimages should begin to bloom on the white circle. The blue sector at the bottom becomes yellow. Green changes to magenta, and cyan changes to red.

Repeat the same experiment, staring first at the center of the multicolored circle for twenty seconds under a strong light. This time shift your gaze to the cyan circle (C). Perhaps you will notice that the afterimages now change your perception of each of the cyan sectors. Which sector appears the most intense version of cyan?

Most people report that the strongest cyan appears where the red sector had been. This is called *successive contrast*. When you look at an object of a certain color, your eyes adjust or adapt to that color. The resulting afterimage affects what you look at next. This is why providing a few areas of complementary accents helps enliven a color scheme.

Colored Illumination Effects

The female plaster head at the top left on the opposite page was set up in white light with neutral fill light in the shadows. The form is rendered in monochrome without any dramatic contrasts of hue between light and shadow.

The plaster head of the man at right was set up over a green-colored table surface, which bounced strong green light into all the shadows. Those greenish hues in the shadow actually changed the appearance of the light side. The light side of the plaster head appeared orange-red by contrast.

When the horse's head was set up over a reddish source of reflected light, the key light appeared to shift toward a greenish hue. All of these plaster heads were lit by the same light source. The change in apparent color of the illuminated side was induced by contrast with the color of the shadow.

These experiments show that we don't see colors objectively. If we did, the side illuminated by the white light would look the same, regardless of the shadow color. The color temperature of the fill light makes the illuminated side appear to be composed of the complementary color.

Cool Light, Warm Shadows

Opposite right, bottom, is a concept sketch for a science fiction paperback cover using a cool key light. To emphasize the coolness of the light, the shadows have a warm hue. Cool light coming from below conveys a weird, artificial feeling, because usually only unnatural or unusual environments are lit in such a way.

The appearance of colors is influenced by at least five factors.

1. **Simultaneous contrast:** The hue, saturation, or brightness of a background color can induce opposite qualities in an object sitting in front of it.

2. **Successive contrast:** Looking at one color changes the next color we see.

3. **Chromatic adaptation:** Our visual system, like the white balance of a camera, becomes accustomed to a given color of illumination. When the illumination changes in color temperature, the sensitivity of color receptors changes in relative proportion, resulting in a balanced impression of color and light levels.

4. **Color constancy:** Thanks to chromatic adaptation and our experience of known objects, local colors appear consistent, regardless of lighting circumstances that may actually change their hue, value, or saturation.

5. **Size of the object:** The smaller a colored object becomes, the less distinct the color appears to be. You can observe this effect on the pigment chart on page 92, where the small spots of color appear to lose chroma as the viewing distance increases.

How does this knowledge help in painting? If you're familiar with all these phenomena, you can use them to enhance the illusion of your picture. As you look at a scene, try to isolate the color, but also try to compare that color to other colors in the scene. Ask yourself: Is it different in hue, different in value, or different in chroma? The only way to really know what color you need to mix is to compare it to other colors in the scene, especially to a known white color.

Do the same when you're mixing a color on the palette. Compare each mixture to white and black, to a gray of the same value, and to the full-chroma version of the hue.

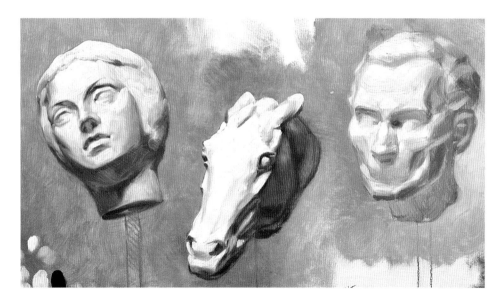

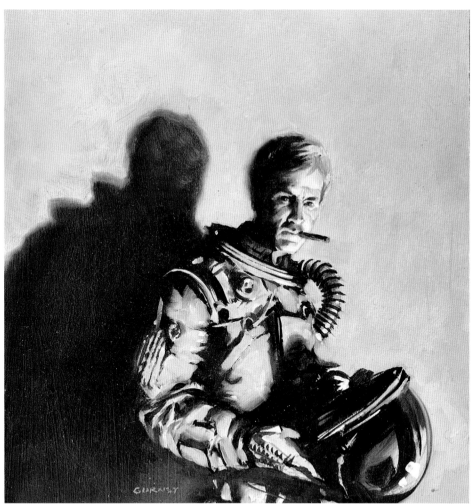

Top: Plaster Heads in Colored Light, 1984. Oil on board, 12 × 20 in.

Above: Cool Spaceman, 1984. Oil on board, 9½ × 7½ in.

APPETIZING AND HEALING COLORS

Can certain colors—or certain groupings of colors—promote well-being, or even healing? Do certain colors stimulate the appetite? According to Carl Jung, "Colors express the main psychic functions of man."

Figure 1. "Healing colors," montage of swatches from a New Age catalog.

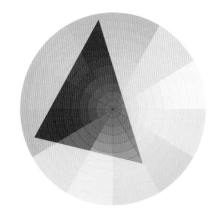

Figure 2. Gamut of healing colors.

The montage of photo samples, left, was made by snipping random bits from the pages of New Age catalogs, which offered products designed to promote inner peace.

The color scheme includes blues, violets, greens, and cool reds, but avoids hot reds and yellows. The gamut map below represents the range of colors.

COLOR THERAPIES

An entire field of alternative medicine called color therapy or *chromotherapy* has developed around the belief that colors have specific therapeutic properties for the mind and body.

These practices are rooted in ancient beliefs of the Ayurveda in India, and in ancient Egypt, where rooms were built with colored-glass windows to promote effects on the body. In China, specific colors were associated with certain internal organs.

In various practices of color therapy, patients observe colors through special viewers, or colors are applied to accu-points on the body, using gemstones, candles, prisms, penlights, colored fabrics, or tinted glass.

COLOR ASSOCIATIONS

Although not all systems of color therapy agree on the associations of each color, most agree that red signifies blood and the base passions, including anger and power. Orange is often associated with warmth, appetite, and energy, followed by yellow, which represents the energy of the sun, and which is used for glandular problems. Advertisers use these

McDonald's Sign, 2000. Oil on board, 10 × 8 in.

bright, warm colors to whet the appetite for fast food, above.

The spectrum of colors continues through green, blue, indigo, and violet, moving more and more toward states of serenity and meditation.

This progression corresponds to the ascending chakras of yogic practice, and can be charted on the body by superimposing the progression of hues on each of the seven spiritual centers of the body.

Mainstream marketers have recently made connections between certain colors and chakra centers. Such claims even appear on the websites of commercial interior paint manufacturers.

VALIDITY OF CLAIMS

Those who doubt the claims of chromotherapy argue that these associations are

nothing more than pseudoscience, because the health benefits can't be proven by clinical tests. If the contemplation of certain colors has any effect on a patient's recovery, they would argue, it's simply due to the placebo effect.

To some extent, the color symbolism of New Age catalogs owes as much to fads and fashions as it does to physiological response. More recent catalogs have a rather different palette than we would have seen ten years ago;

these days health-promoting catalogs tend to sport gold, dull olive, and Venetian red.

Regardless of the scientific validity of these claims, artists, designers, and photographers might wish to remain open to the general idea that color can affect us at an emotional and a physiological level.

Feathered Courtiers, 2007. Oil on panel, 12½ × 13½ in.
Published in *Dinotopia: Journey to Chandara*.

Dinosaur Boulevard, 1990. Oil on canvas mounted to panel, 26 × 54 in. Published in *Dinotopia: A Land Apart from Time.*

TRANSMITTED LIGHT

When sunlight travels through a thin, semitransparent material, the light becomes richly colored. Light that bounces off the surface is fairly dull by comparison. This "stained-glass window effect" is called *transmitted light*.

Into the Wilderness, 1999. Oil, 10 × 5 in. Published in *Dinotopia: First Flight*.

Backlit Maples, 2004. Oil on panel, 8 × 10 in.

You can see transmitted light when the sun shines through the green or yellow leaves of a tree. The effect is also noticeable when the sun backlights a colored balloon, a sailboat's spinnaker, or a translucent nylon umbrella.

In the forest scene at left, there are two bunches of magnolia leaves, one on each side of the figure. On each one, the leaf rising up nearest the viewer is an intense yellow-green.

FOUR KINDS OF LIGHT ON LEAVES

The plein-air oil study of a skunk cabbage plant, opposite, was made outdoors in early spring while the leaves were still fairly new.

The smaller image, below right, shows numbers superimposed on each area of the foliage to analyze what's going on with the light and color.

1. Transmitted light, with a strongly chromatic yellow-green color.

2. The leaf in shadow, facing downward. This is the darkest green. It would be even darker if it weren't picking up reflected light from the adjacent leaf seen edge-on.

3. The leaf in shadow, facing upward. These upfacing planes are blue-green because the blue light of the sky influences them.

4. Sunlight reflecting off the top surface of the leaf. This is the highest value, and the most textural, especially at the terminator. But the chroma is not very intense, because most of the light bounces off the waxy cuticle of the leaf.

A tree that is backlit by sunlight has these four distinct foliage colors happening at a macro scale, even if you can't see individual leaves. Look for the following color groups: transmitted, downfacing shadow, upfacing shadow, and toplit with sun.

The colors will mix together like tiny pixels grouped according to the position of each mass of leaves in relation to the light. As you can see in the faraway view of autumn maples, below left, there are more leaves shining with transmitted light at the lower left margin of the tree. The leaves in the central area are darker and duller because they're lit by the cool skylight.

1. Transmitted light. 2. Leaf in shadow, facing down. 3. Leaf in shadow, facing up. 4. Direct sunlight.

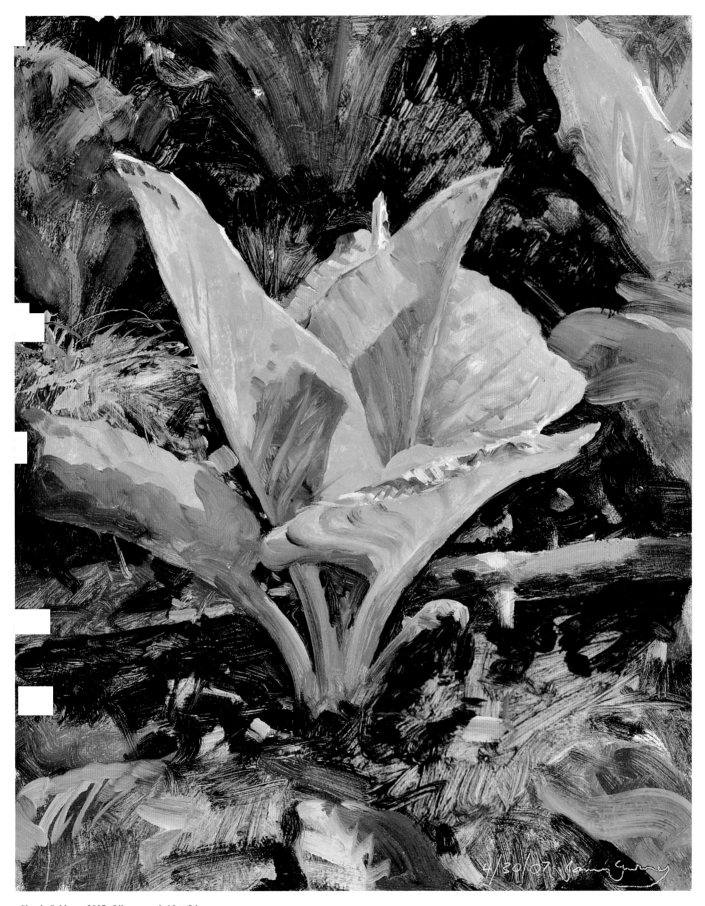

Skunk Cabbage, 2007. Oil on panel, 10 × 8 in.

SUBSURFACE SCATTERING

Light enters the skin or any translucent material and spreads out beneath the surface, creating an unmistakable glow. *Subsurface scattering* affects forms with depth and volume, such as a person's ear, a glass of milk, or a piece of fruit.

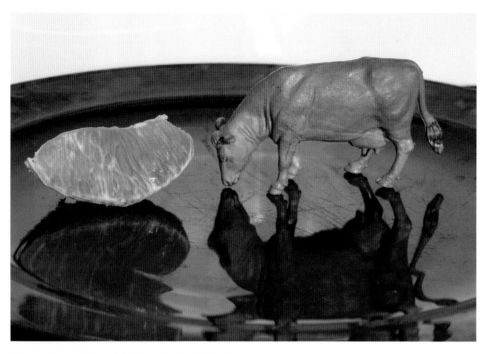

Figure 1. Orange slice and plastic cow lit from the front.

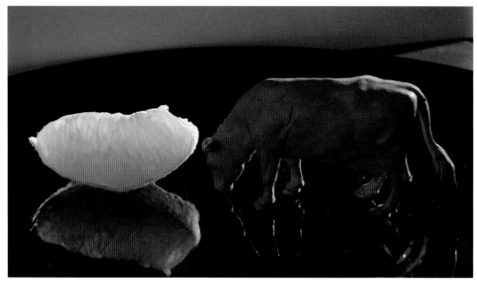

Figure 2. The same objects lit from behind.

At left is a photo of a piece of an orange and a toy plastic cow standing together on a blue plate. They are lit by direct sunlight from the front. The two objects are approximately the same color in terms of hue, value, and chroma. Although an equal volume and quality of light is bouncing off all of the surfaces, only some of the light that touches the surfaces of the forms reflects off it. What happens to the rest of it?

If we swing the light around so that it is shining from behind, everything changes.

The orange section glows from light that enters the transparent skin on the far side. It bounces around inside the fruit, eventually reemerging through the near surface. The glow is brighter where the wedge is thinner because the light has less distance to travel, and less of it is absorbed.

In the cow, all the sunlight that is not reflected is absorbed at the surface. It does not scatter below the surface, so all we see is weak reflected light on the shadow side.

This effect is known as subsurface scattering. It shows up most strikingly when three conditions are met: translucent flesh, small forms, and backlighting. Subsurface scattering is also present on the illuminated side of the orange; it's just not as obvious.

If you hold up your hand in front of the sun or against a bright flashlight at night, light traveling beneath the skin turns the spaces between your fingers bright red.

Subsurface scattering is what makes a

Franklin and Cat, 1995. Oil on board, 10 × 8 in.

Left: Photos of subsurface scattering, 2008.

person's ears turn crimson when they are backlit.

Artists have known about this property for centuries. Peter Paul Rubens rendered skin not as an opaque surface, but as a translucent, glowing, luminous layer.

Some art students begin their training by drawing plaster casts at academic ateliers. When they transition to the live model, they're amazed by the way skin glows, especially in the fingertips, nostrils, and ears.

Sculptors who create hyperreal figures know that in order to fool the eye, the surface layer of skin has to be somewhat translucent. That's why the figures in wax museums look more real than painted plaster. Your eye instantly spots the difference.

In the early days of animatronic creatures, the skin was made of latex, which was a little too opaque, but now creature effects experts generally use silicone when they need the surface to scatter more light.

COLOR ZONES OF THE FACE

The complexion of a light-skinned face divides into three zones. The forehead is a light golden color. From the forehead to the bottom of the nose is reddish. The zone from the nose to the chin tends toward a bluish, greenish, or grayish color.

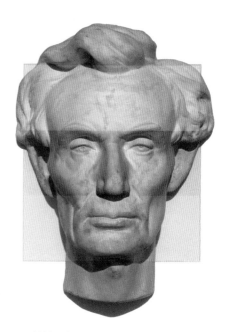

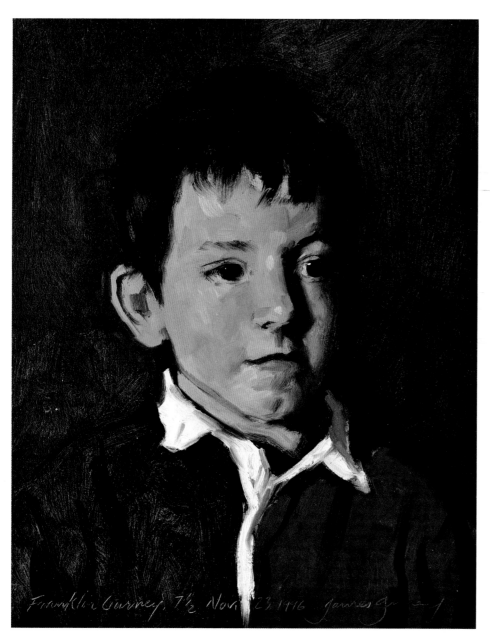

Above: Franklin, 1996. Oil on board, 10 × 8 in.

Opposite: Martin Keane, 1995. Oil on board, 10 × 8 in.

In real life, these zones can be extremely subtle, almost imperceptible. They are more pronounced in men. In the photo of the Lincoln bust, the colors are digitally superimposed to show the three regions.

The forehead has a light golden color because it's freer of muscles and surface capillaries. The ears, cheeks, and nose all lie within the central zone of the face. Those areas have more capillaries carrying oxygenated blood near the surface, causing the reddish color. A person who has been physically active often gets stronger dilation, particularly in the cheeks in a diagonal line running from the inside of the eye to the corner of the jaw. Chronic alcohol consumption or exposure to cold weather can lead to a permanent rupture of the capillaries.

The lower third of the face, especially on a dark-haired man, can have a blue-gray cast from the hair follicles. Even though women and children don't have this five-o'clock shadow, they can appear a bit greenish in the region surrounding the lips, where there are relatively more veins carrying blue deoxygenated blood. Some artists accentuate this subtle bluish or greenish hue to bring out the reddish lip color.

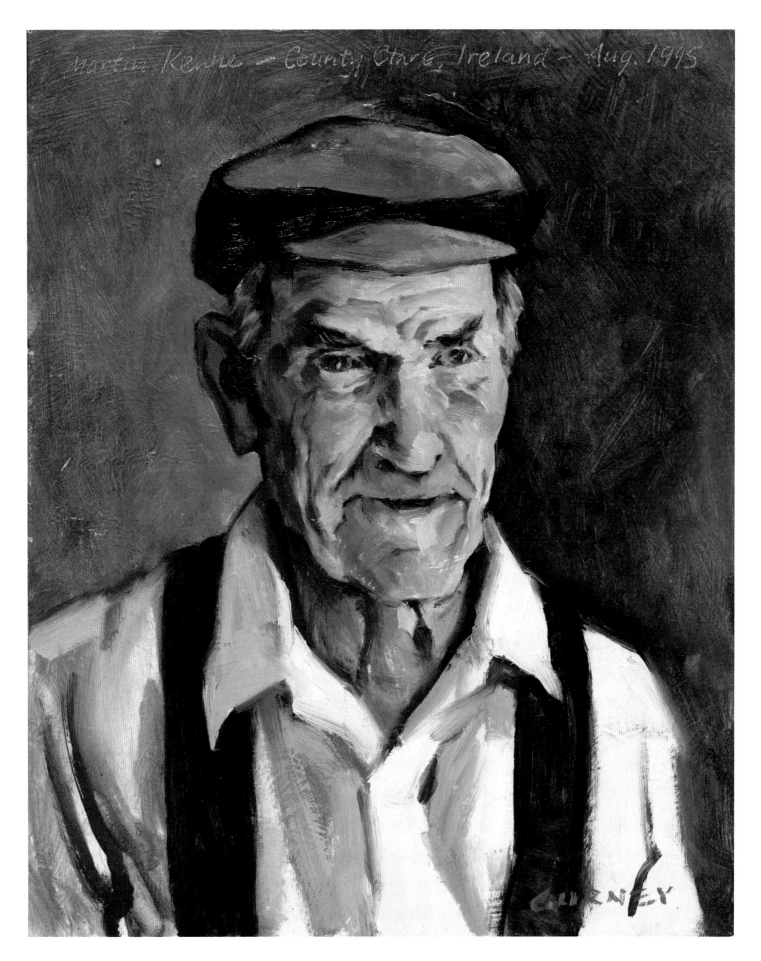

Martin Keane – County Clare, Ireland – Aug. 1995

GURNEY

THE HAIR SECRET

Like water and foliage, hair has always presented a unique challenge to both the traditional and the digital artist. To avoid the stringy look, use big brushes, keep the masses simple, soften the edges, and control the highlights.

Left below: Two Earrings, 1996. Oil on board, 12 × 9 in.

Right below: Patrick, 2003. Pencil, 5 × 4 in.

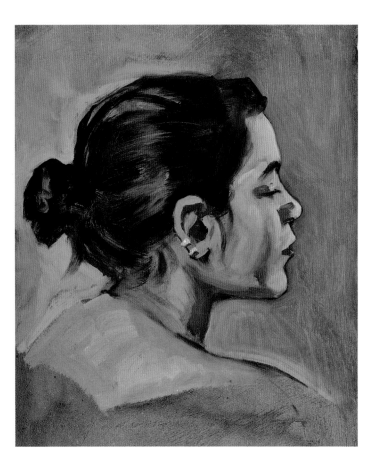

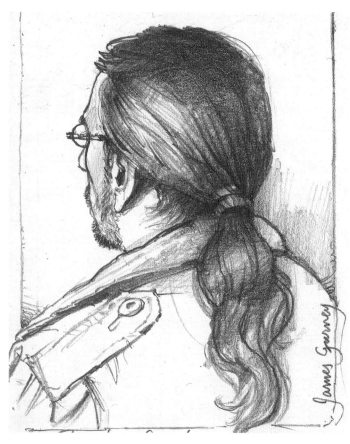

Defining individual locks of hair too much can make the hair look like a string mop. To solve this problem, group the strands of hair into large masses. You can use a big bristle brush to sweep up individual locks into simple patches of tone.

WHERE THE HAIR MEETS THE FOREHEAD

If the edges are too hard, it tends to sit on the head like a leather helmet. Look for a variation along the edge where the hair meets the skin, especially at the

hairline near the temple, as well as the area where the hair meets the neck. In the painting of the model with the bun, above left, note that the curls along her neck are stated in large masses, without inserting many lines in the direction of the hair growth to define individual hairs or locks.

It helps to visualize masses of hair as ribbons. In a real ribbon, the highlight goes across, not along, the curving shapes.

When hair is short or pinned close to the head, as with the examples here, the

highlight extends across the entire head, with the full mass of hair getting darker as it turns away from the highlight region.

Hair has so many textures and colors that there are no recipes for painting it. It might be frizzy, curly, wavy, or a crew cut. Often a lighting arrangement with key light and an edge light can bring interest to the hair. No matter what individual hair type you need to represent, the most useful general advice is to use a large brush, keep the forms simple, and try to state the largest masses.

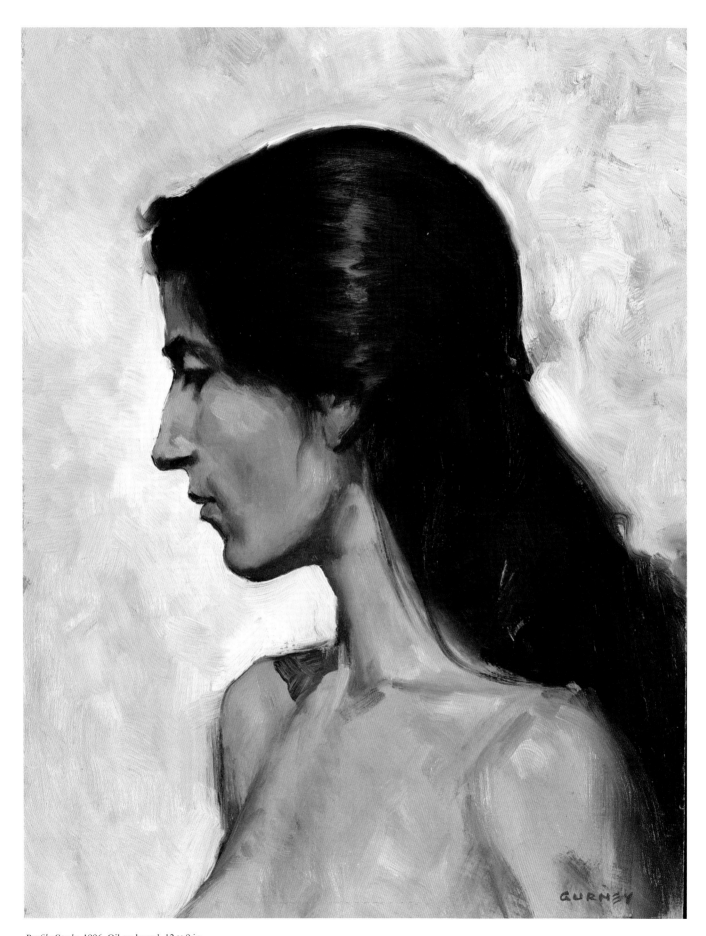

Profile Study, 1996. Oil on board, 12 × 9 in.

CAUSTICS

A drinking glass or a water-filled vase can act like a lens to focus light rays into spots or lines of light. The same effects happen underwater, the result of the undulating waves acting like lenses. This field of optics is called *caustics*.

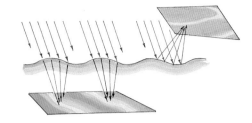

Figure 1. Caustic reflections above a water surface and caustic projections below.

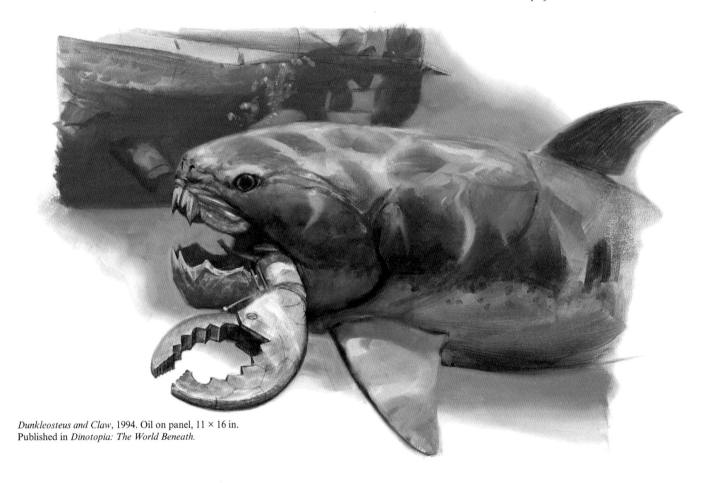

Dunkleosteus and Claw, 1994. Oil on panel, 11 × 16 in.
Published in *Dinotopia: The World Beneath*.

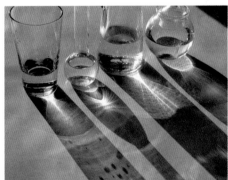

Figure 2. Photograph of caustic projections from glass objects filled with water.

Caustics are the spots, arcs, or wavy bands of light projected onto a surface by means of refraction or reflection from a curved glass or from waves on water.

CAUSTICS FROM TRANSPARENT OBJECTS

In the still life arrangement in Figure 2, set up in the morning sunlight, note the difference in the shapes of the caustic projections. The objects are bending, or refracting, the light, essentially acting as imperfect lenses.

The light bunches up and forms lines of concentration along the boundary of geometric shapes, sometimes with spectral effects along the edges. The caustic effects cluster inside the cast shadows of the glass objects.

The shapes are determined by the curvature of the surface. As we'll see in the next chapter, the rainbow is

essentially a caustic projection from spherical raindrops reflecting back the sunlight to the observer.

UNDERWATER CAUSTICS

Caustic patterns can occur when sunlight is refracted downward by the ripples at the water surface. The waves focus a network of dancing lines on the sea floor or on the backs of creatures below the surface. In the painting on the opposite page, a caustic pattern forms on the back of an extinct fossil fish called a *Dunkleosteus*.

Underwater caustic effects don't occur much deeper than twenty or thirty feet. It would be inaccurate to include them in a deep-sea picture. In addition, they only occur on sunny days and are visible only on the top surface of underwater forms.

CAUSTIC REFLECTIONS

Caustic reflections can be cast upward from wavelets, a common sight on the downfacing planes of the architecture of Venice. A caustic pattern appears on the inside surface of the vaulted arch at right. Figure 1 shows how the waves act like a concave mirror to concentrate the reflected rays of light.

Caustic reflections can also appear inside concave shiny objects such as cups or bowls. The kidney-shaped patterns called nephroid curves appear at the bottom of an empty coffee cup held under a bright light.

You can observe caustic effects almost anywhere the sunlight shines through curving glass or reflects off shiny metallic surfaces.

Sauropolis Gate, 2005. Oil on board, 13½ × 7 in.
Published in *Dinotopia: Journey to Chandara*.

SPECULAR REFLECTIONS

An object with a shiny surface is like a mirror. It reflects an image of whatever is around it. The hood of a car reflects the pattern of tree branches above it, while a chrome hubcap will reflect the road and the sky.

Treasure Room, 1995. Oil, 14 × 15 in. Published in *The World Beneath*.

EXAMPLES

In the diner sketch, left below, the napkin holder acts as a slightly imperfect mirror, reflecting an image of the sugar container. The diamond-shaped area stamped in the chromed surface interrupts the reflection.

The gold treasures, left, don't reflect a clear image, but they have to be rendered with a wider range of values than the diffusely reflecting stone columns and ceiling. In the painting of the spaceman opposite, the shiny skin of the ship captures an image of the fin, with its gray and red graphics. The reflection is compressed because of the cylindrical form of the surface.

THREE RULES OF SPECULARITY

1. The more reflective the surface, the broader the range of values you need to paint it.

2. Convex reflective surfaces, such as chrome, reflect a miniature view of the scene around the object, often including elements beyond the limits of your composition.

3. Whether you're rendering digitally or traditionally, the specular pattern is a separate layer added on top of the usual modeling factors that you use to render the object.

In other words, imagine how you would paint a regular matte-surfaced apple. If the same apple were given a high-gloss wax coating and you painted it again, you'd have to consider the normal modeling factors *plus* the specular effects.

SPECULAR VERSUS DIFFUSE REFLECTION

In *specular reflection*, light rays bounce off the surface at the same relative angle that they approached it. In diffuse reflection, light rays bounce in all directions. Diffuse reflection is typical of a matte surface, such as an egg. Many surfaces are a combination of specular and diffuse reflections.

You can study the effect of specular reflection by putting a polished apple or a billiard ball next to a silver ball, such as a Christmas tree ornament.

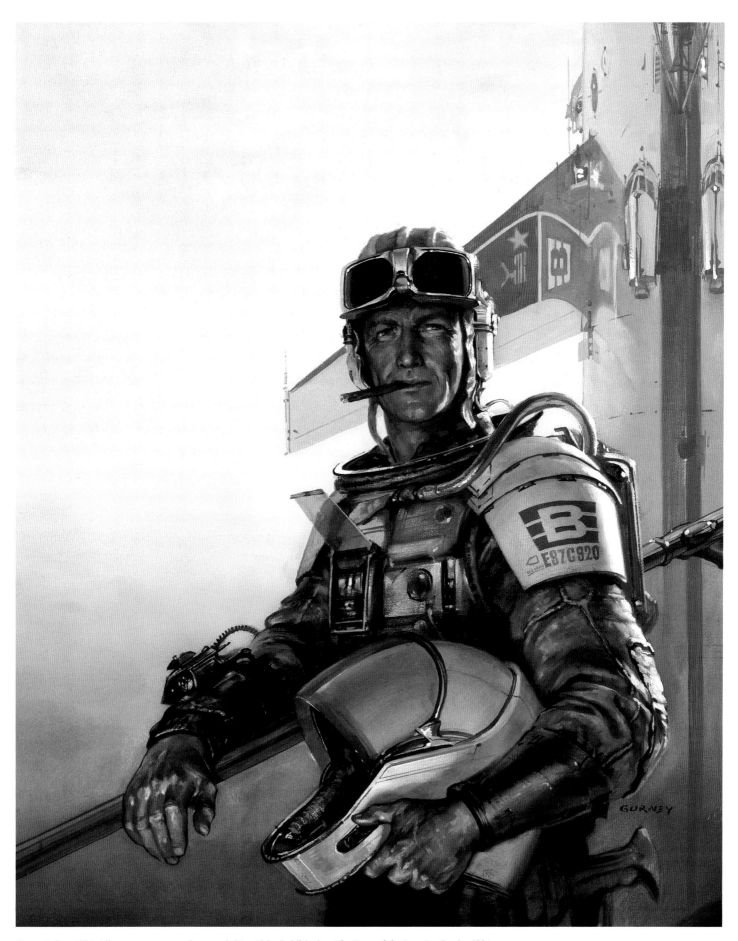

Space Jockey, 1984. Oil on canvas mounted to panel, 24 × 18 in. Published as *The Steps of the Sun*, Ace Books, 1984.

HIGHLIGHTS

Highlights are specular reflections of the light source on wet or shiny surfaces. Imagine placing a pocket mirror beside the object and angling it so that it reflects the light source back into your eye. Any plane parallel to that mirror surface will reflect a highlight back to you.

Zemango Kokobeya, 2007. Oil on board, 6 × 6 in.

SPECULAR HIGHLIGHTS

The sculpted head, right, is covered with reflective silver paint. A green light shines from the left, a magenta light shines from the right front, and a blue light comes in from farther to the right.

Even with three different light sources, the lights don't really mix very much on the planes of the head. Instead, each light source accounts for a separate array of specular highlights, and each set of highlights defines a set of parallel planes. Our brains are able to construct an understanding of form based on these fragmentary bits of information.

The location of the highlights on the giant snake at right helps us to understand that the snake is not cylindrical. Instead, it flattens out a bit where it squeezes against the crocodile.

In general, the highlight on any glossy form is not a pure white, but rather a combination of the color of the source and the local color of the object. For example, highlights in black skin, above, reflect the blue of the sky.

ANNULAR HIGHLIGHTS

Highlights don't form only in the center of large objects. They also can form into a pattern of circles made up of individual scratches on metal or twigs in trees. For example, when you look into the maze of ice-covered bare branches of a forest in winter, you're only seeing a fraction of the detail. The light illuminates only a few of these branches while most of them blend invisibly into the general gray.

Only the branches that are perpendicular to the direction of the light catch the highlight. The illuminated twigs align into concentric rings around the center point of the light source. These annular highlights help the viewer to subconsciously orient to the location of the light source. The three arrows in the photo are placed perpendicular to the illuminated twigs. If you follow the arrows, they lead to the location of the sun.

You can also observe annular highlights in the scratches of a well-used stainless-steel surface, like the cookie sheet and pot lid, below, left. Look for them in the window of a passenger train on a late afternoon, in a cobweb on a dewy morning, in a cornfield lit by a setting sun, or on tree branches surrounding a streetlight on a rainy night.

Figure 1. Annular highlights on a cookie sheet and a pot lid.

Figure 2. Annular highlights on ice-covered branches.

Titanoboa, 2009. Oil on panel, 14 × 18 in.

COLOR CORONA

An extremely bright source, such as a setting sun or a streetlight, is often surrounded by a region of colorful light called a *color corona*. The color corona appears both in human vision and in photography, where it is sometimes called a lens flare.

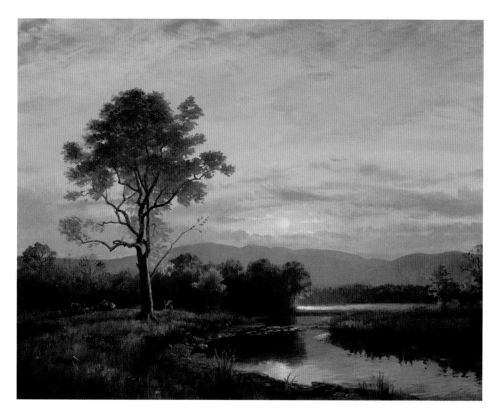

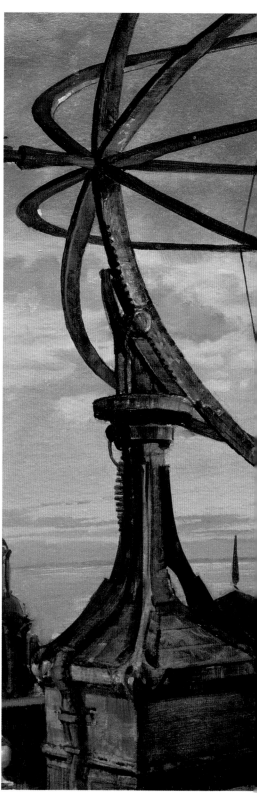

Light ricochets off floating particles in the air, creating a chromatic halo around the source. When this bright light enters the human eye it scatters further in the eyelashes, the cornea, the lens, and the fluid inside the eye. The spillage of light raises adjacent values and fills dark forms with a golden halo.

Photographic lens flares often include starbursts, rings, or hexagons in addition to the softly gradating glow of bright color. The internal scattering of light within the lens elements causes all these artifacts.

A corona will form around any very bright source or reflected source, including streetlights, car headlights, and solar highlights on wet surfaces. The glow takes on the native color of the source. With digital painting techniques, coronas can be added with photo-editing software to give a realistic touch to a fantasy or science fiction rendering.

Both of these images are made with traditional oil paints without digital retouching. At right, the corona forms around the reflections of the light source on the water. The color spreads out from the area of the hottest reflections and lightens all the adjacent silhouettes. In the painting above, the corona gently warms the color of the mountain

silhouettes. A color corona can make a source seem brighter than the white of the paper and can actually make a viewer squint involuntarily.

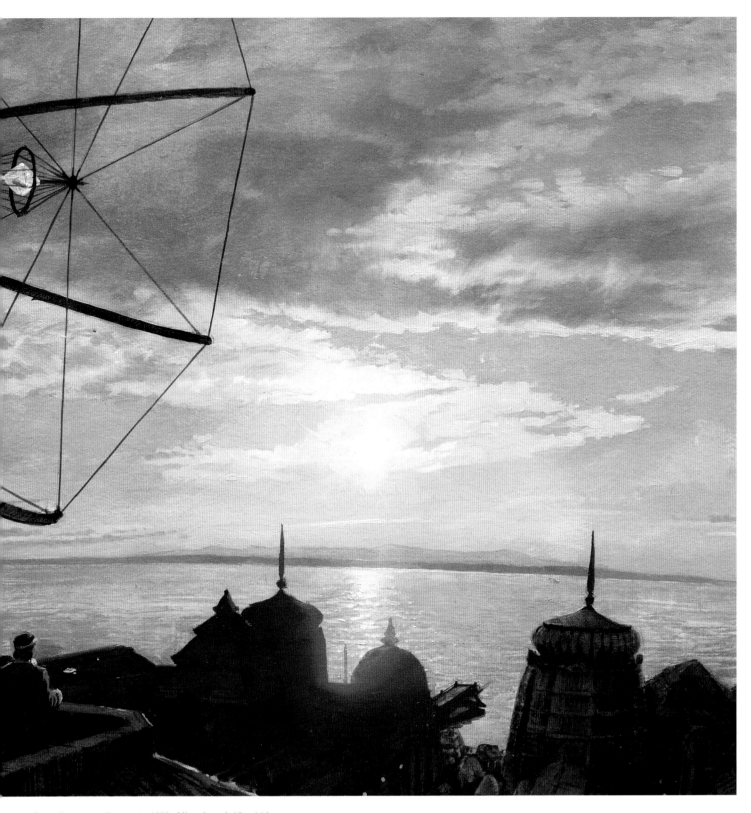

Above: Sunset over Dinotopia, 1998. Oil on board, 13 × 14 in.

Opposite: Sunset over the Catskills, 2003. Oil on canvas, 16 × 20 in.

MOTION BLUR

There are two kinds of blurring that suggest motion or action: *motion blur*, where a form moves rapidly in front of a stationary observer or camera, and *speed blur*, where the camera tracks along with a fast-moving object.

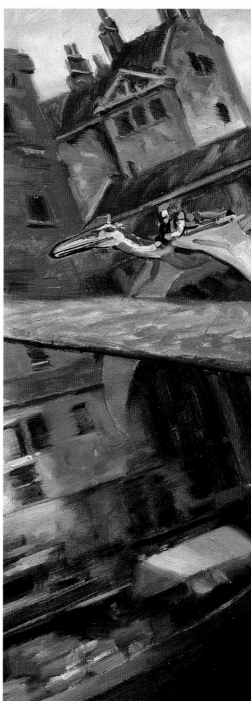

MOTION BLUR

If you look at individual frames from live-action films, any fast-moving object has a softly blurred edge. The ability to simulate motion blur in CGI animation was the revolutionary breakthrough that jump-started the industry.

Primitive CGI animation, like traditional stop motion or drawn animation, leaves hard edges on moving objects, which gives it a characteristic (and sometimes appealing) jittery effect rather than a fluid feeling to the motion.

As painters of still images—digital or traditional—we can take a lesson from these animation pioneers.

The painting below shows Dinotopian dancers dressed up as dinosaurs parading at night through a city. They're caught midstride in a wild dance. Their left feet are swinging forward, and their arms are flapping upward. The faster a form is moving, the more it is blurred. The blur is greatest in relation to the path of the movement.

The figures and the background were painted all wet together, and then the edges were softened in the direction of the movement. For this kind of soft passagework, a slower drying medium helps.

To suggest that the imaginary camera was tracking along with the dancers, and to give a sense of shallow focus, it also helped to blur the details of the crowd across the street. If those elements had crisp edges, they would have lost the feeling of depth and motion.

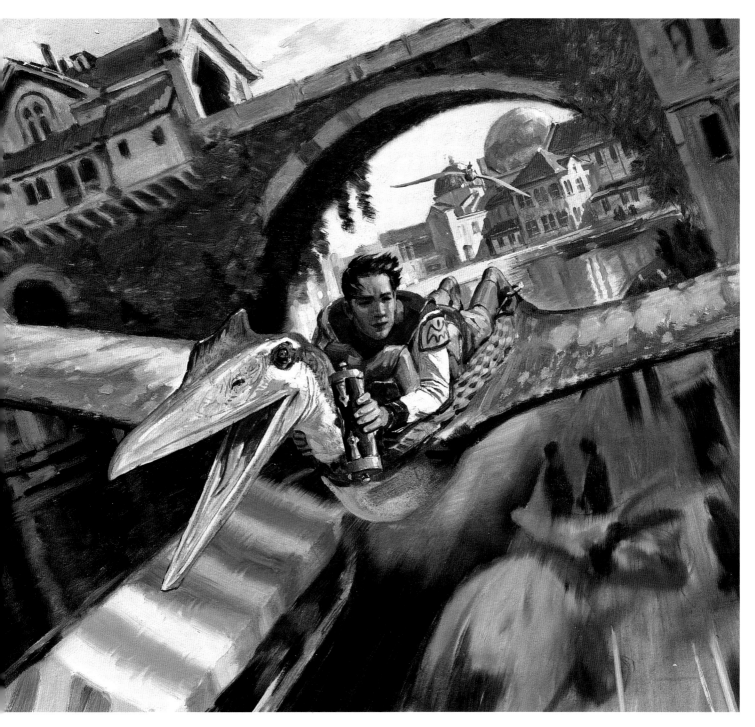

SPEED BLUR

Here's a painting of a Dinotopian pterosaur pilot flying low through a city. The idea was to grab the reader with fast movement.

This effect resembles the look of a frame of film shot during a scene where the camera is tracking a fast-flying object through tight spaces. The whole background blurs radially from the vanishing point along the path of movement. The blur gets more extreme toward the edges of the picture. Forms closest to the camera blur the most. As with motion blur, only the edges perpendicular to the movement get the blur treatment; the ones running along the path of action stay sharp.

The way to paint such an effect in oil paint is to lay in all the colors in wet paint and blend the edges with a soft brush.

Above: Will Arrives, 2005. Oil on board, 12 × 19 in. Published in *Dinotopia: Journey to Chandara*.

Opposite: Masked Dancers (detail), 1998. Oil on board. Published in *Dinotopia: First Flight*.

PHOTOS VS. OBSERVATION

Although photographs are useful reference tools in many ways, they're often disappointing when it comes to recording color. In your plein-air studies, you can observe and record nuances of color that completely elude the camera.

The photo above was taken during the same afternoon that I painted the study opposite, which relied purely on observation. The comparison illustrates the point that cameras tend to distort light and color in the following ways:

1. Deep shadows will appear pure black and bright highlights will appear pure white due to clipping. *Clipping* is the loss of information because of the photosensor's inability to respond to relative extremes of bright or dim light.

2. Colors tend to shift or weaken in chroma and become monochromatic. Subtle or close variations between adjacent warm and cool colors are often not registered.

3. Weak sources, such as reflected colors from nearby objects, are often lost.

USING PHOTOS WITHOUT LOSING COLOR

1. If you're really pressed for time and want to capture a complex scene for future reference, make a quick color note in your chosen medium, and use

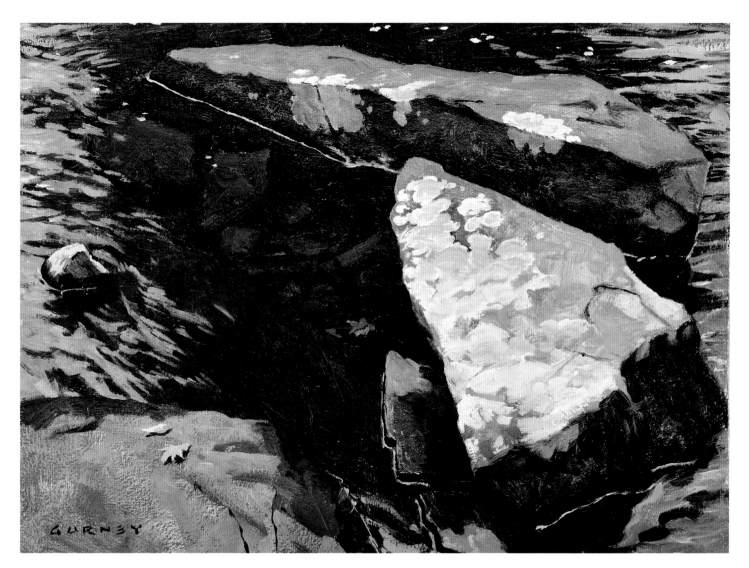

photography to document the details of the scene for later reference.

2. Turn those reference photographs into black and white images by desaturating the color. That way, you won't be influenced by the photographic color.

3. Do what photographers do: wait for overcast days where the light and dark values aren't so extreme, or hold up a large white reflector to bounce light into the shadows if you're shooting in sunlight.

4. Take two exposures, one for the darks and one for the lights, and use those photos separately for reference.

Above: Rocks and Shallows, 2009.
Oil on canvas mounted to panel, 9 × 12 in.

Opposite: Rocks and Shallows, 2009.
Digital photo.

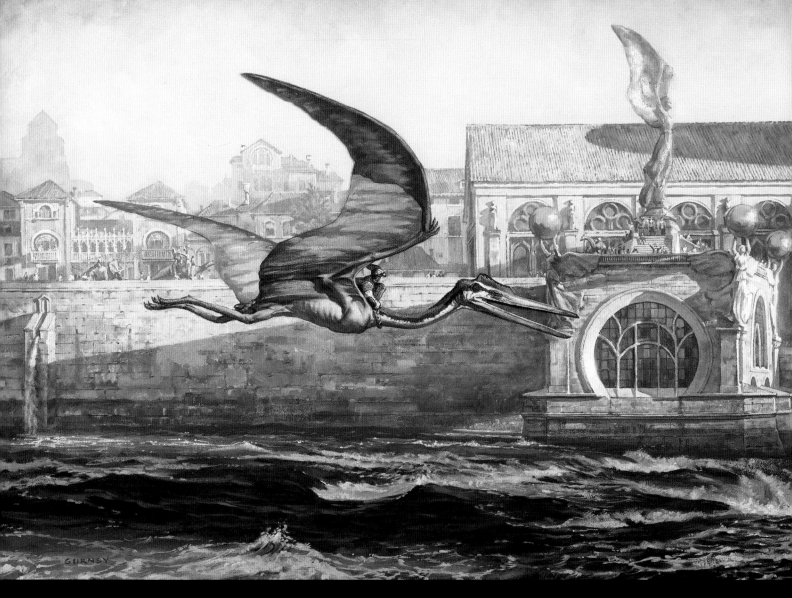

Rumble and Mist, 1992. Oil on canvas mounted to panel, 18 × 52 in. Published in Dinotopia: The World Beneath.

ATMOSPHERIC EFFECTS

SKY BLUE

The sky is not a flat, even blue. There are two overlapping systems of color gradations in a daytime sky. One system, "solar glare," is governed by the proximity to the sun. The other, "horizon glow," depends on the angle above the horizon.

Figure 1. Looking in the vicinity of the sun.

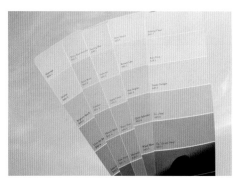
Figure 2. Looking away from the sun at the same moment.

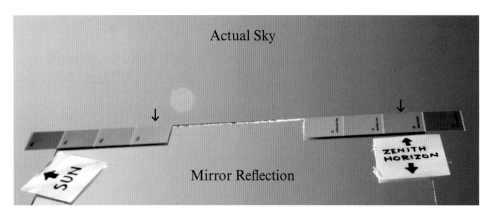

Figure 3. Photographing the swatches in Figure 5.

Figure 4. Looking away from the sun. Note the match at A.

Figure 5. Looking toward the sun.

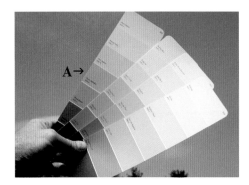

Actual Sky

Mirror Reflection

Figure 6. The gradation caused by solar glare.

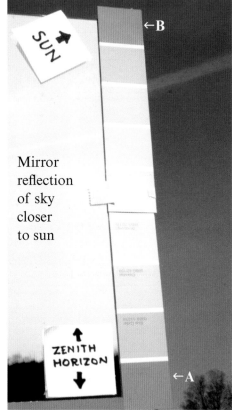

Mirror reflection of sky closer to sun

Figure 7. The gradation caused by horizon glow.

WHY THE SKY IS BLUE

Most people know why the sky is blue. It's caused by a phenomenon called *Rayleigh scattering*. Tiny air molecules refract the shorter wavelengths at the violet or blue end of the spectrum to a greater degree than the red wavelengths. This makes the blue light bounce in all directions, giving the sky its characteristic blue color, while the less affected red and orange light rays continue on their long, straight journey through the atmosphere.

As artists, we need to know a little more than that. How does the blue sky color change as we look in different directions? Where is the blue darkest or most saturated?

TOWARD AND AWAY FROM THE SUN

The photos in Figures 1 and 2 were both taken at 4:10 in the afternoon of April 12, 2008, in Germantown, New York. The one on the left was taken facing toward the sun, and the one on the right was taken seconds later facing away from the sun.

The clouds look completely different. Near the sun, clouds have dark centers and light edges. With the sun shining from behind the viewer in Figure 2, they are lightest at the tops or centers and they get darker at the sides and bases. Smaller clouds are not as white because they have a lesser mass of vapor to reflect back the light.

The color of the sky is different, too. In the vicinity of the sun in Figure 1 there is a region of warm glare, which mixes with the pure blue color, making it more of a dull gray-green. Looking away from the sun, the blue is higher in saturation, as well as a different hue, tending a bit more toward violet.

How do we know the camera isn't deceiving us? Is there another way to check these observations?

MAKING A CYANOMETER

Blue paint swatches from a home improvement store can provide a useful tool, called a cyanometer, to match and measure sky colors. Figure 4 shows how the sky looks compared to the paint swatches while facing away from the sun. One of the blue swatches (A) is a close match to the adjacent area of the sky.

It was difficult to photograph the swatches compared to the sky while facing toward the sky because there was no way to angle the swatches so that the sun could shine directly on them. A mirror set up on the windshield of the car bounced the light back onto the swatches (see Figure 3).

But we can't completely trust this comparison, because the warm light bouncing up from the ground and from my T-shirt influences those color swatches. Perhaps that's why the swatches look a little warmer than they should.

SOLAR GLARE

Figure 6 demonstrates how the sky gets lighter near the sun. By cutting a single paint strip in half, the matching halves can be spaced apart to make comparisons of sky colors. None of the swatches matches the sky exactly. The hue and chroma are different, but the values come close in a couple places.

Clearly the value of the sky darkens as we shift our gaze horizontally away from the sun. The left arrow, nearer the sun, matches the value of the lightest swatch, while the right arrow, just a little bit farther from the sun, matches a swatch that's two steps darker. The mirror is reflecting a higher section of the sky, which also is darker on the right than on the left.

HORIZON GLOW

The sky color also shifts in value from zenith to horizon, as we can see when the cyanometer is arrayed vertically (Figure 7). At (A) there's a close match of value between the darkest swatch and the distant sky, even though the chroma is different. Higher in the sky at (B), the same swatch looks much lighter than the sky surrounding it.

The mirror reflection shows a simultaneous comparison of what's going on behind us in a region nearer the sun. This whole area of the sky behind us is much brighter in value than the sky that's directly visible.

CONCLUSIONS

Let's draw some general conclusions from these observations:

1. In each of the two gradational systems the sky color changes in value, hue, and chroma. The two systems interact with each other so that every patch of sky changes in two different directions at once.

2. As we move from the zenith to the horizon, the sky generally tends to get lighter, because we're looking through more atmosphere. Near the horizon, depending on the time of day and the direction of view, the sky color can range from pale cerulean to warm gray to dull orange, but it's usually lighter than the regions above it.

3. As we approach the sun, the sky color gets lighter and warmer because a great volume of white light is scattered at shallow angles by large particles in the atmosphere. You can see this best by standing near the edge of the shadow of a building with the sun just hidden behind the roofline. A weaker but noticeable lightening also occurs at the *antisolar point*, 180 degrees opposite the sun.

4. The point of the darkest, deepest blue, called the *well of the sky*, is at the zenith only at sunset and sunrise. To be precise, the well of the sky is actually 95 degrees away from the setting sun across the top of the sky. At other times in the day, it is about 65 degrees away from the sun.

THE BOTTOM LINE

What all this means to you when you're mixing the colors for a blue sky is that you must shift your mixtures both from top to bottom as well as from side to side. To do this means mixing at least four separate starting colors to paint any given segment of clear blue sky.

ATMOSPHERIC PERSPECTIVE

Atmospheric perspective refers to the way the appearance of objects changes as they are viewed at a distance through layers of illuminated air. The bold colors of the foreground gradually transform until they match the sky.

Above: Chapel at West Point, 2004. Oil on panel, 11 × 14 in.

Opposite: High Country, 2007. Oil on board, 17¼ × 18¼ in. Published in *Dinotopia: Journey to Chandara*.

Consider that the blue dome of the sky itself is really a semitransparent film of air interposed over the blackness of space.

The illuminated sides of objects generally lose their color saturation, becoming grayer as they go back in space. Warm colors in particular grow duller and cooler. Yellow, orange, or green foliage drops back to a gray-green or blue-green.

The contrast of value between the illuminated and shadowed sides of all objects reduces until everything eventually blends into a flat, pale hue of a distant silhouette against the horizon sky. As the contrast between the lit and shadowed surfaces diminishes, the sense of clarity also decreases, making distant areas appear blurry and unresolved, even though the details may actually be present.

SHADED AND ILLUMINATED SURFACES

The colors of ordinary objects, such as trees, mountains, or buildings, alter in predictable ways as the viewing distance increases. The darkest areas are affected first, generally becoming lighter and bluer. You can observe this outdoors by holding up a black-painted card or piece of black velvet adjacent to a distant open window or a knothole in a tree. Even from across the street, what might at first appear to be a profound black is actually infused with a soft blue or violet, akin to the color of the sky. The same scattering that is happening in the upper atmosphere is also happening in the air between you and any object.

EFFECT ON WHITE OBJECTS

Bright white objects behave differently from dark objects. Rather than growing cooler or grayer with distance, they become warmer in color. The white light of the setting sun near the horizon becomes the most intense orange or red imaginable.

Likewise, white clouds at midday become more orange-colored and darker in value as they approach the horizon, until the light loses its force altogether and it merges with the general tone of the sky at the horizon. Bright white objects, like houses on far hills, remain visible the longest in the far distance, while everything else has merged with the color of the overall silhouette.

Atmospheric perspective only happens if the parcel of air you're looking through is illuminated. If you're looking at a mountain range five miles away on a cloudy day, and a cloud shades half of the parcel of air between you and the mountain, then the mountain range will appear darker behind that shaded region.

DUST AND DISTANCE
The effect of atmospheric perspective is enhanced by the presence of dust,

moisture, haze, or smog. I painted the plein-air study opposite on a very clear March day. The hills three miles distant are still quite dark and distinct, and the cloud shadows are a deep violet.

At eight miles distant, just to the right of the tree, the warmly lit surfaces have cooled considerably but are still visible, and the darks have lightened to a midrange blue. On a very hazy day, the middle-ground hill behind the chapel might have been only a pale silhouette.

In the imaginary landscape above, I enhanced the atmospheric effects by adding moisture to the air. Wherever that moisture is touched by sunlight, the tones are lightened and warmed compared to similar passages on the shadow side of the mountain that are just as far away.

REVERSE ATMOSPHERIC PERSPECTIVE

The general guideline of atmospheric perspective is "warm colors advance, and cool colors recede." But in wonderful, rare instances, the rule is reversed, and the entire scene gets warmer as it goes back.

This happens when moist vapors or dust clouds hover in the air near the sun, especially at sunrise or sunset. Large particles in the air close to the ground scatter the orange-colored sunlight at slight angles to the original rays. A halo of orange glare surrounds the sun. This orange or red illumination spills into the distant dark forms more strongly than does the blue scattered light of ordinary conditions.

The effect is most noticeable if you are looking toward the late-afternoon sun on a misty or dusty day. The unretouched photo below was taken just before sunset in the Catskill Mountains immediately after a heavy rainstorm. The effect lasted only about fifteen minutes.

Note that the foreground is actually cooler than the distance. The light of the setting sun spills out into the surrounding atmosphere, warming the outlines of the trees in the distance.

Because reverse atmospheric perspective is relatively rare in nature, it conveys a feeling of strangeness and excitement. That's why I used it on the first vista of Chandara in Dinotopia (pages 8–9).

Likewise, in the waterfall painting opposite, I deliberately warmed the silhouette of tree and stone at the top of the picture surrounding the warm glare of the morning sunlight.

Warm mountain ranges near setting suns were a favorite device of Hudson River School painters, especially Sanford Gifford, Frederic Church, and Albert Bierstadt, all of whom tended to avoid high-chroma blues in their distant spaces.

The nineteenth-century writer Ralph Waldo Emerson expressed a poetic vision of this quality of sunlight, calling it a "consuming celestial fire" having the power "to burn until it shall dissolve all things into the waves and surges of an ocean of light."

Below: Golden Road, unretouched digital photo.

Opposite: Kaaterskill Falls, 2004. Oil on canvas, 20 × 16 in.

GOLDEN HOUR LIGHTING

Strong color in nature is fleeting. At dawn and dusk, as the sun shines through an ocean of air, the colors become bold and dramatic. Photographers call this time of day the golden hour or magic hour.

West Clare Graveyard, 1995. Oil on board, 8 × 10 in.

Above: Catalina Ballroom, 1984. Oil on panel, 8 × 12 in.

COLOR CHANGES AT DAY'S END

The sun is so low in the sky that its light travels almost parallel to the surface of the earth. A ray of light intersects the sphere of the earth on a line of tangent, like a needle pushed into an orange peel at a very shallow angle. Sunlight travels through many more miles of atmosphere at this angle than when it's coming steeply down to earth at noontime.

Because of the greater distance traveled, more blue wavelengths are scattered out of each parcel of light. This makes the sky above a richer blue.

The remaining sunlight is weaker in overall brightness, and more orange or red in color. Forms lit by the setting sun take on a golden color, and the shadows are bluer than usual, both because the sky really is a richer blue, and because the warmly lit surfaces induce a complementary cast to the shadow areas.

In the sky near the sunset, there's a noticeable progression of color from the blue above to the soft yellows and dull reds near the horizon. This color progression is brighter both in value and chroma in the region of the setting sun.

EXAMPLES

In the plein-air graveyard study, left, three stones with Celtic crosses rise up from an overgrown churchyard in Kilnaboy, Ireland. The pink light of the rising sun lights only the tops of the crosses. The sky behind the crosses changes from gray clouds above through light pale yellows to a deep orange color just above the violet hills.

The light effect on the Avalon ballroom, left, only lasted a few minutes. As the sun set over Catalina Island, the island's shadow rose up the side of the white building. The sky was a deep blue.

The scene at right, painted to celebrate a book festival in New York City, accentuates the height of the Empire State and Chrysler buildings by placing them in the last light of the day, while the smaller buildings below them have already fallen into shadow.

Flights of Fancy, 1996. Oil on canvas mounted to panel, 26 × 18 in. Poster for New York Is Book Country.

SUNSETS

Sunsets present an infinite variety of colors because the sun is interacting with so many different layers of air, dust, and clouds. Photographs rarely capture them accurately. With good preparation, you can paint them from observation.

WHAT TO LOOK FOR IN SUNSETS

If the air is full of moisture and dust, the setting sun will be accompanied by more conspicuous red and yellow clouds. The boldest red-orange glow forms in the sky at the spot nearest where the sun crosses the horizon.

A weaker secondary glow forms at the antisolar point, facing directly opposite the sun. After sunset a gray layer rises up from the horizon in the antisolar region. This layer is the plane of the cast shadow of the earth itself. Eventually the warm colors drain out of the sky entirely. Sometimes a soft violet glow is all that remains until full darkness.

During the first hour of morning, these color progressions reverse, often with pinker colors because less dust has been raised in the air. A person who wakes early is lucky enough to behold what William Wordsworth called the "vision splendid" before the colors "fade into the light of common day."

LAYERS OF CLOUDS

Typically, the light hitting the tops of the clouds remains relatively white compared to the light that's closer to the ground. Whenever there are several layers of clouds at various altitudes, the higher clouds are whiter and the lower clouds are more yellow or red—just like the sky's color bands mentioned on the previous page. The light gets dimmer and redder as it approaches the earth's shadow line. For this reason, in the sunset painting at opposite, top, only the lower clouds are receiving the high-chroma red-orange light.

PAINTING SUNSETS FROM OBSERVATION

When you're painting sunsets outdoors, it helps to premix the colors before the moment arrives, anticipating the effect you want to capture. Then, as the light fades, you can paint mostly from memory as you look at the darkening colors on your palette. You can also use a small LED flashlight to illuminate your palette area. The LED lights are good for this purpose because they give a reasonably white light.

Opposite, below, are two plein-air paintings made during the last hour of a spring day, as the sun was setting over the Hudson River. They are painted about fifteen minutes apart.

In the second painting, right, the sun was sinking into a bank of clouds. The air was full of haze and mist, which reduced the intensity of the sun, allowing me to look safely directly toward it.

One thing photographs often miss is the color of the ground silhouettes. The earth below the sunset is dark, but not black as it appears in a photo. The eye can usually see some local color in a ground silhouette, mixed with the effects of the color corona mentioned on pages 166–167.

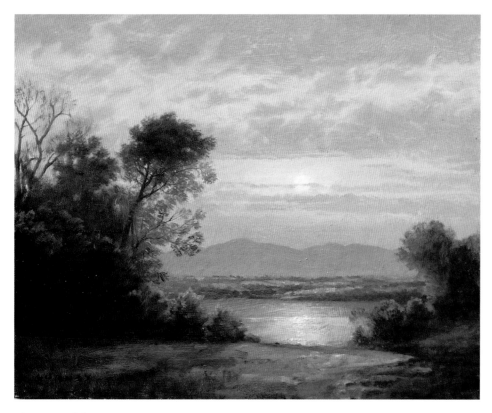

The Turning of the Day, 2004. Oil on panel, 8 × 10 in.

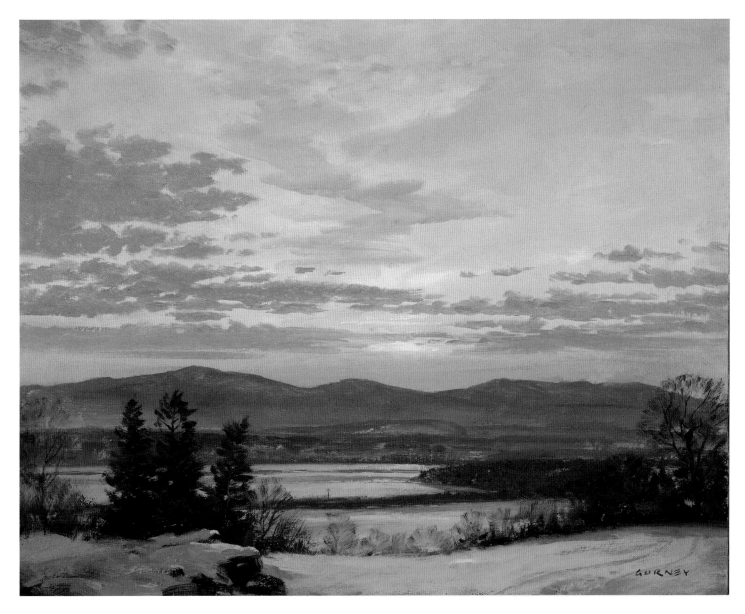

Top: Winter Sunset, 2004. Oil on canvas mounted to panel, 11 × 14 in.

Above: View from Vanderbilt, 2004. Oil on board, 9 × 12 in.

Right: Vanderbilt Sunset, 2004. Oil on board, 9 × 12 in.

FOG, MIST, SMOKE, DUST

In extremely foggy or misty conditions, contrast drops off rapidly as forms recede in space. The sun can't penetrate a deep fog layer, so the light reaching the ground seems to come from all directions.

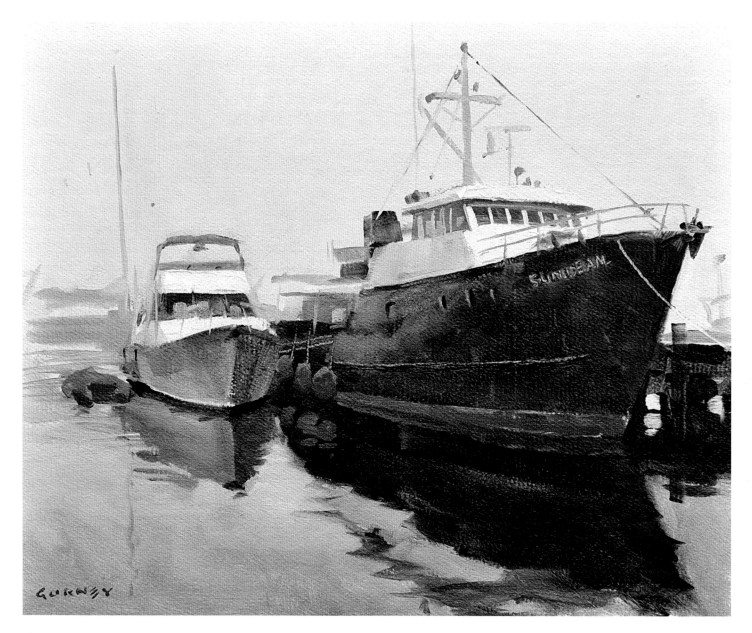

Above: Harbor Fog, 1995. Oil on board, 8 × 10 in.

Opposite: Flight Past the Falls, 2006. Oil on canvas mounted to panel, 20 × 24 in. Published in *Dinotopia: Journey to Chandara.*

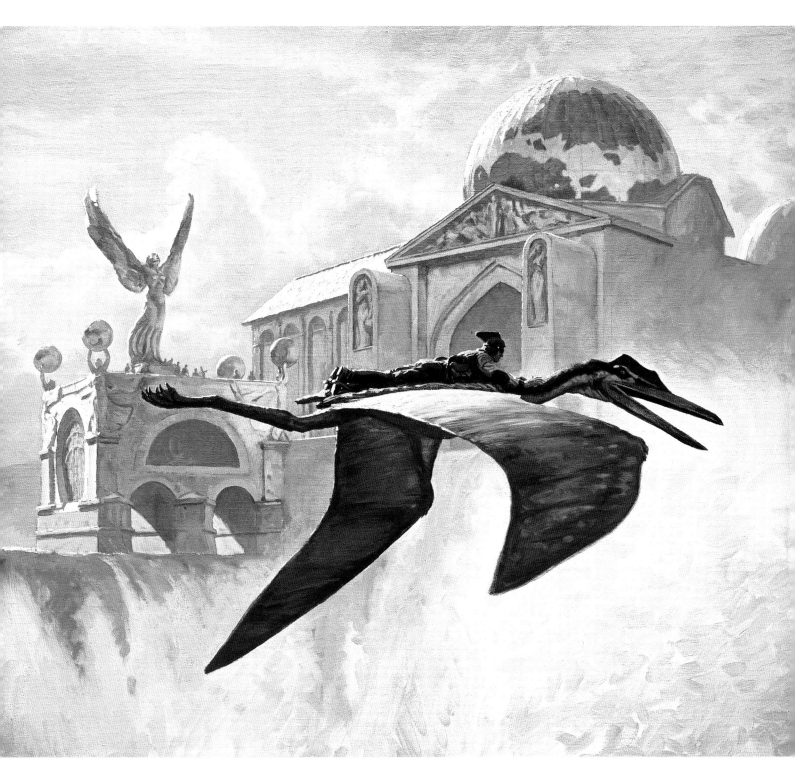

The harbor scene opposite captures a dense fog in Maine. The water was glassy, just one tone darker than the sky. Everything was gray except the red details at the waterline. All the color of the far boats dropped out. The distant sailboat is just a ghost.

This painting above shows a Dinotopian pilot flying through the mists of Waterfall City. The warm colors and the pale tones in the distance give the painting a feeling of lightness and airiness.

The mist layer rises only partway up the buildings. This allows the direct light of the sun to come through and touch the forms, something that doesn't usually happen in foggy scenes. There's also blue illumination from the sky coloring the edge of the falls and the near wing of the flying reptile. In this unusual condition, with mist close to the ground but direct sun entering from above, the shadows will be far lighter than they would be normally.

RAINBOWS

Rainbows have symbolized everything from the leprechaun's pot of gold to God's promise of redemption. Modern science explains rainbows as purely optical phenomena. It's good to keep both mythology and meteorology in mind as you paint them.

Rainbows are formed by light reflected off the inside of rain droplets.

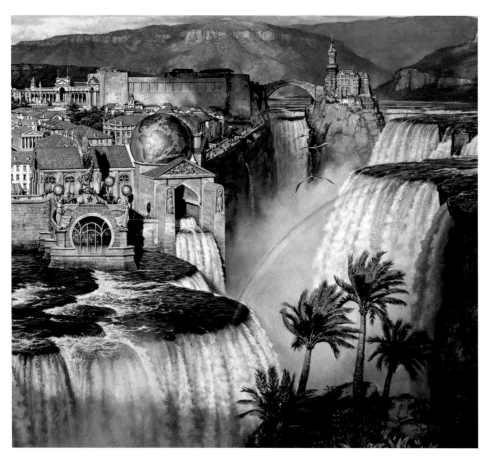

SYMBOLISM
The Greeks believed the rainbow was a path between heaven and earth. In Norse mythology the rainbow was seen as a bridge between Asgard and Midgard, the realms of the gods and mankind respectively. In Chinese mythology, the rainbow was regarded as a slit in the sky, sealed with stones of five different colors.

In the story of Noah, the rainbow serves as a sign of God's promise that the earth will never again be flooded.

Most Renaissance and Baroque painters in Europe used it more broadly as a symbol of God's covenant.

ROMANTIC VIEWS
Sir Isaac Newton was a pioneer in the scientific study of the rainbow, but some poets and artists of the Romantic era believed that such analysis "destroyed all the poetry of the rainbow by reducing it to prismatic colors." "Unweaving the rainbow," as they put it, reduced its power and meaning.

But Newton also had admirers among artists, especially J.M.W. Turner, Johann Friedrich Overbeck, and John Constable, who painted rainbows from observation and called them "this most beautiful phenomenon of light."

From ancient times, people speculated on how many strands of colored light went into the rainbow. Ancients argued for two, three, or four colors. Newton reasoned that there is an infinite gradation, but seven essential hues. Starting from the outermost band, they are red, orange, yellow, green, blue, indigo, and violet.

SCIENTIFIC EXPLANATION
The primary rainbow forms when rays of sunlight reflect off the inside surface of millions of raindrops that remain in the air after a storm. As each ray of light enters a droplet, it is refracted slightly. A portion of each ray then reflects once off the inner surface of the droplet. The ray exits the droplet and refracts again (see the lower two enlarged circular droplets in the diagram above).

As a consequence of the refraction, the white light splits into its component colored rays, each bending in varying amounts, blue more than red. The effect of millions of rays exiting millions of individual droplets is that we see bands of color at fixed angles to our eye.

It doesn't matter whether the droplets reflecting the sunlight are close to the viewer or far away. The rainbow does not occupy a particular geographical space, but rather an angle in relation to the

viewer. You can observe this by studying where rainbows form in a lawn sprinkler.

The primary rainbow forms at about 42 degrees from the antisolar point, the point below the horizon that is 180 degrees away from the sun. As the sun descends in the afternoon sky, the antisolar point rises toward the horizon so that more and more of the full circle of the rainbow becomes visible. Since the antisolar point is at the center of the rainbow, all shadows in the scene should be oriented toward that point

SECONDARY RAINBOW
A secondary rainbow is sometimes visible outside the primary rainbow. It is reversed in its color sequence and weaker than the primary rainbow. The light for the secondary rainbow comes from sunlight that bounces twice inside the floating water droplets (represented by the two enlarged droplets higher up in the diagram).

In a region between the primary and the secondary rainbow, the sky appears slightly darker. This darker region is sometimes called *Alexander's dark band*. It's named after Alexander of Aphrodisias, who first described the phenomenon. The secondary bow forms at about 50 degrees from the antisolar point.

The dark band only looks darker because of additional light reflected back inside the primary bow. In rare conditions, faint *supernumerary bows* form inside the primary bow as a result of additional internal reflections.

TECHNIQUE TIPS
Artists should keep in mind a basic optical law of rainbows: The colors of the rainbow should always be lighter than the background, because the colored light of the rainbow is added to the light in the scene behind it. You can accomplish this in traditional opaque media by painting a semitransparent, soft-edged white arc first, letting it dry, and then glazing colors over it.

The double rainbow above appeared in *Dinotopia: First Flight*. To get the curvature exactly even, I attached the paintbrush to an improvised beam compass, which was basically a long wooden bar pivoting on a nail.

The painting *Blind Girl* by Sir John Everett Millais, on page 17, shows a double rainbow. The majesty of his conception comes from the knowledge that the girl is unaware of the glory behind her. Millais is careful to show the light coming from behind our left shoulder. The shadows are cast just a little to the right of the trees. The antisolar point is outside the frame of the picture, just to the right of the flock of crows. It forms the center of the arc of both rainbows.

In the painting above, the antisolar point would be a little below the center of the composition. In the detail of the painting of Waterfall City, opposite, it would be near the bottom right corner of the painting. Note how the shadows of the buildings are cast downward toward that point.

Above: Gideon's Rainbow, 1999. Oil on board, 12½ × 26 in. Published in *Dinotopia: First Flight*.

Opposite: Waterfall City: Afternoon Light (detail), 2001. Oil on canvas mounted to panel.

SKYHOLES AND FOLIAGE

There can be as many as 200,000 leaves on a large oak tree. If you try to capture all that sharp detail you might miss the sense of softness, delicacy, and interpenetration with the sky. The key is to be aware of skyholes and transparency.

character to suggest that they were fringed with leaves.

SKYHOLES

A tree presents a complex silhouette against the sky, but the silhouette is almost never completely solid. A few skyholes or apertures in the foliage puncture the shape of the tree and let you see through to the light beyond.

Early landscape painters like Claude Lorrain were sparing with skyholes, and they paid great attention to lightening the edge where the tree silhouette meets the sky.

There are two questions that every painter in opaque media, such as oil, gouache, or acrylic faces: Should you paint the sky first and render the leaves over it, or should you paint in the tree shape and add the skyholes later? Should you paint a skyhole with the same exact color note as the sky beyond?

If you enlarge a high-resolution photograph of a tree, the spaces inside the skyholes don't always present an uninterrupted view of the sky. Smaller skyholes often contain a network of fine branches and tiny leaves that weren't apparent from a distance. The presence of these small forms within the skyhole lessen the amount of light passing through from the sky, and thus lower the value. As a result, smaller skyholes should be painted a little darker than the actual sky color beyond.

It often helps to paint skyholes of various sizes, and give them a ragged

TRANSPARENCY OF FOLIAGE

Foliage in trees has different degrees of transparency. When the leaves emerge in the spring, they only partially veil the sky. The leaves make a whisper-thin texture that has to be painted delicately. As the leaves develop their chlorophyll and protective layers, they darken and become more numerous.

Some trees cover the sky more completely than others, with fewer skyholes. The tree shown in the detail above is an oak and happens to be very opaque. In the painting opposite, the tree that reaches into the sky from the left is a willow, which by contrast presents a soft and delicate texture.

Look for a range of degrees of transparency within a single picture. Claude Lorrain almost always had one tree that was very transparent adjacent to another that was more opaque.

Above: Upstream from Clonmel, 2004. Oil on panel, 8 × 10 in.

Opposite, far left: View Toward Indian Head, 2005.
Oil on canvas mounted to panel, 12 × 16 in.

Opposite, near left: Oak in the Hayfield (detail), 2004.
Oil on canvas mounted to panel, 14 × 18 in.

SUNBEAMS AND SHADOWBEAMS

Sunbeams are shafts of light made visible in dust- or moisture-laden atmosphere. They occur in rare conditions, which must be met in the painting if you want them to be convincing. *Shadowbeams* are even more unusual.

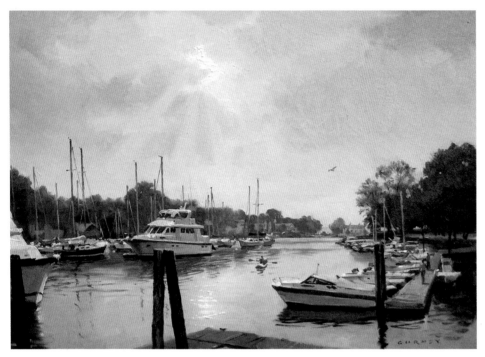

Harbor Island Morning, 2005. Oil on canvas mounted to panel, 12 × 16 in.

SUNBEAMS

In the harbor scene at left, the rays of sunlight seem to converge on the spot where the sun breaks through the clouds. In fact the rays are perfectly parallel, but seen in perspective, they vanish to the point of the sun's position.

Sunbeams occur when the following three conditions are met:

1. A high screen of clouds, foliage, or architecture is punctured by a few openings. The perforated layer must block most of the light to allow a darker backdrop against which the sunbeams can be seen.

2. The air is filled with dust, vapor, smoke, or smog.

3. The view is toward the sun. Large droplets scatter most of the light forward at small angles to the direction of the light. When you're looking away from the light source, the beams become nearly invisible.

The conditions might exist in a circus tent, a ruined building, or a dark forest interior. As with dappled light (see pages 192–193), the farther away the aperture, the more the edges of the beam become softened by the time they reach the ground. You won't see a sunbeam from a far cloud making a small spot of light on someone's lawn.

Bear in mind that sunbeams usually shine through uneven apertures, making three-dimensional columns of light with an amoeba-like cross section. This uneven form makes the density of the beam and the quality of the edges somewhat variable.

The Escarpment View, 2004. Oil on canvas mounted to panel, 16 × 20 in.

The sunbeam influences the shadow values of the forms beyond them even more than they affect the values of the light side. Using traditional paint, this can be accomplished by brushing a light, semiopaque tone over the dry background where the beams appear. However, opaque white pigment will tend to reduce the chroma of the color and make it chalky, so that color may need to be restored by glazing.

Alternately, the colors can be achieved by careful premixing. In the Dinotopia painting above, I premixed one string of colors for the areas inside the sunbeam, and a whole separate string for the colors of the darker unlit forest.

SHADOWBEAMS

The painting opposite, below, shows two shadowbeams, which are slightly darker than the background sky, slanting down to the left, where they intersect the valley floor.

Shadowbeams occur most often when a jet contrail aligns with the line of sight. Think of a contrail shadow as a bar of unilluminated vapor seen edge-on. The adjoining illuminated air is slightly lighter in value. The darker beam is usually only visible when there is a light hazy sky behind it.

Both sunbeams and shadowbeams should be used sparingly because they tend to attract a lot of attention.

King of Kings, 1995. Oil on board, 12 × 19 in. Published in *Dinotopia: The World Beneath.*

Sunbeams are seen to their best advantage while looking toward the sun. They vanish in perspective to that point.

DAPPLED LIGHT

As sunlight passes through the upper leaves of a tree, it covers the ground with a hodgepodge of circular or elliptical spots of illumination, called *dappled light*. The spots are scattered irregularly and they move when the wind blows the treetops.

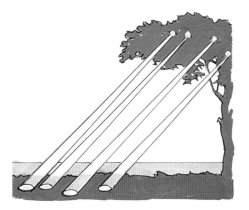

Figure 1. Dappled light.

When rays of light pass through small spaces between the leaves of a tree, each of those spaces acts like a pinhole projector. If you intercept one of the rays of light with your hand, you can trace it back toward the sun, which will be glimmering behind the treetops. If a cloud passes in front of the sun, the spots of light will disappear.

The circles of light touching the ground are actually projections of the circular shape of the sun. On rare days when the sun is partially eclipsed by the moon, each of the circles will seem to have a piece missing or a bite out of one side.

Above: Bilgewater, 2006. Oil on board, 11½ × 19 in. Published in *Dinotopia: Journey to Chandara*.

Left: Jabberwocky, 2002. Oil on panel, 8 × 10 in.

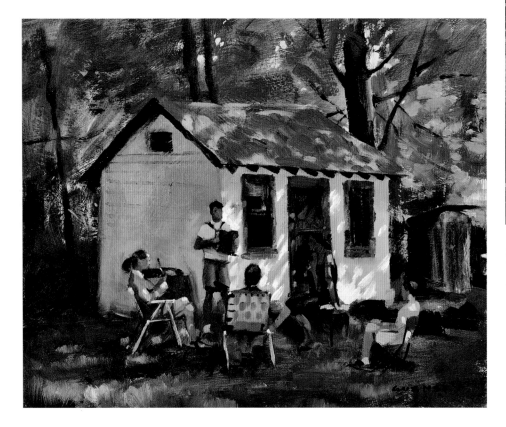

The circular spots of light shining on the ground vary in size depending on how high the projecting canopy is above the ground. A high tree canopy leads to larger circles with softer edges. In the oil study, left, the circles of light on the roof of the shed are about a foot in diameter.

When each cone of light intersects a surface at an oblique angle, it results in an elliptical shape. On a vertical surface parallel to the picture plane, the long axis of that ellipse always angles back toward the source of the light.

In the painting above, the rays of light are coming from the right and striking the upturned hulls of the ships. The elliptical spots of light elongate as the form of the ship's red hull curves away on the left side.

CLOUD SHADOWS

On a partly cloudy day, passing clouds interrupt the view toward the sun. As a result, patches of direct sunlight drift across the landscape, surrounded by cloud shadows. This uneven distribution of light is a tool you can use to control the viewer's attention.

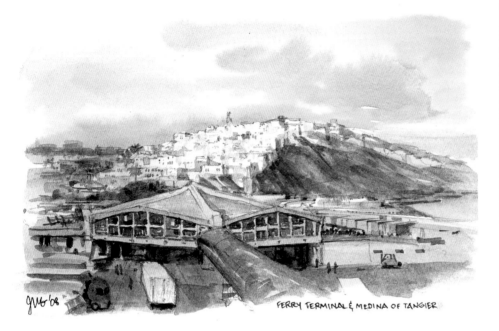

FERRY TERMINAL & MEDINA OF TANGIER

Dutch landscape painters frequently used cloud shadows to add variety to otherwise dull, open expanses of farmland. Since the eye is attracted to spotlit areas, you can position the light wherever you want to draw interest.

Illuminated objects are attractive when set against shadowed regions, and vice versa. If you're called upon to render a large townscape, you can place half of it in shadow. In both the plein-air painting above and the fantasy painting at right, the central part of the settlement is fully lit, while the rest falls away into shadow.

THREE RULES OF CLOUD SHADOWS

1. The margin between light and shadow must be a soft edge. It takes about half a city block to transition from full sunlight to full shadow.

2. The size and spacing of cloud shadows must be matched by the clouds visible in the sky.

3. The shadow area is darker and cooler than the sunlit area, but the shadow doesn't have quite as much of a blue cast as do the cast shadows on a clear day. This is because the light entering the shaded area is an average between the blue light from the open patches of sky and the diffused white light emanating from the cloud layer.

TECHNIQUE TIPS

Painters using transparent media can run a cool gray wash or glaze across the whole shadowed region to key it down. Some opaque painters prepare separate premixed colors for the shadowed and lighted areas. Another strategy is to paint the whole scene first as if it were in shadow, and define the lit areas last.

Above: Windmill Village, 2007. Oil on panel, 11¼ × 18 in. Published in *Dinotopia: Journey to Chandara.*

Opposite: Ferry Terminal, Tangier, 2008. Watercolor, 4¾ × 7½ in.

ILLUMINATED FOREGROUND

Instead of casting the foreground in shadow, as is the common practice in European and American painting, another approach is to put the immediate foreground in light, load it with detail, and then throw the middle distance into shadow.

Above: Light at the Crossroads, 2008. Oil on canvas mounted to panel, 11 × 14 in.

Opposite: Mammoth, 2009. Oil on board, 18 × 14 in.

In the painting above, the road invites us to step into the painting. The middle ground settles into shadow. The light returns to the redbrick building at the town center, where the activity clusters around the far intersection.

Painting this transition means premixing a second set of cooler and darker colors for the road, the yellow lines, the white lines, the grass, and the sidewalk.

The painting of the woolly mammoths, opposite, uses the illuminated foreground to concentrate the attention on the baby and on the dangerous footing along the water's edge.

SNOW AND ICE

Snow is denser than clouds or foam, so it's whiter. It picks up the colors of everything around it, especially in shadow. Cast shadows on snow take on the color of the sky. A blue sky makes blue shadows. Shadows on a partly cloudy day are grayer.

Awakening Spring, 1987. Oil on canvas mounted to panel, 16 × 24 in.

Snow reflects light as any opaque white surface would, but there are some important differences. In addition to diffuse reflection from the surface, there's a lot of subsurface scattering, especially on new, powdery snow.

You can observe this best on a sunny day when fresh snow is next to a more opaque white object like a white statue. The edges of smaller cast shadows on the snow will be a little softer and lighter, like a shadow cast on a bowl of milk. Snow that is backlit by the sun will show some subsurface scattering into the shadow area, lightening the edge along the terminator.

Light scattered below the surface of snow takes on its native blue-green hue due to the absorption of red wavelengths. This color can best be

seen in hollows in the snow and ice on overcast days.

As snow ages and compacts, it becomes darker, both from accumulated dirt and from transmission of more light below its surface. As the ice crystals get larger, the snow also develops more specular reflection, becoming shinier in certain places. This difference between new and old snow can best be observed on days when a light, new snowfall is blown into the hollows of older snow.

The whiteness of the snow makes a stream running through it look almost black by comparison. In the plein-air study above, the water was no darker than it would have been on a summer day, but it appears dark compared to the brightly lit snow. Note how the reflections of the trees and sky are much darker than the objects themselves, a phenomenon we'll look at more closely on the next page.

Rhinebeck Park in Snow, 2005. Oil on canvas mounted to panel, 9 × 12 in.

Following Pages, Left to Right: Bard Rock, 2004. Oil on canvas mounted to panel, 9 × 12 in.

Along the River, County Tipperary, 2004. Oil on panel, 8 × 10 in.

Riverbank View, 2004. Oil on panel, 8 × 10 in.

WATER: REFLECTION AND TRANSPARENCY

When light rays angle down toward the surface of still water, some of the rays bounce off the surface (reflection) and some travel down into it (refraction). If the water is shallow and clear, we're able to see the bottom, thanks to refracted light.

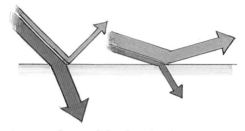

At steep angles, more light refracts into the water. At shallow angles, more light reflects off the surface.

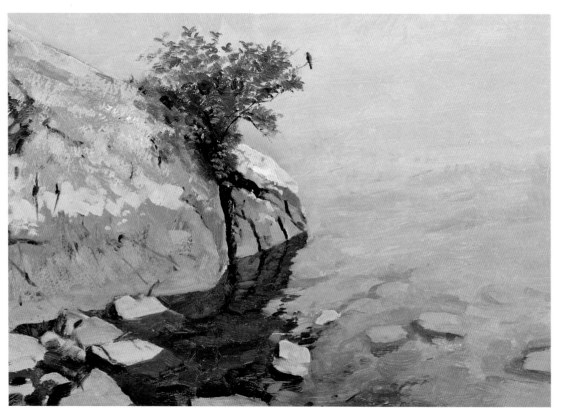

REFLECTION AND REFRACTION

Water approaches the reflectivity of a perfect mirror only when you're looking straight across it at a very shallow angle. As the steepness of the angle of reflection increases, the percentage of light entering the water also increases.

If you are looking steeply down onto the surface of the water, not much light from the sky will reflect to your eye. Think how dark the water in a lake or ocean appears when you look straight down into it from the side of a boat. This is also why the river in the foreground of the Streeton painting on page 21 is so much darker than the sky.

Since some of the light touching the water penetrates it rather than bouncing off the surface, the reflection of a light object in water will appear slightly darker than the object itself. Light objects might be clouds in the sky, a white house, or light-colored foliage. In the painting above, the light rock reflects considerably darker.

The light that enters the water is the very same light that you would see if you were snorkeling under the surface. If water were a perfect mirror, fish would live in pitch darkness. Because each

parcel of light is reduced by the amount of light that is diverted into the water, the amount of light reflected off the surface is also reduced.

TRANSPARENCY

In the painting above left, the bottom of the river is most visible in the foreground. In the upper part of the picture, looking straight out across the water, the gray reflection of the sky prevails.

In the area on the left half of the foreground, the tones of the river bottom are darker because the reflected light from the sky is blocked by the mass

of the rock. Polarized sunglasses will also selectively remove some of the glare of reflected skylight, allowing you to see more of the river bottom.

REFLECTION OF DARK OBJECTS
Just as light tones, such as the sky, reflect on the water surface, so too do the dark tones, such as trees. Their behavior, however, is governed by different factors.

The way they reflect on water depends

VERTICAL AND HORIZONTAL LINES
Water reflections differ from a mirror image in another way: The image is distorted by the wavelets on the water. Even if the wind is very light, tiny waves break up the reflection, and confuse the horizontal lines. Vertical lines, though, are still preserved in the reflection. As a result, water reflections always emphasize verticals over horizontals. In the words of John Ruskin, "All motion in

The plein-air study on the right was painted in a two-hour session. The details of the smaller masses of foliage are all swept together with vertical strokes in the reflection. The warm illuminated shallows become lighter in the foreground.

Painting reflections takes a combination of precision and freedom, accuracy and looseness. It's important to think about physics and geometry, but it

on two things. One is the amount of silt or sediment in the water, and the other is the amount of light shining into the water.

If the water is dirty, and if that dirty water is illuminated, the darks will lighten and turn browner, as they did in the plein-air study, above, of a river after a heavy rain. Reflections on muddy water are at their purest at dusk, when no direct light is touching the water. Muddy water under those conditions will reflect just as well as clear water.

water elongates reflections, and throws them into confused vertical lines."

TECHNIQUES FOR REFLECTIONS
Reflections appear spontaneous and gestural, but they also follow definite laws. Edges with strong contrasts, like a brightly lit wall against the sky, or a dark boat hull, break up in a loose—but controlled—painterly way.

Subordinate edges are usually blended and lost in the reflection. For example, on a fishing boat's reflection, you might see the outer edge of the stern, but not the lettering of the boat's name.

also helps to surrender to an irrational impulse.

CAST SHADOWS
An old law of landscape painting says that you can't cast a shadow over deep water. It's usually true, but only when the water is clear. If the water is filled with sediment, cast shadows are perfectly apparent, but their edges are more diffuse than shadows cast on land because the light transmits throughout the medium of the diffused particles.

MOUNTAIN STREAMS

Mountain streams behave differently than lowland streams and lakes. The water is usually clearer, and it moves with velocity and turbulence over the rocky stream bottom, forming rapids, ripples, eddies, and haystacks.

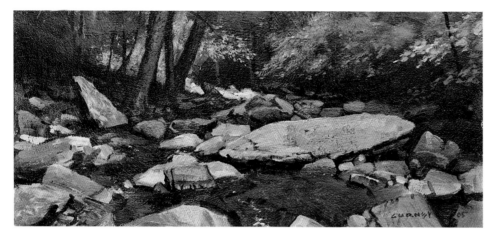

Plattekill Creek (detail), 2005. Oil on canvas mounted to panel, 9 × 12 in.

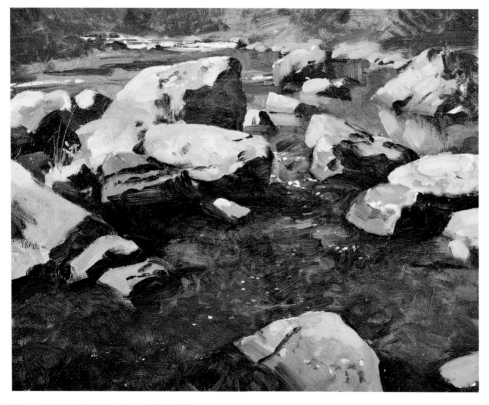

Esopus Creek, 2003. Oil on board, 11 × 14 in.

COLOR OF THE STREAM BOTTOM

When you look down into a clear mountain stream on a sunny day, there's often far more color beneath the surface of the water than above it. Because of water's color-filtering effects, stones shift to darker, warmer versions of the same local colors seen above water. Deeper than about three feet, the colors get progressively bluer and the bottom surface less distinct.

Details on the stream bottom become distorted by the rippled surface of the water. Underwater forms can be painted with a degree of looseness using strokes where the paint is incompletely mixed.

In all these examples, note the warm colors of the shallows. The colors shift to blues and greens in the deeper pools. In the distant parts of the stream in the painting at left, green color from the trees and blue color from the sky reflects off the surface of the water.

FOAM

In regions of whitewater, the current pulls foaming bubbles beneath the surface, where it appears warmer and darker. As the foam rises to the surface, it forms ringlets of bubbles around each spreading cell of rising water.

The bubbles quickly disperse as they travel outward. To make the foam appear to ride on the surface of the water, it should be painted last. These same effects of foam can be seen in a ship's wake in the open ocean.

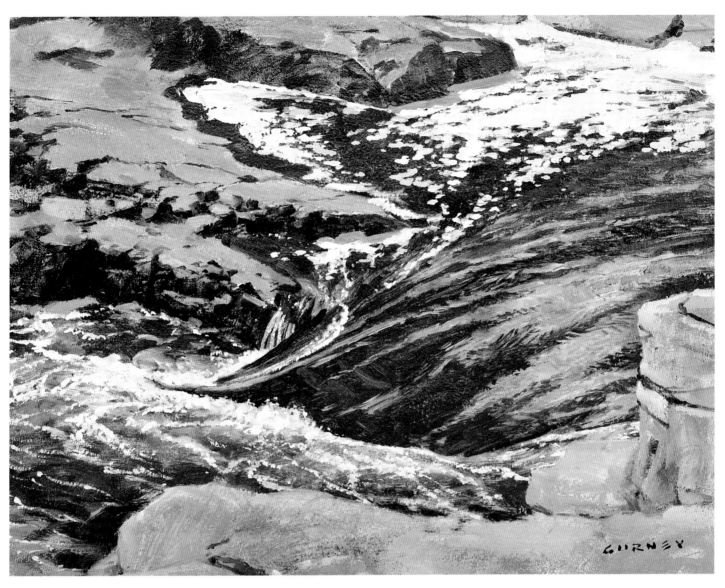

Lehigh River, 2009. Oil on canvas mounted to panel, 9 × 12 in.

WATER LEVEL CHANGES

The water level in a mountain stream often fluctuates noticeably from day to day or even throughout a single painting session. In fine weather after a rainstorm the level can drop several inches in a few hours. The coating of water leaves the rocks darker except where they catch specular highlights. This can also be seen on the study on page 171.

COLOR UNDERWATER

Water selectively filters out colors of light passing through it. Red is mostly absorbed at ten feet. Orange and yellow wavelengths are gone by twenty-five feet, leaving a blue cast. At much greater depths, only violet and ultraviolet light remain.

This effect occurs not only with light traveling downward into a column of water, but also to light traveling horizontally underwater. A bright red object seen fifty feet away through clear, shallow water will appear just as dull as the same object seen up close at fifty feet of depth.

Photographers use a flash to restore colors in deep water. The ability of the flash to enhance warm colors also diminishes rapidly with distance. The painting below shows ancient sea creatures as if lit by an underwater flash.

The submersible and marine reptiles in the painting opposite are rendered in grays, blues, and greens. All the reds from the brass parts are missing, so those areas appear more greenish. The distant sea creatures have lost almost all contrast, and nearly match the background color.

Various impurities discolor water in different ways. Silt or clay gives water a brownish color and drops visibility dramatically. Algae growth, typical of freshwater lakes, gives water a greenish appearance.

Devonian Seafloor, 1994. Oil on board, 12 × 13 in. Published in *Dinotopia: The World Beneath.*

Underway Undersea, 1994. Oil on board, 13 × 19 in. Published in *Dinotopia: The World Beneath.*

Dream Canyon, 1993. Oil on board, 14 × 29 in. Published in *Dinotopia: A Land Apart from Time.*

LIGHT'S CHANGING SHOW

SERIAL PAINTING

Serial painting is the creation of multiple plein-air studies of the same subject under different lighting conditions, or the making of a set of closely related studies one after another, like frames from a film or comic book.

From the Window of the TGV Train, 2008.
Watercolor, 4 × 7 in. overall.

VALENCE · FROM THE T.G.V. TRAIN

A VILLAGE ALONG THE RHONE

EAST OF LYON

ENTERING THE MOUNTAINS ·

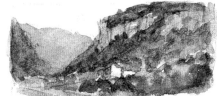

NEAR GENEVA

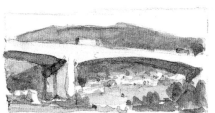

BELLEGARDE

BOGLANDS IN THE JURA 4 OCT
FRASNE

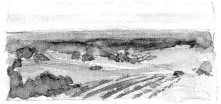

DOWN FROM THE MOUNTAINS

FARM NEAR DOLE

FROM THE WINDOW OF THE T.G.V. TRAIN

STORYBOARD A DAY IN YOUR LIFE

A fun way to pass the time on a long train ride is to do quick sketches of the changing landscape. These are tiny watercolor sketches, only an inch and a half wide. Since the landscape view disappears as quickly as it appears, you have to rely on your visual memory. You're forced to form a mental image of the characteristic landscape of the area you're passing through. The small shapes may change, but the big areas of color stay about the same for a few miles at least. After a long ride, you'll have a series that will capture a range of color and light effects.

You can do the same thing by taking your watercolors and sketching a color storyboard of a day in your life. At the end of the day you'll have a true-life series of color schemes that show the changes of the light from morning to night.

A Series of the Same Subject

In the 1890s, Claude Monet made a famous series of studies of Rouen Cathedral under a variety of lighting conditions. But the idea of multiple studies of the same subject goes back at least to Pierre Valenciennes in 1785.

At right are two plein-air paintings of the same valley vista. The first one shows the morning light touching the farthest range of mountains. The colors in the central mountain mass are cool and close in value.

The afternoon light emphasizes the rugged forms of the mountains. In the warm light, the pinks and oranges of the chaparral blaze in contrast to the deep blue-gray shadows. The sky appears relatively darker and more chromatic.

The experience of painting a series of the same subject brings up an important principle: The colors that you actually mix for a landscape painting often owe more to the particular conditions of light and atmosphere than to the local color of the objects themselves.

Tips for Serial Painting

1. Choose a motif that has a piece of sky, some distant reaches of space or mountains, and ideally a house or other white object with planes facing in different directions.

2. Paint the images either on a set of separate panels on a larger board taped off into smaller rectangles.

3. Keep the drawing consistent each time, so that the only variable is the light and color. Spend the first day resolving the drawing for all the panels, or do one careful line drawing, photocopy it, and glue identical copies down on each separate panel.

4. As you begin each study, don't look at the previous ones.

5. Paint the subject at different times of day, and if you can, return to the same spot at a different season of the year.

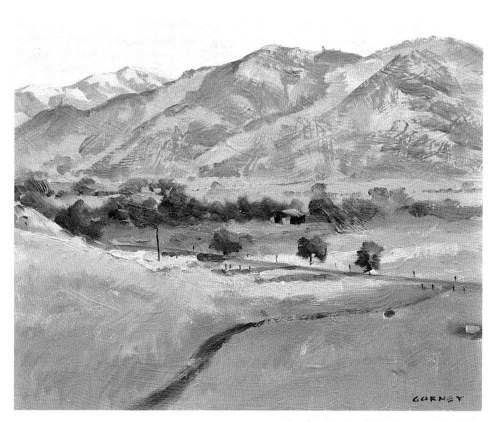

Ranch in Morning, 2002. Oil on panel, 8 × 10 in.

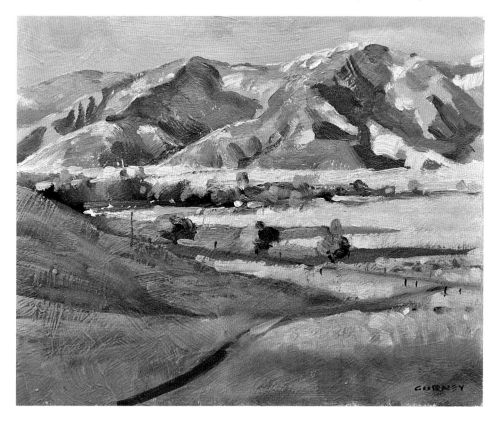

Ranch in Afternoon, 2002. Oil on panel, 8 × 10 in.

AT THE END OF THE DAY

Now that we've come to the final stop on our grand tour through color and light, let's look back at the main themes that have woven through all the separate topics. Keep these ten points in mind as you continue your journey.

1. *Color and light are not separate topics, but rather closely related.*
We started by looking at light and color separately. But as we progressed, they became more and more intertwined. Painting water, rainbows, color coronas, and sunsets involves the close interaction of light and color.

2. *Viewers will see the subject, but feel the color and light.*
We've seen how differently Abe Lincoln's face looks in various lighting arrangements. We've also seen how color schemes can create different moods. Illumination can transform any subject. The response to these effects is largely unconscious.

3. *Choose a lighting plan and stick to it.*
Before you begin painting, clearly establish the source of light. Keep it simple. If you're painting an imaginary subject, make sure your lighting reference is consistent.

4. *Know your wheel.*
You might use the Munsell system, the Yurmby wheel, or the RGB color space. Regardless, know the space and where your pigments are within it.

5. *Know your gamut.*
Whether you prefer premixing, free mixing, or limited palettes, be sure of the boundaries of your gamut. Good color schemes come from knowing what colors to leave out of the gamut.

6. *Vision is an active process.*
We don't see as a camera does. Our visual brain assembles the world for us, second by second, sifting and sorting and organizing the chaos that swirls around us.

7. *There is not a single brand of realism.*
Your paintings can be true to nature but emphasize different aspects of visual truth compared to another artist. The way you paint is a record of how you see. It will still be accepted as realism. This explains why Vermeer or Gérôme are instantly recognizable. Each is attentive to different facts of nature. Those who describe realism as slavish imitation miss this point.

8. *Compare, compare, compare.*
In a given scene, colors and values are known by their relationships rather than by absolute values. The color we see depends on a lot of factors other than the local color. As you paint, you must constantly make comparisons from one area to another. The color you mix is almost always shifted away from the local color.

9. *The outer eye fuels the inner eye.*
Study the principles in this book. Look for them in nature around you. Capture them in observational sketches. Use those observations in your imaginative paintings.

10. *We are fortunate to be living today.*
The pigments available today are relatively cheap and lightfast, something that the old masters could only have dreamed about. We have access to millions of reference images on the Internet. The digital revolution has deepened our understanding and given us powerful new tools. Let's learn from each other and go out and do our best work.

Lingering Light, 2004. Oil on canvas mounted to panel, 16 × 20 in.

Gideon's Arrival, 1998. Oil on board, 12 × 25½ in. Published in *Dinotopia: First Flight.*

GLOSSARY

absorption of light: Retention of light by the surface and conversion to heat, rather than reflection.

additive mixture: Mixing of colored illumination, including the blending of color in the eye rather than in pigments.

afterimage: A visual sensation that remains after an external stimulus has ended.

alla prima: A painting method where the work is completed in a single session.

Alexander's dark band: The relatively darker region between the primary and secondary rainbows.

ambient light: A generalized and relatively directionless illumination that remains when the key light is removed.

analogous colors: Hues that are adjacent to each other along the outer edge of the color wheel.

annular highlights: Patterns of small specular highlights that form into concentric rings around a light source or a principal highlight.

antisolar point: The point in the sky or below the horizon that is 180 degrees away from the sun.

artificial light: Light not produced by natural sources, especially electric light.

atmospheric (or aerial) perspective: The change in the appearance of objects as they are viewed at increasing distances through layers of illuminated air.

atmospheric triad: A color scheme based on a triangular gamut that does not include neutral gray.

backlight: A light that shines on the subject from behind to separate it from the background.

background light: A light that shines on the area behind the subject to raise the value of the background or define it more clearly.

brightness: The perceived intensity of a light.

broad lighting: A form of portrait lighting where the light shines more on the nearer or broader side of the face.

broken color: The placement of adjacent strokes of contrasting hues, which mix in the eye to form another color.

cast shadow: A shadow projected by an object onto another surface, as opposed to a form shadow.

caustics: The reflection or refraction of light by curved glass or by water waves, causing spots, arcs, or bands of light to be projected onto another surface.

chroma: Perceived strength of a surface color, that is, the degree of difference from neutrality, defined quantitatively in relation to standard color samples. High-chroma surface colors reflect light of high saturation and brightness for a given level of illumination.

chromatic adaptation: The tendency of the visual system to adjust to a given color of illumination.

clipping: In photography, the loss of information due to the photosensor's inability to respond to relatively bright or dim light levels.

color accent: A small area of color that stands out from the rest of the composition, usually because it's complementary or more intensely chromatic.

color cast: The dominant wavelength of a light source, typically measured in degrees Kelvin. Also, the dominant color woven throughout a color scheme, expressed as the center of area of a gamut.

color constancy: The perception of stability of local colors, despite changes in overall color cast.

color corona: A region of brightly colored light surrounding an intense light source, such as a setting sun or a streetlight; similar to a lens flare in photography.

color note: A particular color sample or swatch defined by hue, value, and chroma.

color rendering index (CRI): A measure of how accurately artificial light simulates the appearance of colors in natural sunlight.

color scheme: The selection of colors used in a composition.

color scripting: In a sequential form such as an illustrated book or animated film, the planning of the limited range of colors within each given sequence, and the transitions between them.

color space: The three-dimensional volume defined by the dimensions of hue, value, and chroma.

color string: A series of prepared paint mixtures, usually modulating a color note in various steps of value.

color temperature: A psychological attribute of color, relative to its proximity to orange (warmest) or blue (coolest).

color wheel: A circular figure made by distributing the hues of the spectrum around a circle.

complementary colors: Two hues of opposing or balanced color characteristics.

cone: Retinal receptor specialized for color vision and discrimination of detail.

contre jour (French): A type of backlighting where the subject is seen in front of a bright field of light.

convenience mixture: A blend of pigments that provides a useful paint color for which no single pigment exists.

cool colors: Colors tending toward blue and away from orange on the hue circle.

cyanometer: A device for evaluating sky colors.

dappled light: The patchwork of circular or elliptical spots of light caused by sunlight passing through small openings in an overhead canopy.

depth of field: The photographic quality that results from the inability of a lens to focus on more than one plane of distance at a time. The image becomes blurry away from the plane of focus.

dichromat: A person with color blindness, especially the inability to distinguish red from green.

diffuse reflection: Light that reflects irregularly off an uneven surface, as opposed to specular reflection.

downfacing planes: Parts of the form that face downward. Also called underplanes.

dye: Transparent colorant that dissolves in a liquid.

edge light: Light that comes from behind to illuminate the fringes of the form, separating it from the background. Also called rim light or kicker.

edges: The painterly control of blurriness, especially along the boundary of a form, useful for immersing a form in a background, creating a sense of depth, or suggesting dim illumination.

fall-off: The effect of the weakening of a light source in relation to the distance of the object away from it.

fill light: Light that illuminates the shadow side of a form and whose effect is to reduce contrast.

fluorescence: The absorption of light at one wavelength and reemission at a longer wavelength, typically converting ultraviolet to visible light.

form principle: The analysis of objects in terms of solid geometric objects and the application of that knowledge to the representation of other elements in nature.

form shadow: The shadowed side of an object, as opposed to a cast shadow. Also called attached shadow.

fovea: The area of the retina corresponding to the central point of vision, specialized in distinguishing fine detail.

free mixing: The practice of producing paint mixtures as needed throughout the painting process. Also called open palette. See also **premixing**.

frontal lighting: A lighting arrangement where the key light shines directly forward on the subject, leaving little visible shadow. Also called frontlighting.

fugitive: Susceptible to fading, especially after exposure to light.

gamut: The full range of color notes that can be mixed by a given set of primary colors; also, the region on the color wheel that represents that range.

gamut mapping: The practice of marking the outer boundaries of a region of the color wheel in order to describe, define, or plan the limits of a color scheme.

gel: A transparent material placed in front of a light to change the color, amount, or quality of a light.

glare: Strongly polarized light creating a region of intense illumination around a source.

glaze: A transparent layer of paint laid over a passage to intensify, deepen, or otherwise modify a color.

golden hour lighting: The light qualities of the first and last hour in the day, together with the effects of sunrise, sunset, and twilight. Also called magic hour.

gradation: A smooth transition from one color note to another, changing in hue, value, chroma, or all three at once.

grisaille: A painting or underpainting made in gray tones.

half-light: The region of the light side of the form approaching the terminator, where low, raking light accentuates texture.

halftone: Any of a series of intermediate tonal values that can be observed as the planes of a form transition from full light to the edge of shadow. Also called half-tint or demi-teinte.

hard light: A focused, directional light emanating from a relatively small source, which creates deep shadows, bright highlights, and sharp transitions.

harmony: A subjective evaluation of the compatibility of two or more colors.

high key: Having a lighter overall tonal range. In film lighting, having a low contrast between light and shadow.

highlight: A specular reflection of the light source on a wet or shiny surface.

hue: The attribute of a color that allows it to be identified with yellow, red, blue, green, or other color of the spectrum.

HVC: Shorthand for hue/value/chroma, a way of defining a specific color note.

impressionism: A style of painting associated with subjectivity of perception, commonplace subject matter, alla prima handling, high-key values, broken color, and colorful shadows.

incandescence: The emission of visible light by an object heated to a high temperature.

induced color: The accentuated perception of a hue caused by the stimulation from another, usually complementary, hue.

inverse square law: The rule which states that the intensity of light from a point source falling on a surface varies inversely as the square of the distance between the source and the surface.

key light: The dominant light, usually illuminating the object from above or in front.

lightfastness: The ability of a pigment or a dye to resist fading as a result of exposure to sunlight. Also often referred to as permanence.

lighting ratio: The ratio of key light to fill light.

limited palette: A restricted selection of pigments, often resulting in a painting with a reduced gamut. Also called a restricted palette.

local color: The color of the surface of an object, as opposed to the actual paint mixture you use to represent it.

luminescence: The ability of an object to emit light at low temperatures, as opposed to incandescence.

masstone: A pigment as it appears in a thick layer, straight from the tube, as opposed to an undertone.

modeling: The description of form using a controlled set of light and dark values.

modeling factors: An orderly and predictable series of tones representing planes of a solid form, including highlight, light, halftone, core, and reflected light.

monochromatic: Composed of variations in value or chroma of a single hue.

motion blur: Softening of edges that occurs when a form moves rapidly in front of a stationary camera.

motivation of light: The impression that a given lighting arrangement derives from a source understood by the viewer (usually in film).

neutral color: 1. A color made by mixing two complementary colors together, thereby eliminating any hue identity. 2. A color note with zero chroma, namely white, gray, or black.

occlusion shadows: Small, dense areas of shadow occurring at points of contact or proximity, where forms come close enough to each other to interfere with the light.

oiling out: Rubbing the surface of a dry painting with a thin layer of medium to make it more receptive to paint. Also called oiling up.

opacity: The resistance of a pigment to the transmission of light.

opponent process theory: The theory of human vision which originally stated that all perceived colors are the result of interactions between pairings of red/green, blue/yellow, and black/white receptors, now an element of zone theory, which holds that inputs from long-, medium-, and short-wavelength receptors are converted into red/green, blue/yellow, and brightness signals.

optical mixture: The blending of separate, usually adjacent, colors in the eye.

palette: The selection of pigments used by a painter; also the surface where the paints are stored and mixed.

peak chroma value: The value at which a given hue reaches its highest chroma.

permanence: The resistance of paint to various forms of fading, darkening, or otherwise changing.

pigments: Powdery, dry, insoluble materials that selectively absorb and reflect wavelengths of light to produce color.

premixing: The practice of preparing organized paint mixtures on the palette in advance of painting. Also called setting a palette.

primary colors: In Newton's theory, any purely monochromatic hue. In pigments, the smallest set of colors that can yield the widest possible gamut of mixtures, especially yellow, magenta, and cyan, or their nearest pigment equivalents. In

lighting and digital photography: red, green, and blue light.

Purkinje shift: A perceptual effect in very dim light where the rods, which are most sensitive to bluish wavelengths, cause greenish or bluish hues to appear lighter in value.

Rayleigh scattering: The effect of small air molecules upon light passing through them, resulting in the refraction of more short (blue) wavelengths than the long (red) wavelengths, resulting in the blue color of the sky.

reflected light: Light bounced from an illuminated surface, usually into a shadow. Also called diffuse inter-reflection.

refraction: The bending of light rays as they pass from a medium of one density into another medium of a different density.

Rembrandt lighting: A portrait lighting arrangement where the head is lit on the far side of the face, leaving a lighted triangle on the cheek closest to the viewer.

reverse atmospheric perspective: Progression of color from cooler colors in the foreground to warmer colors in the background.

rod: The receptor in the eye that is especially sensitive to low levels of light, but cannot discriminate color.

saturation: Often used for perceived "purity" of a surface color, meaning in effect chroma, or chroma relative to the maximum possible or envisioned. More usefully defined as color purity of light. Surface colors that give off high-saturation light include both relatively light, high-chroma colors and deep, dark, lower-chroma colors.

saturation cost: The inevitable reduction in chroma produced by mixing colors of different hues.

scotopic vision: Vision at very low levels of illumination, usually involving only the rods.

secondary colors: The halfway or intermediate mixtures between any two primaries. If the primaries are yellow, magenta, and cyan, the secondaries are red, blue, and green. If the primaries are red, blue, and green light, the secondaries are magenta, yellow, and cyan light.

serial painting: The creation of multiple plein-air studies of the same subject under different lighting conditions, or a set of closely related studies made one after another, like frames from a film or comic book.

shade: A hue mixed with black or otherwise darkened in value.

shadowbeam: An atmospheric effect where a shadow cast by clouds, contrails, or tree branches appears as a darker shaft within a region of illuminated air.

short lighting: A lighting arrangement where the foreshortened farther side of the face is illuminated, leaving the closer side more in shadow.

simultaneous contrast: The phenomenon in which a color appears to change due to the effect of an adjacent color.

sky panel: A surface prepared with a sky-colored gradation to be used as a base layer for future painting.

skyholes: Openings or apertures within the silhouette of a tree through which the light of the sky is visible.

soft light: Light that emanates from a diffused or wide source, resulting in gradual fall-off, less noticeable highlights, and less contrast.

spectral power distribution: A graph showing the amplitude of each of the wavelengths of visible light in a given light source.

spectrum: A continuum of pure hues distributed according to their wavelength, as when white light is refracted through a prism.

specular reflections: The tendency of shiny objects to behave like a mirror, reflecting light rays at the same angle of incidence from a surface.

specular highlight: A reflection of the light source on a wet or shiny surface.

speed blur: Softening of edges that occurs when a camera tracks along with a fast-moving object, blurring the entire background along the path that the camera travels.

spotlighting: A concentration of light on the central focus of a scene.

subjective primaries: Any three starting colors used to mix a gamut of other colors. Subjective primaries may be any hues and they may be reduced in chroma. The subjective neutral is the center of area of a particular gamut.

subsurface scattering: The phenomenon where light enters any thick, translucent material and spreads out beneath the surface, creating a glow.

subtractive mixture: The mixture of color by means of pigments, dyes, or gels.

successive contrast: The effect of an afterimage on the experience of a currently viewed subject.

sunbeam: A shaft of sunlight made visible in dust- or moisture-laden atmosphere.

sunset color bands: Horizontal bands of colors that form low in the sky at sunset; usually orange near the horizon and blue above.

supernumerary bows: Rainbows that form at angles of less than 42 degrees inside the primary rainbow.

terminator: The part of the form where the light transitions into shadow.

tetrachromat: A person with four sets of color receptors.

three-quarter lighting: Illumination angled at about 45 degrees to the subject, leaving a fourth of the form in shadow.

tint: A hue mixed with white.

tinting strength: The degree to which a pigment maintains chroma with the addition of white.

tone: A hue mixed with gray.

transmitted light: Light that has passed diffusely through a thin, translucent material, sometimes becoming richly colored.

transparency: The tendency to permit the unscattered transmission of light, as opposed to translucency (permitting scattered transmission of light) and opacity.

triadic scheme: A color scheme with three primaries whose gamut is a triangle.

trichromat: A person with normal human vision, consisting of three kinds of color receptors.

underlighting: Primary illumination from a source below the subject.

undertone: The appearance of a pigment spread thinly, as opposed to a masstone.

upfacing planes: The parts of a form that face upward. Also called top planes.

value: The lightness or darkness of a color note in relation to a gray scale. Also often called luminance.

warm colors: Colors tending toward orange on the color wheel.

well of the sky: The part of a clear sky that is the darkest and purest color of blue.

Yurmby wheel: A color wheel with yellow, red, magenta, blue, cyan, and green (YRMBCG) evenly spaced around the circumference.

PIGMENT INFORMATION

This is a list of modern, familiar, reliable pigments, along with some of their properties, followed by a list of pigments that should be avoided or used with caution. This is not meant to be complete or exhaustive. For more comprehensive information, please visit the resources listed in the recommended reading section.

CIN	Color Index Name: PW=Pigment White, PY=Pigment Yellow, PO=Pigment Orange, PBr=Pigment Brown, PR=Pigment Red, PV=Pigment Violet, PB=Pigment Blue, PG=Pigment Green, PBk=Pigment Black.
Alternate	Other names or trade names.
ASTM	Lightfastness: I=excellent, II=very good, III-V=not sufficiently lightfast.
OP	Opacity: 1=very opaque, 2=somewhat opaque, 3=somewhat transparent, 4=very transparent.
TS	Tinting Strength: 1=strong, 2=moderate, 3=weak.
TX	Toxicity: A=safe, B=somewhat toxic, C=extremely toxic.
DR	Drying Rate in oil: 1–slow, 2=moderate, 3=fast.

Common Name	CIN	Alternate	ASTM	OP	TS	TX	DR	Remarks
WHITES								
titanium white	PW 6		I	1	-	A	2	Opaque, safe white. Greatly used in industry.
zinc white	PW 4	Chinese white	I	2-3	-	B	1	Slightly less opaque than other whites, good in tints.
YELLOWS								
benzimidazolone lemon	PY 175		I-II	2	2	A	2	Mixes well both to greens and oranges.
cadmium yellow light	PY 35	lemon yellow	I	1	2	B	1	Good mixer, close to primary yellow.
cadmium yellow	PY 37	aurora yellow	I	1	2	B	1	Worth the cost, but handle with care. 1840.
hansa yellow	PY 3	arylide yellow	II	2-3	1	A	2	Also called lemon yellow.
Mars yellow	PY 42	yellow oxide	I	2-3	1-2	A	2	Synthetic iron oxide, higher chroma than y. ochre.
nickel dioxine yellow	PY 153	new gamboge	I	2-3	2	B	2	Bright yellow orange.
nickel titanate	PY 53	nickel yellow	I	2	2-3	B	1	Recent synthetic, reliable, oxide of nickel and titanium.
yellow ochre	PY 43		I	2-3	1-2	A	2	Natural iron-based yellow, mellower than PY 42.
ORANGES								
benzimidazolone orange	PO 36		I	2	2	A	2	Recent red-orange. Reliable.
cadmium orange	PO 20		I	1	2	B	3	Good coverage and mixing, but handle with care.
perinone orange	PO 43		I	3	1	A	2	Good alternative to cadmiums, but less opacity.
pyrrole orange	PO 73	vermilion hue	I	2-3	2	B	2	High chroma.
quinacridone orange	PO 48		1	3	1	A	2	
BROWNS								
burnt sienna	PBr 7 or PBr 101		I	3	2-3	A	3	iron oxide. Variety of colors and quality.
burnt umber	PBr 7		I	2	2	A	3	iron oxide. Best grades from Cyprus.
Mars brown	PBr 6		I	2	2	A	2-3	Synthetic iron oxide.
raw sienna	PBr 7 or PBr 101		I	3	2	A	2-3	iron oxide. Darker than yellow ochre.
raw umber	PBr 7		I	2	2	B	3	iron oxide. Dark color from manganese dioxide.
REDS								
cadmium red	PR 108	cad. scarlet	I	1	2	B	1	Opaque, rich color, but toxic. Introduced 1910.
naphthol red	PR 112	scarlet, azo	I-II	3	2	A	2	OK in oil and acrylic, but not as lightfast in watercolor.
naphthol scarlet	PR 188	scarlet lake	I	2	1-2	A	2	Reliable orange-red.
perylene maroon	PR 179	p. crimson	I	3	1	A	2	Dark brownish red.
pyrrole red	PR 254	Winsor red	I	2	2	A	2	Semiopaque, very lightfast, mixes to warm and cool.
pyrrole rubine	PR 264	p. alizarin	I	3	1	A	2	Good replacement for alizarin crimson.
quinacridone red	PR 209	q. coral, I	1	3	1	A	2	High chroma, transparent, lightfast, good mixer.
quinacridone magenta	PR 122		I-II	4	2	A	2	Most permanent in this color range. Good primary.
trans. red oxide	PR 101		I	4	2	A	3	Small particle size gives it transparency.
Venetian red	PR 101	English red	I	1	3	A	3	Variations of iron oxide. Indian red is more violet.

Common Name	CIN	Alternate	ASTM	OP	TS	TX	DR	Remarks
VIOLETS								
cobalt violet	PV 14, 49		I	2-3	2	C	2	Inorganic synthetic, toxic. PB 49 is pale version.
manganese violet	PV 16	mineral v.	I	1-2	3	C	3	Permanent, but toxic.
Mars violet	PR 101		I	2	2	A	2	Good underpainting color.
quinacridone violet	PV 19	permanent rose	I	4	1	A	2	Brilliant red-violet.
ultramarine violet	PV 15	ultra. red	I	2	2	A	2-3	Available in blue and red shades.
BLUES								
cerulean blue	PB 36		I	1	2-3	B	1	Opaque blue-green, useful for landscape.
cobalt blue	PB 28		I	2-3	3	C	2	Expensive due to use on jet turbine blades.
phthalo blue	PB 15	Winsor blue	I	4	1	A	2-3	Intense and transparent. Avail. in red & green shades.
phthalo cyan	PB 17	selkalite	I-II	4	1	A	2-3	Close to primary cyan.
Prussian blue	PB 27	Antwerp blue.	I-II	3	1	A	3	Largely replaced by superior phthalo blue.
ultramarine blue	PB 29	French ult.	I	3	2	A	2	Excellent, well deserving its popularity.
GREENS								
phthalo green	PG 7	Winsor green	I	4	1	A	2	Intense tinting strength, transparent.
viridian	PG 18	-	I	3	2	B	2-3	Inorganic synthetic chromium. Good glazing color.
cobalt teal blue	PG 50	c. titanite	I	2	2-3	B	2-3	Blue-green.
terre verte	PG 23	green earth	I	2-3	3	A	2	Dull, weak green made from clays.
chromium oxide green	PG 17		I	1	2-3	C	2	Used in military camouflage. Durable. Toxic.
BLACKS								
ivory black	PBk 9	bone black	I	2	2	A	1-2	Once made from real ivory. Slow drier.
lamp black	PBk 6	carbon black	I	2	1	A	1	Once made from vegetable oil, now petroleum oils.
Mars black	PBk 11	iron black	I	1	3-4	A	2	Synthetic iron oxide.
perylene black	PBk 31		I	2	-	A	-	Extremely dark green.

HISTORIC OR NOT RECOMMENDED PIGMENTS

Common Name	CIN	Remarks
alizarin crimson	PR 83	Cool red, not lightfast; replace with quinacridone, pyrrole, or perylene.
asphaltum		Bitumen tar product. Self-destructs. Avoid.
aureolin	PY 40	Also called cobalt yellow. Toxic and not reliably lightfast.
carmine red	NR 4	Made from beetles. Also called cochineal and crimson lake. Not lightfast.
chrome yellow		Lead chromate. Introduced 1797. Toxic and darkens on exposure.
emerald green		Copper aceto-arsenate. So poisonous it's used as an insecticide.
flake white		Excellent working qualities, but high toxicity makes it undesirable. Also called white lead.
gamboge		Yellow, not sufficiently lightfast.
Hooker's Green	PG 8	Original pigment unreliable. Now usually a mix of PO 49 and PG 36.
Indian yellow		Intense yellow pigment supposedly made from the urine of cows force-fed mango leaves.
indigo		Deep blue used in blue jeans. Not lightfast.
lithol rubine	PR 57:1	Standard process magenta printing ink.
rose madder		Laked pigment used as a useful textile dye made from a root. Fugitive in watercolor.
manganese blue	PB 33	No longer in production. Toxic.
mummy brown		Discontinued not for lack of mummies but for fear of illness.
naples yellow		Once made of lead, now various convenience mixtures, usually of yellow ochre and white.
naphthol AS scarlet	PR 9	Not lightfast in watercolor. Substitute pyrrole red or pyrrole scarlet.
olive green		Conventional name for a dull, green-yellow made from various convenience mixtures. Use caution.
Van Dyke brown		Not lightfast, poor handling properties.
vermilion		Red-orange made from toxic mercuric sulfide. Also called cinnabar.
verdigris		Synthetic green, unreliable in combination with other chemicals.

RECOMMENDED READING

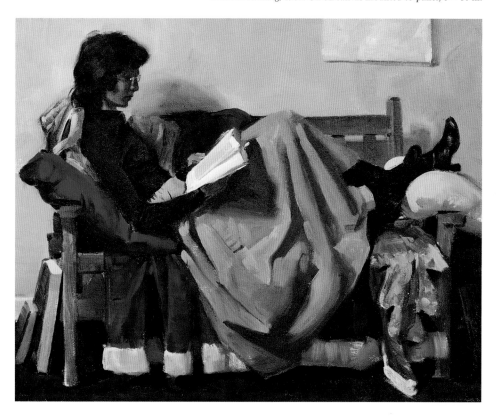

Jeanette Reading, 1985. Oil on canvas mounted to panel, 8 × 10 in.

BOOKS

Berlin, B. and Kay, P. *Basic Color Terms.* Berkeley: University of California Press, 1969. The classic study of color names from the perspective of linguistic and cultural anthropology.

Bluhm, Andres and Lippincott, Louise. *Light: The Industrial Age, 1750–1900: Arts & Science, Technology & Society.* Amsterdam and Pittsburgh, Thames & Hudson, 2000. A survey of how science and light technology influenced artists in the nineteenth century.

Carlson, John F. *Elementary Principles of Landscape Painting.* New York: Bridgman Publishers, Inc., 1929. Revised and republished as *Carlson's Guide to Landscape Painting* by Dover Publications in 1958. Useful material on design, light, aerial perspective, color, clouds, and composition.

Chevreul, Michel Eugene. *The Principles of Harmony and Contrast and Their Applications to the Arts.* West Chester, Pennsylvania: Shiffer Publishing, Ltd., 1987. Introduction and notes by Faber Birren. Updated edition of the influential masterwork from 1839, which lays out theories of complements, simultaneous contrast, and harmony.

Dorian, Apollo. *Values for Pictures Worth a Thousand Words: A Manual for Realist/Representational Painters.* Tucson: Apollodorian Publisher, 1989. A detailed but at times impenetrable account of the method taught by Frank Reilly at the Art Students League, using Munsell color charts and terminology.

Edwards, Betty. *Color: A Course in Mastering the Art of Mixing Colors.* New York: Jeremy P. Tarcher, 2004. A readable introduction to the study of color, covering basic theory, terminology, materials, mixing, and psychology.

Ferber, Linda. *Kindred Spirits: Asher B. Durand and the American Landscape.* New York: The Brooklyn Museum, 1997. Appendix includes Durand's influential "Letters on Landscape Painting" from 1855.

Finlay, Victoria. *Color: A Natural History of the Palette.* New York: Ballantine Books, 2002. Fascinating stories about the origins of the pigments.

Gage, John. *Color and Culture: Practice and Meaning from Antiquity to Abstraction.* Boston: Little, Brown and Company, 1993. History of cultural ideas about color, from ancient Greece to the present.

Goethe, Johann Wolfgang von. *Theory of Colours (Zur Farbenlehre).* John Murray, 1810. Republished as *Goethe's Color Theory* by Van Nostrand Reinhold. Begun as a refutation of Newton, Goethe connected color and light to observation in a way that inspired many later artists.

Guptill, Arthur L. *Color in Sketching and Rendering.* New York: Reinhold Publishing, 1935. Helpful advice on theory and practice of watercolor painting, intended for architectural illustrators, with many fine color plates.

Hatt, J. Arthur H. *The Colorist: Designed to Correct the Commonly Held Theory that Red, Yellow, and Blue are the Primary Colors, and to Supply the Much Needed Easy Method of Determining Color Harmony.* New York: Van Nostrand Company, 1908.

Hawthorne, Charles. *Hawthorne on Painting.* (Collected by Mrs. Charles W. Hawthorne.) New York: Dover Publications, 1960. First published by Pitman in 1938. Pithy precepts from a student of William Merritt Chase and Frank

Vincent Dumond and the founder of the Cape Cod School of Art.

Hoffman, Donald D. *Visual Intelligence: How We Create What We See.* New York: W. W. Norton, 1998. Current theories in the science of visual perception.

Khan, S. and Pattanaik, S. 2004. "Modelling blue shift in moonlit scenes using rod cone interaction." *Journal of Vision* 4(8): 316a. http://journalofvision.org/4/8/316/.

Kemp, Martin. *The Science of Art: Optical Themes in Western Art from Brunelleschi to Seurat.* New Haven: Yale University Press, 1992. One third of the book covers the history of color theory as it relates to art history, supported by many primary source quotes and illustrations. Also covers perspective and optical aids.

Lane, Terence. *Australian Impressionism.* Melbourne: National Gallery of Victoria, 2007. Fine reproductions of Arthur Streeton and his contemporaries.

Livingstone, Margaret Stratford. *Vision and Art: The Biology of Seeing.* New York: Harry N. Abrams, 2002. A Harvard neurobiologist explains how aspects of human vision are manifested in impressionist paintings.

Loomis, Andrew. *Creative Illustration.* New York: Bonanza Books, 1947. Helpful chapters on tone and color with pointers on choosing and combining color.

Minnaert, M. *The Nature of Light and Colour in the Open Air.* New York: Dover Publications, 1954. A keen observer shares his explanations of natural phenomena, such as dappled light, rainbows, clouds, and halos.

Munsell, A. H. *Color Balance Illustrated: An Introduction to the Munsell System.* Boston: George Ellis Co., 1913. Introduction to Munsell's system, with many diagrams of his approach to color and suggested program of study.

————. *A Color Notation.* Boston: George H. Ellis, 1905. Short but comprehensive handbook explaining Munsell's conception of color based on the three dimensions of hue, value, and chroma.

Overheim, R. Daniel and Wagner, David L. *Light and Color.* Edinburgh: John Wiley & Sons, Inc., 1982. Properties of light and color in relation to physics and physiology.

Pollock, Montagu. *Light and Water: A Study of Reflexion and Colour in River, Lake, and Sea.* London: George Bell and Sons, 1903. Analysis of reflections on smooth, rippled, and wavy water, with diagrams and explanation.

Rood, Ogden. *Modern Chromatics: Students' Text-Book of Color with Applications to Art and Industry.* New York: Van Nostrand Reinhold Company, 1973. This facsimile edition of the first American edition from 1879 was edited by color expert Faber Birren, who puts Rood's landmark study in context as a major influence on painters.

Ross, Denman Waldo. *On Drawing and Painting.* Boston and New York: Houghton Mifflin Company, 1912. Ross was a contemporary of Munsell who advocated premixing with set palettes. The text is useful, though illustrations are few and far between.

Ruskin, John. *The Elements of Drawing.* New York: J. Wiley & Sons, 1877. The chapter on color covers the setting sun, reflections, foliage, and gradation.

————. *Modern Painters.* New York and London: Penguin Books, 1982. First published in 1843. The first volume is full of close observations of reflections, clouds, and light.

Sanford, Tobey. *Capturing Light: A Guide for Photographers & Cinematographers in the Digital Age.* New York: Self-published, 2005. Available from Greatpix.com. Analysis of color and light in picture–making from a professional photographer's point of view.

Sargent, Walter. *The Enjoyment and Use of Color.* New York: Dover Publications, 1964. Reprint of original Scribner's edition of 1923. The elements of color and practical approaches to achieving color harmony.

Stobart, John. *Pleasures of Painting Outdoors with John Stobart.* Cincinnati: North Light Books, 1993. A series of plein-air landscape demonstrations with useful insights on light and color.

Varley, Helen, ed. *Color.* London: Marshall Editions, 1980. Comprehensive illustrated survey exploring theory and history, with an emphasis on cultural perspectives.

Wilcox, Michael. *The Wilcox Guide to the Best Watercolor Paints.* Cloverdale, Perth, Australia: Artways, 1991. An exhaustive analysis of the composition of each watercolor pigment from each of the manufacturers, accompanied by swatches and lightfastness tests.

INTERNET RESOURCES

Some of the most up-to-date and complete information is on the Web.

artiscreation.com by David G. Myers. Thorough chart of pigments and their properties.

handprint.com by Bruce MacEvoy, 2005. Extensive website with information about color vision, theories of light and color, and detailed evaluations of watercolor pigments.

hilarypage.com by Hilary Page. Reviews and tests of watercolor pigments.

huevaluechroma.com by David Briggs. Scientifically grounded analysis of light and color theory.

paintmaking.com by Tony Johansen. Reference primarily for oil painters, especially those who want to make their own paints. Advice on pigments, binders, equipment, and safety.

makingamark.blogspot.com by Katherine Tyrell. Various resources for artists, including summaries about color theory with additional links.

ACKNOWLEDGMENTS

When I set out to write a book on color and light, I didn't expect that I would spend so much time stumbling around in the dark. At the outset I underestimated the complexity of the subject, which has challenged minds far keener than my own. Understanding color and light means grappling with physics, visual perception, and solid geometry, as well as the special vocabularies of painting, photography, computer science, and psychology.

Many friends have lent a hand to lead me through the labyrinth, correcting drafts and making helpful suggestions. Two photographers, Tobey Sanford and Art Evans, shared their sensitive perceptions of light and color from a perspective quite unfamiliar to me as a painter. I would like to thank vision scientists Greg Edwards, Margaret Livingstone, and Semir Zeki for answering my questions. Color experts Bruce MacEvoy and David Briggs reviewed parts of the material, though I hasten to say that any remaining errors are entirely my own.

Some of my fellow artists who are also teachers assisted me by reflecting on the material from their vast reserve of experience. In particular I would like to acknowledge Dennis Nolan, Ed Ahlstrom, Mark Tocchet, Nathan Fowkes, Christopher Evans, and Armand Cabrera. Lester Yocum and Eric Millen helped me work out some computer challenges.

Much of this material has been shared and discussed by my blog readers, far too many to name. Their comments have influenced every page of this book, and they helped choose the cover image with an online poll. I'm grateful to all of them for taking the time to encourage, correct, or enlighten me.

Thanks to the museums and private collectors of the artwork reproduced at the beginning of the book. Every effort has been made to trace the copyright holders. The author apologizes for any unintentional omissions and would be pleased, if any such case should arise, to add an appropriate acknowledgment in future editions. To the readers who regret the absence of their favorite artists in the historical section, I freely admit that I passed by many beloved masterworks in favor of paintings that have rarely been reproduced in other art books.

I would also like to express my appreciation to my editor Caty Neis, and the entire team at Andrews McMeel Publishing for their support of this project and their expertise in bringing the book into tangible form.

My deepest thanks goes to my sons Dan and Frank, who believed in this dream and cheered me on at important milestones. Most of all I thank my wife and sketching companion, Jeanette, who read through countless drafts and reviewed endless layout changes.

INDEX